MODERNISM AT THE BARRICADES

STEPHEN ERIC BRONNER

# MODERNISM
# AT THE BARRICADES

*AESTHETICS, POLITICS, UTOPIA*

 COLUMBIA UNIVERSITY PRESS    NEW YORK

Columbia University Press

*Publishers Since 1893*

New York   Chichester, West Sussex

cup.columbia.edu

Copyright © 2012 Columbia University Press

All rights reserved

Library of Congress Cataloging-in-Publication Data

Bronner, Stephen Eric, 1949–

   Modernism at the barricades : aesthetics, politics, Utopia / Stephen Eric Bronner.

     p.    cm.

   Includes bibliographical references and index.

   ISBN 978-0-231-15822-0 (cloth : alk. paper) — ISBN 978-0-231-53088-0 (ebook)

   1. Arts, Modern—20th century. 2. Arts and society—History—20th century.

3. Aesthetics, Modern—20th century. I. Title.

   NX456.5.M64B76  2012

   700'.4112—dc23

                                            2012005414

Cover design: Michael Gibson

References to Internet Web sites (URLs) were accurate at the time of writing. Neither the

   author nor Columbia University Press is responsible for URLs that may have expired or

   changed since the manuscript was prepared.

*In memory of my dear friend and comrade*
Robert Fitch

One must be absolutely modern.

*—Arthur Rimbaud*

Make it new!

*—Ezra Pound*

Let us make room for freedom!

*—Erich Mühsam*

# Contents

# Illustrations

# Preface

*Modernism at the Barricades* makes no pretense to being an inclusive history or an overarching formal analysis of a cultural transformation that still marks our time. Its concern is more modest. The studies in this volume deal with different aspects of the confrontation between modernism and modernity. Each chapter, after its fashion, explores the cultural politics of an international avant-garde intent on resisting bureaucracy, standardization, mass society, and the commodity form. Modernists everywhere complied with Ezra Pound's injunction to "make it new!" But that didn't prevent them from appropriating certain elements of the past in contesting trends that they identified with cultural decadence and the erosion of authentic feeling, along with alienation and reification. Few had any use for reform. Visions of the apocalypse, in fact, became a substitute for old-fashioned ideas of revolution inherited from 1789. Modernists believed that their world stood in need of utopian redemption. New ways of feeling, new forms of expression, and new possibilities of experience and solidarity were required for an increasingly decadent civilization hurtling towards war. Expanding the realm of experience and reinvigorating everyday life served as the focus of their efforts. Modernism had from its inception implicitly identified this kind of cultural resistance with politics, and the implications of that identification remain with us today.

Modernism popularized the notion of cultural politics: the transformative project now centered on liberating the individual from the constraints of tradition while envisioning a new notion of community. Institutions rarely played a role in this undertaking any more than material interests or the ability to specify objective constraints on action. Culturally enriching what

Walter Benjamin termed "the poverty of the interior" was the primary purpose of social action. That painting should have played such a central role in this enterprise only makes sense. Around the turn of the twentieth century it was still the medium in which, quite literally, the public saw itself. Articulating new possibilities of experience on the part of modernist painting may objectively have had its roots in attempts to rescue the medium from photography and film, which appeared to have captured the "real," but subjectively, these new visual experiments constituted a scandalous affront to tradition and how reality was understood. Expressionism, futurism, Dada, and surrealism privileged painting. Their innovative forms projected a radical and often utopian content. Repressed desires and denied experiences became the stuff of visionary change. Modernist painting at its best crystallizes the latent tensions and the underside of a period commonly identified with a confident self-satisfaction in scientific and industrial progress and the triumph of enlightened ideals. Cultural rebellion against this self-understanding became conflated with political revolution.

*Modernism at the Barricades* shows how the experiments undertaken by the international avant-garde (often unintentionally) created cultural preconditions for political action, how some of their efforts proved progressive and others reactionary, and how culture and politics sometimes overlap and other times contradict one another. Its chapters highlight both the political responsibility of the artist and the way in which authorial intention can be manipulated. They speak to avant-garde movements now past and offer glimpses of what might be reconfigured for progressive purposes in the present. They also, I hope, offer insights into some of the confusions still operative in cultural politics today. Ultimately, this book attempts to remind us of the political dimension in developments that are, today, usually treated in purely aesthetic terms. But it also questions the self-indulgence, political ignorance, and plain irresponsibility within the modernist tradition.

The introduction explores the logic of modernism, the implications deriving from its understanding of cultural politics, and the normative impulses governing this study. The next chapter deals with the tradition of radical cultural criticism, its limits and contributions, and the politically charged meaning of terms like *realism, modernism,* and *postmodernism*. Such categories are then rendered concrete in chapters that analyze the thinking of various representative artists and the political ideologies of movements like expressionism, futurism, and surrealism. These movements and their artists often had real political impact. That is why it makes

sense to consider events like the Bavarian Soviet of 1919, known as "the government of the literati," as well as the monumental exhibition "Paris and Berlin, 1900–1933," which took place at the Pompidou Center in 1978. The last chapter looks back on the past with an eye to the future.

*Modernism at the Barricades* grew out of an interest in modernism and modernist painting that began while I was growing up during the 1960s. Ernst Bloch, who influenced my views on aesthetics, insisted that modernist painting contributed most to the international cultural transformation generated by the European avant-garde. That is part of the reason why I place such emphasis on the visual arts in this book. Painting helped me imagine the character of a counterculture and a new sensibility. Utopian sentiments were also pervasive during the 1960s. Enough intellectuals and activists echoed the call of Ernst Barlach, the great expressionist artist, for "the regeneration of humanity." Cultural politics marked the 1960s, and building upon the modernist legacy, art was seen as a transformative weapon that would change the world—so to speak—from the inside out. Jules Michelet, G.W. F. Hegel, and Karl Marx may have taught that inner experience was constructed by social life and that the transformation of the self was possible only if society was transformed first. But the German expressionists, the Italian and Russian futurists, the French surrealists, and the rest thought differently. In works like *An Enemy of the People* (1882) and *A Doll's House* (1879), Henrik Ibsen showed his audiences that social conflicts could be understood in terms of interpersonal conflicts. The intensification of subjectivity became the ever more heated response to an increasingly drab and inauthentic social reality. Indeed, from the beginning, modernism constituted a self-styled revolutionary assault on alienation and reification connected with modernity.

All of this appealed to the radicals of my generation. Unleashing subjectivity against a bureaucratic and industrial society with a puritanical veneer, and contesting artistic authority and repressive social norms, was an essential part of our undertaking. Among my more radical friends and comrades there was a belief that liberalism and social democracy had become domesticated. Modernists tended to believe the same thing—though, admittedly, for different reasons. The age of democratic revolutions from 1688 to 1789 was a thing of the past, and the Revolutions of 1848 had failed. Modernism emerged in the twilight of revolutionary liberalism during the Second Empire of Louis Napoleon, the Second Reich of Otto von Bismarck, and the reign of Queen Victoria. This was when Charles Baudelaire, Gustav Flaubert, Richard Wagner, Friedrich Nietzsche, Ben-

jamin Disraeli, George Bernard Shaw, and Oscar Wilde grew to maturity. Each of them felt betrayed by the political timidity of the bourgeoisie, contemptuous of simple economic reformism, and appalled by the conformism and philistinism of the existing order. Their feelings mirrored those of many among my generation who were appalled by the "liberal" support of imperialist wars, the domestication of the labor movement, and the conformism demanded by the "silent majority."

We too, for the most part, saw our enemy less as the sociological representative of a class or status group than as an image: the redneck racist, the corporate creep, the hard hat, the sexually repressed nerd, the unethical businessman, the operative from one secret agency or another, the hypocritical politician, the greaser, or even the guy with the American flag on his lapel. Our enemies were the philistines who sought to constrict our knowledge and experience, and we considered our assault on them political insofar as they represented "the system." Many of us looked for inspiration to those modernists who fused art and life in their rebellion against modernity. Sex, drugs, and rock 'n' roll did play an important role in the adversary culture that was so intimately connected with political events. Art was often seen as an existential reservoir of resistance against the commercial values associated with the culture industry and the propaganda of mass media. Locating resistance in the cultural realm, however, is as abstract and one-sided as situating it in an institutional context. Neither an idealism lacking in the ability to make sense of interests and institutions nor the usual materialism, with its blindness to the integrity of cultural attitudes and normative impulses, is sufficient. Impulses shaping transformative social movements get lost from either perspective. The philistines are still with us, and the need still exists for a more critical and concrete approach toward cultural politics.

Over the years, many of my friends urged me to write a full-blown work on aesthetics and politics. That I never did so was in part due to my shifting intellectual interests as well as new political activities in the arena of public diplomacy and human rights. But it seems that *Modernism at the Barricades* is of a piece with my studies on modernity, and the reaction to it, such as *A Rumor About the Jews: Anti-Semitism, Conspiracy, and the Protocols of Zion* (Oxford University Press, 2003) and *Reclaiming the Enlightenment: Toward a Politics of Radical Engagement* (Columbia University Press, 2004). This volume blends new essays and ideas with reconstructed intellectual efforts of a different time. The result, I hope, is an innovative study in cultural criticism with a political character and purpose.

I wish to acknowledge the following publications in which my work appeared: "Ecstatic Modernism" initially appeared in *Passion and Rebellion: The Expressionist Heritage*, ed. Stephen Eric Bronner and Douglas Kellner (New York: Columbia University Press, 1988); "The Modernist Spirit" was first published in *Vienna: The World of Yesterday, 1889–1914*, ed. Stephen Eric Bronner and F. Peter Wagner (Atlantic Highlands, N.J.: Humanities Press, 1997); "Modernists in Power" is based on an article in *New Politics* 5, no. 2 (Winter 1995): 83–94; and "Paris and Berlin, 1900–1933" was originally written for *New German Critique*, no. 16 (Winter 1979): 145–53.

# Acknowledgments

There are a number of people whom I would like to thank for their contributions to this book. Amy Buzby, Vivian Kao, Nimu Njoya, Ben Pauli, and Wendy Wright participated in a seminar on the drafts of this work. Beth Breslaw provided much help as my research assistant. My old friends Robert Fitch, Kurt Jacobsen, and Eliot Katz also generously gave me their provocative insights and intelligent suggestions. I remember well my discussions about these themes with friends like Douglas Kellner and Joel Rogers. I also wish to express my gratitude to my editor at Columbia University Press, Philip Leventhal, as well as to Michael Simon and Alison Alexanian for their help with the manuscript. Let me not forget my wife, Anne Burns of Anne Burns Images, who helped me choose and secure the illustrations to this book.

**MODERNISM AT THE BARRICADES**

# 1

## The Modernist Impulse

SUBJECTIVITY, RESISTANCE, FREEDOM

Modernity is a crucial concept in contemporary discourse. It is often vaguely described as a set of cultural and political preoccupations that arose during the seventeenth and eighteenth centuries. These involved the nature of moral autonomy, tolerance, the character of progress, and the meaning of humanity. Modernity justified itself through scientific rationality and an ethical view of the good life that rested on universal values and the democratic exercise of common sense. Civil liberties and the tolerance associated with a free public sphere were logically implied by these secular liberal notions, along with ideas concerning the rule of law and citizenship. All of this was part of an assault on powerful religious institutions and aristocratic privileges in the name of a liberal "watchman state" coupled with a free market. The rising bourgeoisie introduced a new economic production process that rested on the division of labor, standardization, bureaucratic hierarchy, and the profit-driven values of the commodity form. The use of mathematical or instrumental rationality by this class tended to define reality in such a way that qualitative differences were transformed into merely quantitative differences. Those who worked to create commodities were treated as a cost of production, or an appendage of the machine, while the accumulation of capital served to inspire all activity. The living subject (workers) that produced and reproduced society thereby appeared as an object, whereas the dead object of its activity (capital) appeared as a subject. The result was what first G. W. F. Hegel and then Karl Marx termed the "inverted world"—a world of modernity shaped by alienation and reification.

Modernism was the response to this world. The assault was launched by Jean-Jacques Rousseau. *The Discourses* (1750), *The Social Contract* (1762),

and *Émile* (1762) not only embraced nature as a standard for combating the illusions attendant upon progress and the alienation reflected in its arts and sciences. They also championed a new form of democratic community and a new pedagogy to educate the sensibility as well as the mind. Rousseau's *Confessions* (1782) demonstrated a remarkable sexual frankness and a pre-occupation with authenticity. Trends like "Storm and Stress" (*Sturm und Drang*) and schools like romanticism and classical idealism acknowledged their debt to Rousseau. Out of his vision other philosophers constructed their critique of materialism, utilitarianism, and the suffocating elements of industrial progress.

Aesthetic ideals such as the sublime arose with thinkers like Edmund Burke, Immanuel Kant, and Friedrich Schiller.[1] Art would now refashion emotions like fear, anguish, and even terror in such a way that each member of the audience might feel sympathy for the persecuted and, recognizing himself in the other, a sense of common humanity and dignity. Works like J. W. Goethe's *The Sorrows of Young Werther* (1774) and Benjamin Constant's *Adolphe* (1816) captured the world of youth with its *Weltschmerz*, along with the tensions between authentic feeling and the hypocrisy and prudery of established conventions. The emotional intensity and dramatic verve of Schiller's *The Robbers* (1781) created a sensation—and it only made sense that his "Ode to Happiness" (1824) should have been employed by Ludwig van Beethoven for his Ninth Symphony (1824). The wonderful poetry of Lord Byron, John Keats, and Percy Bysshe Shelley echo these themes. All of them embraced a bohemian style that mixed an insistence on expanding personal experience with a hatred of injustice born of solidarity with the less fortunate. A stance emerged that would juxtapose the aesthetic (and often the premodern past) with the reality of modern life. These trends prefigured and shaped what would become known as modernism. But, ultimately, these earlier movements did not offer an overarching assault on society. Reinvigorating art was their purpose. Revolutionary politics was another matter. For the modernists, by contrast, the one was the precondition for the other. Or, better, they were one and the same.

Modernism would call into question every aspect of modern life, from the architecture through which our apartments are designed, to the furniture in which we sit, to the comic books our children read, to the films we watch and the museums we visit, to the experience of time and individual possibility that mark our lives. Modernists may have believed that they were contesting modernity, but their efforts and their hopes were shaped by it. Their activities legitimated what they intended to oppose. Their cri-

tique, in short, presupposed its object. Modernists believed that they were contesting tradition in the name of the new and the constraints of everyday life in the name of multiplied experience and individual freedom. These artists were essentially anarchists imbued with what Georg Lukács termed "romantic anti-capitalism."[2] They opposed the "system" without understanding how it worked or what radical political transformation required and implied. Oddly, they never understood how deeply they were enmeshed in what they opposed. Modernists envisioned an apocalypse that had no place for institutions or agents generated within modernity. Theirs was less a concern with class consciousness than an opposition to the alienating and reifying constraints of modernity. Unfettered freedom of expression and a transformation in the experience of everyday life were the modernists' goals. Even when seduced by totalitarian movements, whether of the left or the right, most of them despised what Czeslaw Milosz called the "captive mind." Not all the problems that they uncovered—sexual repression and generational conflicts, among others—required utopian solutions. But their utopian inclinations were transparent from the beginning. Modernists believed that the new would not come from within modernity, but would appear as an external event or force for which, culturally, the vanguard would act as a catalyst.

Modernism is not reducible to its artists, works, or intended purposes. The modernist ethos highlights experience in its immediacy and the constraints that tradition places upon it. Bohemian radicals everywhere sought to resist tradition and the ingrained habits of everyday life. Michel Foucault emphasized just this point by noting how modern painting derives from the new understanding of the "picture object" introduced by the spatial, perspectival, and lighting techniques of Manet.[3] Modernists sought to break down the wall separating the audience from the work. Style, in short, went public, ultimately shaping the perception of the enemy and the self-professed political resistance of the artist. Liberal humanist Italy thus spawned an antihumanist and bellicose futurism, while an authoritarian-militarist Germany generated a mostly humanist and pacifist expressionism. Modernism surely underestimated liberalism, with its reliance on the individual as the cornerstone of society and its insistence on prohibiting only what is condemned by law. The liberation of experience was far more important. Intensity became the ethical purpose of life. Ludwig Rubiner— an expressionist poet and a democrat—put the matter bluntly in *Man in the Middle* (1918) when he wrote, "Politics is the public manifestation of our ethical intentions."

Modernism was not about institutions; its advocates didn't think about them. Their enemy was decadence, and in responding to it, they appropriated diverse contributions from nonwestern cultures. Painters and sculptors in particular, but also certain writers like André Gide and D. H. Lawrence, turned to Africa, Asia, and Latin America for inspiration. Modernists thereby transformed and broadened the understanding of art. Pluralism and tolerance lie at the core of modernism, but it never required liberal institutions to flourish.[4] The Austrian, German, and Russian empires served as crucibles for modernism. Its symbolic power of resistance is, arguably, diminished in more liberal societies where the culture industry thrives on fads and artists are encouraged to challenge limits. Authoritarian regimes repress the new while liberal regimes domesticate it. For all that, however, modernism retains its salience, exhibiting what Ulrich Beck termed a "subpolitical" quality. It tests existing customs and mores by sparking the desire for new adventures, new experiences, and new ways of understanding the world. Modernism enlarges the world and strengthens the cosmopolitan sensibility. With its injunction to "make it new," indeed, modernism serves as the inner core or existential truth of modernity.

No wonder then that the modernist undertaking should have taken place in cities. The urban landscape breeds cosmopolitanism and the bohemian response to traditionalism. Journals like the expressionist *Der Sturm* and *Die Aktion*,[5] the futurist *Lacerba*, and *Révolution Surréaliste* appeared and championed the new, not just in Berlin, London, and Paris but also in Barcelona, Bucharest, Budapest, Florence, Kiev, and elsewhere.[6] An international avant-garde—a term first introduced by Henri St. Simon—crystallized throughout Europe. Its particular movements often overlapped. All of them opposed philosophical formalism, institutional politics, and an economy built on calculable profit and materialist values. Ironically, however, they all considered their actual admirers to be their implacable enemies. Their individualism, experimentalism, and cosmopolitanism appealed to the liberal elements of the bourgeoisie. Peasants and shopkeepers had little use for their assault on traditionalism and authoritarian attitudes. The bohemian style of the modernists, moreover, made them the object of scorn by a semiliterate working class living in hideous conditions and burdened with very different concerns.

Modernism was mostly immune to the influence of Marx. Most of its partisans were contemptuous of the seemingly more mundane concerns of the socialist labor movement and its cultural tastes. Few emphasized the disenfranchisement and systemic exploitation of the proletariat and even

**FIGURE 1.1** *Die Aktion* magazine (1911–1932).

fewer participated in its political organizations. Modernists were more pre-occupied with existential matters and aesthetic exploration—what Flaubert might have termed an education of the sentiments. They understood them-selves as engaged in a "higher" politics whose agent, whatever it was, was not the working class. The modernist avant-garde was focused on neither reform nor revolution. Its members experimented with multiplying expe-rience, broadening the possibilities of perception, exploding the habitual, and transforming the way in which people relate to one another. Inter-generational tensions were raised in works like *Patricide* (1922) by Arnolt Bronnen and *The Maurizius Case* (1928) by Jakob Wassermann. The dev-astating implications of sexual repression, innocence, and hypocrisy were given sensational expression in plays like *Spring's Awakening* (1906) by Frank Wedekind and *Julie* (1888) by August Strindberg. Patriarchy and gender oppression were the themes of masterpieces like *A Room of One's Own* (1929) by Virginia Woolf and *A Doll's House* by Ibsen. Same-sex love was brought out of the closet in *The Immoralist* (1902) by André Gide and the poems of Gertrude Stein. All of this was connected with articulating a new sensibility; institutional power was an afterthought. The subpolitical became the substitute for politics.

Modernists justified their cultural understanding of politics through a seemingly endless supply of manifestoes and philosophical tracts that usu-ally combined a mishmash of half-baked claims.[7] For all the bombast, there were no practical programs for social or political change. Modernists were content with imagining a new cultural community in which their radical individualism would blossom. Oscar Wilde is a case in point. His witty and satirical plays made him the toast of London, before his sensational trial left him bereft of friends and a disgraced exile in Paris.[8] Wilde was a homosexual dandy with socialist sympathies who hated vulgarity as much as injustice. He exemplified that strange mixture of elitism and populism that marked the avant-garde. Author of a lovely essay, "The Soul of Man under Socialism" (1891), he may not have thought much about the means for bringing about a transformation in human nature, but, like so many other modernists, he did understand that the liberating quality of socialism depended on something other than more efficient production and more equitable distribution of wealth. Wilde symbolized the assault on Victorian prudery and hypocrisy. He also personified the bohemian opposition to the standardizing, mecha-nizing, and alienating tendencies of the commodity form and mass society.

Modernism can be understood as an antiauthoritarian reaction to modernity or, more precisely, the reification process usually identified with

modernity.[9] All the major movements and artists identified with modernism contested the sexual constraints of the Victorian age, the attitudes of their own national bourgeoisie, and the consensual and common-sense understanding of the real. Some modernists tended to the left and others to the right; some were advocates of technology and a ruthless realism, while others embraced the religious and the sentimental. For all that, however, there remains what Louis Althusser would have called the "problematic" of modernism. Only by focusing on that problematic is it possible to illuminate the contributions, contradictions, and utopian projections of the modernist enterprise

Modernists confidently considered their enterprise an apocalyptic breakthrough. They desired to reenchant and invigorate the world that modernity had disenchanted and deadened. This marked their rebellion and their rationality of resistance. It also generated a political outlook in which modernism was so often defined by what it opposed.[10] That is why modernist artists could often comfortably stand on both sides of the political barricade and still treat one another as comrades. Those on the left like Émile Zola, Pablo Picasso, Heinrich Mann and others are well known. But modernism also had its famous right-wing partisans, including Maurice Barrès, Paul Cézanne, Edgar Degas, Louis-Ferdinand Céline, Wyndham Lewis, Ezra Pound, and a host of others whose stars have dimmed.[11] These two political wings of the modernist movement knew one another, influenced one another, and—especially before the Russian Revolution of 1917—often associated with one another both at home and abroad.

Representatives from opposing political wings of the modernist movement still shared certain cultural convictions. These, I believe, centered on the existence of a common enemy and a common (if indeterminate) utopian ideal: the "cultural philistine" (Bildungsphilister) and the "new man" who would supplant him.[12] Who is the cultural philistine? There is no clear answer. He is the anxiety-ridden petty bourgeois, the provincial fearful of the new, the liberal banker puffing his cigar, the old geezer admonishing the young, the schoolteacher eulogizing the classics, the censor intent on banning James Joyce's Ulysses (1922), the uneducated proletarian, the sexually repressed rationalist, the aristocratic traditionalist, or—thinking back to a song from the 1960s by The Kinks—"the well-respected man about town doing the best thing so conservatively." An exact definition doesn't matter; the cultural philistine was not the representative of any specific class, status group, or institution. Sometimes the modernists' image of the cultural philistine perfectly fit with the stalwart of political reaction. The small-minded

# PROCLAMATION

TIRED OF THE SPECTACLE OF SHORT STORIES, NOVELS, POEMS AND PLAYS STILL UNDER THE HEGEMONY OF THE BANAL WORD, MONOTONOUS SYNTAX, STATIC PSYCHOLOGY, DESCRIPTIVE NATURALISM, AND DESIROUS OF CRYSTALLIZING A VIEWPOINT...

WE HEREBY DECLARE THAT :

1. THE REVOLUTION IN THE ENGLISH LANGUAGE IS AN ACCOMPLISHED FACT.

2. THE IMAGINATION IN SEARCH OF A FABULOUS WORLD IS AUTONOMOUS AND UNCONFINED.
(*Prudence is a rich, ugly old maid courted by Incapacity*... Blake)

3. PURE POETRY IS A LYRICAL ABSOLUTE THAT SEEKS AN A PRIORI REALITY WITHIN OURSELVES ALONE.
(*Bring out number, weight and measure in a year of dearth*... Blake)

4. NARRATIVE IS NOT MERE ANECDOTE, BUT THE PROJECTION OF A METAMORPHOSIS OF REALITY.
(*Enough! Or Too Much!*... Blake)

5. THE EXPRESSION OF THESE CONCEPTS CAN BE ACHIEVED ONLY THROUGH THE RHYTHMIC " HALLUCINATION OF THE WORD ". (Rimbaud).

6. THE LITERARY CREATOR HAS THE RIGHT TO DISINTEGRATE THE PRIMAL MATTER OF WORDS IMPOSED ON HIM BY TEXT-BOOKS AND DICTIONARIES.
(*The road of excess leads to the palace of Wisdom*... Blake)

7. HE HAS THE RIGHT TO USE WORDS OF HIS OWN FASHIONING AND TO DISREGARD EXISTING GRAMMATICAL AND SYNTACTICAL LAWS.
(*The tigers of wrath are wiser than the horses of instruction*... Blake)

8. THE " LITANY OF WORDS " IS ADMITTED AS AN INDEPENDENT UNIT.

9. WE ARE NOT CONCERNED WITH THE PROPAGATION OF SOCIOLOGICAL IDEAS, EXCEPT TO EMANCIPATE THE CREATIVE ELEMENTS FROM THE PRESENT IDEOLOGY.

10. TIME IS A TYRANNY TO BE ABOLISHED.

11. THE WRITER EXPRESSES. HE DOES NOT COMMUNICATE

12. THE PLAIN READER BE DAMNED.
(*Damn braces! Bless relaxes!*... Blake)

— *Signed* : KAY BOYLE, WHIT BURNETT, HART CRANE, CARESSE CROSBY, HARRY CROSBY, MARTHA FOLEY, STUART GILBERT, A. L. GILLESPIE, LEIGH HOFFMAN, EUGENE JOLAS, ELLIOT PAUL, DOUGLAS RIGBY, THEO RUTRA, ROBERT SAGE, HAROLD J. SALEMSON, LAURENCE VAIL.

**FIGURE 1.2** "The Revolution of the Word Proclamation" (appeared in issue 16/17 of *Transition*, June 1929) by Eugene Jolas.

tyrant described so beautifully by Heinrich Mann in his novel *Professor Unrat* (1905) is a case in point. (Its more conservative cinematic adaptation, *The Blue Angel* (1930), launched the career of Marlene Dietrich.) But the use of the stereotype also led modernists astray. Robert Musil's devastating caricature of Walther Rathenau in *The Man Without Qualities* (1930) identified the cultural philistine with a supposedly superficial individual of immense power who, in his real life, was a liberal foreign minister, a cosmopolitan, and an admirer of modernism. In any event, the cultural philistine was not simply identical with an advocate of political reaction. Kurt Tucholsky, the great journalistic satirist, as well as the anarchist Erich Mühsam, skewered all those who were "lukewarm" in their cultural and political opinions. There was the social democratic *Spiesser*, the liberal who always sees both sides, the phony revolutionary (or *Revoluzzer*) no less than the stuffy conservative, the self-righteous nationalist, and the know-nothing Nazi. Attacking the cultural philistine was considered a political act by the modernists because he appeared as the incarnation of all authority.

The cultural philistine was everywhere, and modernists believed that he was the principal obstacle to the transformation of everyday life and the introduction of the new man. The cultural philistine thrived on mass culture with its leveling tendencies. Just when literacy was beginning to climb, and the possibilities of cultural experience were reaching out to a broader public, capitalism was already beginning to standardize artistic production and privilege the lowest common denominator. The issue here is not high versus popular culture. It is rather traditionalism.[13] Many modernists embraced popular themes and styles. But they rejected simplification for its own sake and the reproduction of what was already familiar. The conformity and parochialism of mass society led Baudelaire to present himself as a dandy and to speak ironically about the "heroism of modern life." While progressive political activists of the radical liberal or socialist variety were still concerned with universal suffrage and economic reform, modernists insisted that the real fight involved contesting popular tastes. The contradiction is palpable. The fact is that "a number of modernists were democrats, but modernism was not a democratic movement."[14]

The cultural philistine assumed different guises in different national situations, and different modernist groups held different images of the society that they wished to transform. Until after World War I, this was arguably a matter of secondary importance. Contesting the stereotypic laziness and humanitarian liberalism of the Italian bourgeoisie generated a preoccupation with war and technological dynamism by the Italian futurists. In

Spain, by contrast, the religious dogmatism and archaic monarchy with its feudal habits produced the elitist liberalism of José Ortega y Gasset and the "generation of '98." In Austria the stultifying provincialism, religiosity, and small-mindedness fostered the liberal rationalism of Sigmund Freud and Stefan Zweig as well as the more bohemian assault conducted by Arthur Schnitzler, Egon Schiele, and Oskar Kokoschka on the sexual decadence and hypocritical puritanism of a society still under the sway of "throne and altar." The chauvinism and authoritarianism of imperial Germany produced the radical individualism and spiritual populism of expressionist painting. It also led to the often histrionic assault on patriarchy and sexual repression that the Norwegian August Strindberg had taught to Germany's far less influential and talented playwrights.

But the point of reference was always the philistine.[15] William Morris understood socialism as the response less to capitalism than to the "philistinism of modern society." Knut Hamsun viewed the philistine as a democrat, scorned the masses, and ultimately wound up idolizing Benito Mussolini and Adolf Hitler. In *Birth of a Nation* (1915), the first international blockbuster film, D. W. Griffith saw the philistine as a liberal hypocrite incapable of admitting the need for white supremacy and an organic patriarchal society such as that envisioned by the KKK. Satirists in the Weimar Republic sketched the philistine as the bourgeois war profiteer and sexual exploiter with a cigar stuck in his mouth, unconcerned with the misery surrounding him. Others simply saw the philistine as the complacent and self-satisfied bourgeois; indeed, such was the position of Adrian Leverkuhn, the modernist composer in Thomas Mann's *Dr. Faustus* (1947) who sought to "take back" Beethoven's Ninth Symphony.

Society remained an enigma. If the cultural philistine was an abstraction then so was the philistine world that the modernists wished to transform. Its economic contradictions, political conflicts of interest, and institutional dynamics were rarely of interest. Nostalgia existed for the elemental and natural experiences that modern society was imperiling. The new cultural politics was intended to liberate them. F. T. Marinetti understood these qualities in terms of a supposedly liberating manliness and aggression, a rebellion against all order and authority, but others saw it differently. The images of the lowly and the downtrodden presented by poets like Else Lasker-Schüler and in the early novels of Alfred Döblin are far more telling. The general sentiment is actually best expressed by the unjustly forgotten expressionist Leonhard Frank in the title of his collection of short stories, *Man is Good* (1918), and his later autobiography *Heart on the Left*

(1952). Modernists of the left basically wished to bring that elemental good-ness and communitarian feeling to light. That was the sense in which they would lead the masses, or whoever would follow them. The elitism of the modernists was usually complemented by naïve populism. This mixture gave rise to a politics of the spirit.

In a postmodern age suspicious of grand narratives and overriding cat-egories, of course, suspicions will also exist concerning the legitimacy of speaking about an international cultural movement. Labels can be em-ployed arbitrarily, and they often obscure the uniqueness of individual artists and particular works. Even those who engage the idea of a move-ment, therefore, often do so hesitantly, almost apologetically. The modern-ist movement lacked a program and a theory of action. Its members were loosely connected with one another. Modernism was composed of diverse avant-garde groups. Heated conflicts usually generated by personal slights and stylistic differences took place in and between them. Each had its crit-ics, dealers, publishers, curators, hangers-on, and individual artists. But the whole was more than the sum of its parts. A common impulse ani-mated them. Indeed, for "the artists of the fin de siècle, the goal was not art but truth which has no end except the refusal to abide by the bad, the lopsided, the untrue. They wanted to say it as it really was, and the 'it' is always the experience that aims at the whole and can claim no legitimacy before the forum of public knowledge."[16]

Modernists had their own views of agency. These were generated dur-ing a time when retrograde monarchies still dominated Europe. Kaiser Wilhelm II, in fact, remained a believer in the divine right of kings until his death. Liberalism had already surrendered its revolutionary politi-cal verve in favor of free trade and Victorian cultural attitudes following the Revolutions of 1848. As for the working class, whatever its republican aspirations and commitments to social reform, its cultural views were deeply provincial. More apocalyptic and revolutionary understandings of transformation were thus associated with an avant-garde—a small circle unencumbered by tradition or popular sentiment, capable of anticipat-ing the future. Intellectual elites took center stage. Nietzsche wrote for the young who wished to think the world anew and who "understood." Vilfredo Pareto and Gaetano Mosca spoke of "circulating elites"; Robert Michels, a radical socialist who later turned to fascism, developed the "iron law of oligarchy" while condemning the reformist trend in social democracy; and, most famously, V. I. Lenin called for "a party of [a] new

type" composed of "professional revolutionary intellectuals," an idea that would be appropriated by Mussolini. What these various standpoints had in common was contempt for the petty bourgeois habits of the masses and established political movements.

Modernism transformed the meaning given to revolution by Marx and his followers in the aftermath of 1848: nationalization of industry and new economic policies to privilege the interests of the working class, a socialist republic to supplant the existing monarchies, and a new secular and enlightenment ideology to contest the ethos of the aristocracy and the church. Implied in the term *revolution* was now a transformation of the inner experience of reality and all social relations. Revolution became so overloaded with expectations and demands that the idea connoted something more akin to apocalypse or the Second Coming. But the problem was not merely that radical expectations were heightened to the point where any real revolution could only prove a disappointment.[17] It was also that modernists had little meaningful to say about how to deal with the inner life of the masses as it was historically constituted and actually lived. They sought a break with history, and they identified the refusal by others to seek it with cowardice, material interests, or "false consciousness." The avant-garde believed that the experience manifested in their work was the one that their audience, or prospective audience, actually sought but had not yet discovered. Indeed, explaining his attraction to the Nazis, Martin Heidegger wrote to Herbert Marcuse on January 20, 1948: "I expected from National Socialism a spiritual renewal of life in its entirety."[18]

Opposition to liberal republicanism was the norm among the modernist avant-garde. Not only was parliament seen as tainted by the selfish interests of different factions but, far worse, it was boring: its politics rested on coalitions, consensus, and routine. Parliament symbolized the meaninglessness of everyday life. That was as true for many modernists of the left (Mayakovsky, Brecht, Breton) as well as of the right (Marinetti, Jünger, Céline). When it came to liberal politics, indeed, what united the modernists was ultimately more important than what divided them. That is why so many supposedly political artists with radically divergent political views could feel themselves bound within the same international cultural revolt. A journal like *La Société Nouvelle: Revue Internationale* could thus list among its contributors to a volume in 1892 Peter Kropotkin, the Russian anarchist; Barrès, the French conservative; Nietzsche, the German cultural anarchist with reactionary political tendencies;

8me Année          LXXXV-LXXXVI          Janv.-Fév. 1892

# La
# Société Nouvelle

## Revue internationale

## Sommaire

PARIS

H. Le Soudier
174, Boulevard Saint-Germain.

BRUXELLES

Bureaux :
32, rue de l'Industrie, 32

Paris. — Albert Savine, 12, rue des Pyramides.

1892

FIGURE 1.3   *La Société Nouvelle: Revue Internationale* cover (Jan.–Feb. 1892).

Emile Verhaeren, the Belgian literary bohemian; and William Morris, the English socialist.

Modernists saw themselves as revolutionaries of the spirit and harbingers of a new humanity. Their new community would have an anarchist flavor. Hardly any modernists indulged in the longing for a leader or a savior. If they embraced the notion of an *Übermensch* then, legitimately following Nietzsche, it would be a superman who liberated culture from its constraints. Apocalyptic visions may have created the elective affinity between modernism and totalitarian movements—especially when the latter were on the rise. But the modernist concern with individuality and a liberated form of everyday life threatened the demands for regimentation and conformity demanded by totalitarians once they were in power. It is no accident that Mussolini marginalized Marinetti in the twenties, that Joseph Goebbels included Nolde in the "Degenerate Art Exhibition" of 1937,[19] or that Stalin drove Mayakovsky to his death. Stalin and Hitler responded to Igor Stravinsky no differently than had Czar Nicholas and Kaiser Wilhelm. The little men with little minds would have had the same philistine views about daring and expressive dancers like Mary Wigman and Martha Graham. Contemporary authoritarians still denounce modernism, and for good reason: they know what they have to fear.

Nietzsche was perhaps the seminal philosophical influence on modernism. His insistence that "the subject is a fiction" highlighted subjectivity and the lived moment in which self-definition begins. Embracing "perspectivalism" while rejecting objective versions of the real, envisioning a "new dawn" and the sustained fulfillment implied by the "eternal recurrence," Nietzsche undermined the petrified truths associated with the routines of everyday life, existing standards of perception and representation, from a utopian vantage point. His emphasis on self-realization and self-expression no less than his rejection of all traditions of aesthetic, social, and political authority radicalized the romantic impulse and shaped the thinking of a new generation. Visions of cultural renewal through the "transvaluation of values" inspired the assault against reification. Wagner's *Ring* (1876) was intent not merely on intoxicating the audience but in producing a "total work of art" (*Gesamtkunstwerk*) directed against the division of labor and the alienation it generated. The boundaries between different forms of cultural representation collapsed: poems turned into poster-images, images became texts, texts changed into paintings, paintings evoked music, and music elicited colors.[20] In *Thus Spoke Zarathrustra*

(1871) Nietzsche blurred the distinction between art and philosophy. In 1911 the young Lukács destroyed the rigid distinction between art and art criticism.[21] Modernism was everywhere intent on breaking down scholastic and time-honored distinctions.

Foresight and judgment were required to make sense of it all. Visionary art dealers like Paul Durand-Ruel, Ambroise Vollard, Paul Cassirer, and Daniel-Henry Kahnweiler recognized as "art" what others initially considered rubbish—and they cashed in accordingly.[22] New formal techniques not only exploded existing cultural assumptions but also opened new possibilities for artistic expression and the expression of individuality. Marx had already spoken about the eye becoming a human eye and the ear a human ear: sights and sounds would be heard differently. A profound change in perception would find expression first in the great impressionist painters, whose sense of what Schiller termed "the beautiful illusion" indicted everyday life, and then with sculptors like Ernst Barlach who engaged in a "conquest of the ugly." Salvador Dalí evidenced disdain for a standardized life ruled by clock time, while striving for the infinite became a dominant theme. Various artists responded first to photography and then to film by demolishing representation and turning line or color into the "object" of the work.[23] Cubism, indeed, put the viewer in the position of reconstructing an object that had previously been deconstructed by collapsing three dimensions into two.

Tradition came under attack in every way and in every genre. James Joyce gave radical expression to stream of consciousness and the epiphany, while in the 1950s, the "new novel" of Alain Robbe-Grillet and Nathalie Sarraute allowed events to be judged with distance and empirical objectivity—and from the perspective of the reader alone—by stripping away context, narrative, and the external depiction of experience. Marcel Proust understood memory as an associative process—as in the famous use of the madeleine biscuit being dipped into a cup of tea in *Swann's Way* (1913)—and he employed a nonobjective notion of time to elicit the construction and potentially ongoing reconstruction of the lived life. Expressionist dramatists created new relations between text, music, and staging, before Bertolt Brecht finally provided a theoretical basis for the overthrow of Aristotelian categories in the theater.

Modernism exploded fixed assumptions about time and space that underpinned both idealism and materialism. The assault on philosophical foundations undercut the need for mimetic representation and set the stage for Wassily Kandinsky and Arshile Gorky. The imagination triumphed. So

it became legitimate for Franz Marc to paint a horse blue, Proust to construct a novel around memory, and Döblin to express through montage the tempo of urban life in *Berlin, Alexanderplatz* (1929). No longer was it possible to encompass the unique experiences of individuals within universal categories. Turning their backs on the manner in which social reality was historically produced, and equally opposed to the abstract and universal categories of idealism, the modernists followed their own path—a *third path* predicated on philosophically privileging emotional intensity and a life-affirming vitality.

Modernism hoped to invigorate the future by redeeming the past. Its painters and sculptors cast established standards by the wayside as they embraced Oceanic and African art, as well as forgotten representatives of the medieval inheritance like Matthias Grünewald and El Greco. Fearful of modernity, suspicious of science, many modernists sought to reenchant the world. This was especially true of poets like Lautreamont in *The Songs of Maldoror* (1868) and Arthur Rimbaud in *The Drunken Boat* (1871) and *Illuminations* (1874). They extolled decadence and injected a sensuous excess into bourgeois existence, while later, Kafka exposed the world of bureaucracy with its incoherence, vacuity, and assault on subjectivity. Painters like the brilliant J. M. W. Turner, who had fallen out of fashion, were rediscovered as impressionists learned from his blinding use of light, Fauves from his symbolic use of colors, futurists from his dynamism, and expressionists from his virtual elimination of the object in his series *The Burning of the House of Lords and Commons* (1835). Similarly, painters sought either to recreate the objective world in their own likeness, through reducing it to the most basic forms as in futurism or cubism, or eradicating it entirely as in the tradition which took sustenance from Claude Monet's haystack paintings. Indeed, whether in art or philosophy, modernists sought to "ground" subjectivity and preserve it from the menace of an increasingly standardized and bureaucratized reality.

Modernism sought to elicit an experience that is universal and yet intensely individual to the point of being inexpressible. That is why expressionist playwrights chose to provide their characters with the most abstract labels: the boy, the girl, the poet, and the like. The same impulse led Reinhard Sorge, the expressionist author and playwright, to demand the formation of "a prophetic vision above and beyond the groping of language." For playwrights on the left like Ernst Toller, as well as Bronnen on the right, experiential states and personal visions become transformed not merely into public events but also supposedly into political challenges to the status

quo. Humanity itself was speaking through their inexpressible experience of singularity against the misery of existence. *Endgame* (1957) by Samuel Beckett is more radical in its form, far less pretentious in its political claims, and transforms the process: it speaks to the subjectivity of each without speaking to anyone in general.[24] "One is alone," writes Sorge, "and black with anguish is the world."

Existence itself became the object of critique. Society lost its mediated character and the world turned into a symbolic chaos. Asserting human dignity while retrieving some repressed human essence served as fundamental impulses for modernist art. These tasks required a break with formal conventions for depicting reality and the introduction of new techniques for reconfiguring discrete and unrelated objects in order to express a "higher" experience. Distortion and exaggeration took on lives of their own. Subjectivity was unleashed with ever growing vehemence until, finally, the object itself vanished. Line and color became the objects of painting. Only this increasing reliance on form seemed to allow an escape from givenness of existence. André Breton, the driving force behind the surrealist movement, put the matter well when he wrote that "the earth, draped in its verdant cloak, makes as little impression upon me as a ghost. It is living and ceasing to live that are imaginary solutions. Existence is elsewhere."[25]

Freedom no longer had anything in common with what Hegel and Marx termed "the insight into necessity." It lost any connection with the opportunities and constraints embedded in real historical situations. Classes vanished along with the production process and the determinate context in which the individual becomes what he or she is. The utopian imagination would emanate from what Maurice Barrès termed "the cult of the self." Modernists were never concerned with power in any meaningful sense. Nor were they concerned with eliminating discernible structures of oppression. They sought instead to "penetrate into the realm of shadows, which cling to everything and lurk behind all reality. Only after their conquest will liberation become possible. The poet must learn again that there exist worlds quite different from the world of the five senses—worlds comprising the super world."[26]

Modernism redefined solidarity, making it the arbitrary designation for a supposedly common experience. Franz Rosenzweig could speak about the need for an emotional catharsis that would produce a "new" Jew. Else Lasker-Schüler empathized with a "poor little humanity." Even Heidegger talked about the experiential transition from a singular existence to the "we" in his *What is Metaphysics?* (1929). For the most part,

however, solidarity was dependent on style, an antibourgeois attitude, and—perhaps above all—a willingness to evidence what Breton called the "great refusal." What unified all these positions, again, is the call to transform the meaning and experience of existence. If these concerns were connected with politics, then it was mostly in an indirect way. Something else was primary. Nietzsche had intuited what amounted to an international crisis born of decadence and nihilism that was threatening to engulf Europe. This was the key to modernism.

As the twentieth century began, continental political parties clashed, cultural standards seemed on the decline, and the the mass man was on the rise. Intensity and nonconformity took on a value of their own. These attitudes crossed national borders. They were articulated in England by Disraeli, Shaw, and Oscar Wilde; in France by Baudelaire, Barrès, and then Henri Bergson; in Italy by Benedetto Croce and Gabriele D'Annunzio; in Russia by Fyodor Dostoyevsky; and in the United States by Henry and William James. Some with more and some with less insight and acumen derided organized religion, settled habits, the reign of mediocrity, and the repression of the instinctual and the intuitive. Indeed, if Nietzsche's fame was generated among the bohemian avant-garde of Germany, that was not the case for someone like Henri Bergson, the thinker of the 1890s "with the greatest charisma, the one whose direct personal influence was most compelling."[27]

Bergson was the most famous philosopher in France.[28] He was also the teacher of Georges Sorel, whose *Reflections on Violence* (1911) would translate his concern with the dynamic experience of life into the political realm. Bergson's notion of the élan vital, the foundational moment of human existence underpinning all analytic and ideational forms, parallels Nietzsche's emphasis on the will to power and provides a French version of the third path in philosophy that opposes both materialism and idealism. So, too, Bergson's willingness to confront objective clock time with the subjective experience of time, *le durée*, profoundly influenced Proust and other major figures of the French modernist avant-garde. It undercut the primacy accorded mimetic representations of the real and, thereby, echoed the perspectivalism of Nietzsche. Most important, however, Bergson highlighted the unacknowledged experience of reality that could inject vitality into life.

F. T. Marinetti is a minor thinker in comparison to Nietzsche and Bergson. But his influence on modernism was, arguably, as profound. Neither a misunderstood hermit nor an academic philosopher, Marinetti was a flamboyant publicity seeker as well as the founder and mainstay of Italian futurism. His personal tours of Germany were overwhelming successes, and his

manifestos appeared in Herwarth Walden's great expressionist journal, *Der Sturm*. Working in an economically underdeveloped nation, complacently recalling its grand tradition of Renaissance humanism, Marinetti opposed the cultural philistine by demanding a new commitment to unfettered technological development and a rejection of anything connected with classical humanism. He envisioned a new foundation for human existence in the experience of "speed" that ruthlessly cuts away the past, intensifies the present, and multiplies the interactions between individuals and their world. His futurists, indeed, served as the organizational prototype for a modernist vanguard imbued with the belief that the future is theirs.

Modernism no longer treated tradition as prefabricated. Its artists were unconcerned with what Edmund Burke would have termed the hidden bond between "the dead, the living, and the yet unborn." Tradition now implicated the interests and will to power of the individual in its constitution and definition. Nietzsche articulated this position best in *The Uses and Abuses of History* (1874). The past would now be treated in terms of what was useful for the creativity and vitality of the artist. Modernity was thus often juxtaposed in its artificiality, hypocrisy, and brutality with the simplicity, authenticity, and elemental beauty of nature and those in touch with it. Or it all could be understood the other way around. Always, however, the instinctual communion with organic forces would provide the moment of revelatory ecstasy. The past would be refashioned in light of the artist's desires for the future that explodes the present. Nietzsche envisioned an unleashing of the intensified experience hidden in us all, and he identified the prospect of each of us finally realizing this possibility with the vision of a "new man."

What marked this new man would be the way in which he touches, thinks, feels, and speaks. The new man would explode the ordinary ways of experiencing the world—and the modernist anticipates this possibility. Thus, the poet Verhaeren sought to destroy syntax and common word usage in the name of a new language that could express thoughts previously incapable of formulation. Not material conditions, or new institutions, but rather the experiential capacity of individuals to receive these new messages would bring about the new man. The sublime character of art would generate new possibilities for human sympathy. Determining the context in which this new man would thrive was not the concern of the new politicians of the spirit. The new man would always remain indeterminate, a fleeting image, a symbol of utopia embraced by artists on both ends of the political spectrum. Unfortunately, however, the new man that arrived never

quite met the modernists' expectations. Interpreting modernism today begins with this recognition and and the task of drawing out its implications. Modernism makes clear the mistake in attempting any mechanical identification of radical cultural tastes with radical political commitments. These are two very different dimensions of the struggle for liberation, and if they often overlap, each still retains its own logic. That is something those seeking to appropriate the modernist inheritance should try to remember.

# 2

## Modernism in Context

NOTES FOR A POLITICAL AESTHETIC

Radical aesthetics has flourished since the 1960s. New schools of criticism have emerged with astonishing rapidity along with new objects of concern and scrutiny. There is no lack of disgust for the standardized and commercial cultural products of advanced industrial society. Contemporary aesthetics has become disillusioned with political ideologies and mass movements. Even humanism and its enlightenment offshoots have been castigated for their reliance on universal assumptions and categories. The particular is now what counts, as well as unique forms of experience. Identity has similarly turned into a matter of increasing interest following the collapse of the civil rights movement, the poor people's movements, and the great protests against the Vietnam War. Legitimate concerns have arisen for dealing with ever more specific forms of prejudice. As a consequence, aesthetics now highlights questions of subjectivity. In doing so, however, it often evades the importance of ideals and categories that articulate more general understandings of solidarity. There is a pressing need to reestablish the connection between cultural criticism and constructive political thinking, one that calls for rethinking the most basic traditions of modern political aesthetics.

Perhaps the place to begin is with the liberal heritage of modernity. In the aftermath of the Revolutions of 1848, the European bourgeoisie surrendered its most radical philosophical and political values along with its revolutionary posture in exchange for economic hegemony under the conservative and aristocratic regimes of autocrats like Napoleon III and Bismarck. The goal of realizing the republican values of political liberty and equality under the law, which inspired bourgeois philosophy and the French Revolution, thus fell into the hands of socialist movements based in the working

class that grew so rapidly during the last quarter of the nineteenth century. To put it simply, social democracy wound up shouldering a dual burden: it sought both to fulfill the universal political aspirations of the bourgeoisie and champion the economic interests of the proletariat. Its leaders were thus preoccupied with political and economic demands rather than experimental cultural ones. Unconcerned about the effects of an already nascent mass culture, skeptical of "salon anarchists" and modernist experiments, social democratic activists wished to provide workers with the classical and bourgeois liberal heritage that had been substantively denied them. Against a tide of reaction, social democracy committed itself to the liberal political legacy of the Enlightenment and sought to contest economic exploitation and provide *Bildung* for its proletarian constituency.

To be sure, the movement had a place for artists like Oscar Wilde and George Bernard Shaw. But the aesthetic views of social democracy somewhat mechanically corresponded to its political needs. Classical humanism and realism not only seemed to depict the reality of capitalism but also fostered the consciousness necessary for the creation of a new socialist order. If Honoré de Balzac and Charles Dickens exposed the workings of capitalism, Molière showed the corrosive effects of snobbery and hypocrisy, Gotthold Lessing highlighted the injustice of anti-Semitism in *Nathan the Wise* (1779), and Goethe manifested that great and unrealized notion of "personality" that capitalism seemed to stunt. Consequently, as Max Weber noted, an "elective affinity" appeared between the values to which social democrats were politically committed and the choice of artistic outlook that would give those values sustenance in the struggle.

A paradox resulted. The most politically radical mass movements of the time, whose leading aestheticians were Franz Mehring and Georgi Plekhanov, were generally considered culturally conservative by writers and artists who had little attachment to the classical, realist, or naturalist traditions. Leon Trotsky and other socialist politicians like Paul Levi, the German communist leader, were more daring in their tastes. But they constituted a tiny minority. Socialist attempts to build on the cultural heritage of the bourgeoisie created an aversion to a burgeoning modernist avant-garde whose preoccupation with subjectivity was becoming ever more vehement and pronounced. The works favored by social democrats were not simply propagandistic in character; rather, they highlighted the experiences of oppression and the sentiments of resistance among workers. Even following World War I, when the movement grudgingly tolerated new modernist tastes in the arts, its real literary heroes were not giants of their genres like Picasso, Schoenberg, Joyce,

and Proust. Workers instead embraced writers like Sinclair Lewis, author of *Main Street* (1920) and *Babbit* (1922), and Upton Sinclair, who gained world acclaim with *The Jungle* (1906). Nevertheless, the socialist labor movement did not insist that its members toe any political line on the arts.

Cultural politics assumed a different character in the Communist International. Lenin cared little about aesthetic issues beyond his view that art should not venture into direct criticism of the revolution. But Anatoly Lunacharsky, his first Commissar for Enlightenment and Education, was a devoted admirer of Proust, while Trotsky supported Russian futurism and the modernist avant-garde in works like *Literature and Revolution* (1924). Following Stalin's rise to power, commitment to the party line on aesthetic matters became more stringent. This was especially true during the 1930s, which witnessed the growing subordination of aesthetic concerns to the Soviet party's more immediate political priorities. The aesthetic politics of the time can be seen as an uncritical cultural reflection of the terror-ridden "consolidation" program within the Soviet Union, and of the country's attempt to rally all external "progressive" parties—both democratic and antifascist—around a European "popular front." Wishing to draw a line of demarcation between antifascist and fascist forces, the Communist International attempted to provide the cultural foundation for a political alliance with the progressive bourgeoisie and its social democratic supporters. As a consequence, the Comintern stoutly embraced realism and crudely vilified all divergent artistic styles. But the communist acceptance of traditional realism was actually a concession. As far as Stalin and his apparatchik cultural commissar, Andrei Zhdanov, were concerned, the task for Soviet artists was to infuse the old realism with a new, prescribed content. The result was socialist realism, a form that would retain the descriptive emphasis of the old realism while liquidating its critical and reflexive character, and would thus conform to the dictates of communist politics. Given the way in which the realist tradition became tainted by this totalitarian enterprise, and the vehemence with which it was attacked by the modernist avant-garde, even the salience of its more "critical" variants can no longer be presupposed. Nevertheless, the realist aesthetic has a role to play in any progressive understanding of cultural politics.

## Realism and Revolution

Georg Lukács can be seen as a traitor to modernism. A major figure of the bohemian intelligentsia in Budapest before World War I, he was the author

of daring avant-garde works of criticism like *Soul and Form* (1910) and *Theory of the Novel* (1920), and the heterodox Marxist classic *History and Class Consciousness* (1923). However, his writings of the 1930s and '40s, including *The Historical Novel* (1937) and *Studies in European Realism* (1948), are usually condemned for their sterility and subservience to Stalinist orthodoxy. Lukács remained a staunch communist until the end of his life. He also never denied his initial support for Stalin. But there is a way in which these works of literary criticism raise questions that transcend Lukács's political affiliations and even provide the basis for an immanent critique of them. His arguments are actually more nuanced than his critics choose to believe. Henry Pachter, the socialist political thinker, had a point in suggesting that Lukács was actually engaged in a "guerrilla war" against the worst excesses of Stalin's cultural policy. In fact, even while Stalin was still alive, in 1948, Lukács insisted that "a great realist literature could play the leading part, hitherto always denied to it, in the democratic rebirth of nations." This theme runs through his late work. Indeed, his writings on realism exhibit a philosophical and aesthetic coherence that demands to be taken seriously.

Lukács maintained that the great realists reflected the social order of their time as a "mediated totality." In contrast to socialist realism, the issue here is not how workers—or, by implication, the party—is represented. Instead, it is a matter of how literature illuminates the contradictions that allow the "position" of the working class to be understood. The author's politics is not a preeminent concern either, as is evident in Lukács's admiration for Balzac and Thomas Mann. What counts is how a writer provides an "objective" rendering of his epoch for a reader, who can then clearly see how real social forces and institutions directly and indirectly affect the lives of fictional characters and the choices that they make. It is the attempt to rationally comprehend reality as an "ensemble of social relations," as Marx put it, that supposedly offers the critical insight into the production and reproduction of capitalist oppression—as well as, in principle, any other form of oppression. Thus, according to Lukács, the commitment to the realist enterprise creates a link between the rationalist and democratic ideals of the revolutionary bourgeoisie and the proletarian attempts to build a better world.

Lukács's aesthetic expresses the concerns and values of the antifascist Popular Front of the 1930s. It also maintains the Comintern line of political demarcation. On the one side are the forces of democracy, reason, science, and progress. On the other side are the exponents of subjectivism, intuition, irrationalism, and chaos. Where the former inherently stand in oppo-

sition to fascist values and culture, the latter create an ideological climate in which fascism can thrive—beyond the subjective intentions of the author in question. Such was the claim that informed the famous essay by Lukács, "Expressionism: Its Significance and Decline" (1934), which launched a huge debate on the left about the political role of modernism in general and expressionism in particular. The argument is clear: if reality is not understood in objective, rational, and historical terms, it becomes a chaos whose meaning will be arbitrarily determined through merely experiential means. Modernism gives just such a fundamental epistemological primacy to intuition and direct experience, and precisely for this reason, Lukács considers it a form of irrationalism, whose idea of radicalism is ultimately indeterminate, ahistorical, and apocalyptic. Even worse, since this indecipherable chaos necessarily becomes unbearable, it engenders feelings of despair and a desire to escape from freedom by seeking salvation in some form of authority that can end the nightmare once and for all.

Lukács did not take the generic differences between literature and painting or music into account. He also clearly attempted to chain future artistic production to a particular style inherited from Balzac, Tolstoy, and Thomas Mann. The debate over expressionism that he initiated in 1934, moreover, took place after the original excitement about the new avant-garde had passed. But there were still Communist members and sympathizers who had learned much from the prewar aesthetic movements and who feared the new dogmatism regarding cultural matters. Certain thinkers therefore raised their voices to oppose Lukács, the most prominent of whom were Ernst Bloch and Bertolt Brecht. They insisted that Lukács was engaging in a mechanistic formalism that identified realism with one historical style, that he chose to ignore the unrealized utopian moments of joy, wonder, and play evident in modernist works, and that he dogmatically eliminated their introduction of formal innovations like stream of consciousness, montage, etc. In short, they argued, Lukács equated the modernist experiment with mere decadence—and they were right.

Not all of Lukács's arguments, however, are wrong or misguided. Writers claiming to be political and realistic should be interrogated about the ways in which they depict society. It is not illegitimate to insist that reality has an objective structure and that the quality of its depiction should be open to political discussion. If reality cannot be comprehended in its determinate workings, then its rational transformation becomes impossible. Whether building the will to engage in such a transformation requires realism, of course, is another matter. It doesn't. Art, more broadly, does have an

impact on the political climate by evoking unacknowledged problems. It can always shed new light on experiences of exploitation, repression, terror, and love. But there is also truth to Lukács's contention that neoromanticism and irrationalism helped shape the conditions in which fascism could thrive. Perhaps he conflated aesthetic criticism with social theory. More to the point, Lukács asked all writers to write the works that he wished to read. His position ultimately came down to the belief that art must perform a particular function, and if it does not, then all other functions it might perform are thereby invalidated. Assuming that the realist form is inherently progressive, while the modernist form is inherently reactionary, he made no attempt to comprehend the positive and progressive ways in which modernism generated sentiments of resistance. Quite simply, Lukács refused to consider the legitimacy of cultural and aesthetic concerns that were not anticipated by Hegel or Marx.

## Modernism and Utopia

Modernism was an international movement that reverberated throughout Europe during the roughly fifty years prior to the rise of Hitler in 1933. It shattered traditional linguistic, visual, and theatrical conventions. It promulgated free verse, stream of consciousness, montage, photomontage, collage, and numerous other formal innovations in order to illuminate experiences that older forms and devices could not (or would not) explore. Modernism also expanded our understanding of what constitutes art. New recognition was accorded the contributions of African and Oceanic culture, medieval painting and sculpture, and more. Modernists longed to transcend the limitations of a capitalist status quo and foster the longing for a liberating alternative. Modernist rebels may have suffered from romantic anticapitalism, but they also fastened onto moments of the totality, particular forms of repression, that neither the radical bourgeoisie nor the working class was willing to challenge. Their stance regarding the transformation of the status quo may have been utopian, but the problems they uncovered did not all require utopian solutions.

Modernism became popular with the middle classes during the 1920s. Mainstream publishers such as Samuel Fischer and the Insel Verlag brought out expressionist anthologies like *The Uprising* (1919) and *The Twilight of Humanity* (1920) by Kurt Pinthus. In 1920 the "Austrian terror" Oskar Kokoschka secured a teaching post at Dresden, and Max Beckmann, Walter Hasenclever, and a host of others followed suit. The Her-

mitage began building its spectacular modernist collection, and the New York Grand Armory Show of 1913, despite initially hostile reactions to it, prefigured what would become an influx of European avant-garde works into the major museums of the United States. Bohemia entered the academy and many of its members became respected, if often controversial, figures in the mainstream cultural life of the 1920s. This cultural influence was intertwined with a political message that offered an abstract opposition to, rather than any concrete confrontation with, the status quo. The modernist avant-garde never appreciated either political liberalism or social democracy. Democratic ideals seemed to play into mass society with its commercialism and loss of cultural standards. The unique experience of society thereby seemed imperiled, along with the ability to transform the character of everyday life. As the twentieth century dawned, contrary to popular opinion, it was not Marxists who were concerned with issues like alienation, reification, and the loss of subjectivity. Modernists were preoccupied with these phenomena even if they posed few solutions for dealing with them. Artistic revolutionaries sought to explore the internal world beyond objectivity and the possibilities of experiencing and reorganizing the object according to the desires of the subject. This occurred in different ways depending on the genre: free verse was pitted against rhyme, montage was employed against narrative, new tonal scales changed the way we hear, and line or color supplanted the consensual image.

Modernism embraced a utopian outlook from its inception. It was vague, arbitrary, and often self-referential. But it expressed the longing for an alternative—any alternative (for better or worse), so long as it was total. This was the glue that bound modernists to one another in spite of their differing political attitudes. The point was to be in opposition. Abstract and indeterminate understandings of politics became intertwined with very concrete experiments that projected new ways of hearing, seeing, and portraying the world. Thus a perspective emerges with which to assess the continuity and discontinuity that characterizes the relation between modernism and "postmodernism."

## Postmodernism and the Crisis of Radical Purpose

Like modernism, postmodernism embraces many diverse tendencies, and its legacy is also conflicted and contested. Some adherents would surely object to any general characterization of it. There is, nonetheless, a logic that defines the postmodern undertaking. Its thinkers all begin with an

assault on philosophical absolutes and metaphysical universals. All deny the possibility of impartial judgments, or objectivity, and all highlight the moment of ambiguity and individuality. Though grand claims often emerge, whether in terms of a "postmodern tradition" or of histories of modernity, in principle, all postmodernists reject the grand narrative and the privileging of methodological coherence. All attempt to liberate subjectivity from intractable systems or claims. But the postmodern imagination has little of the utopian impulse that once inspired modernism. Totalizing narratives and scientific rationalism are seen by leading postmodern thinkers like Jean-François Lyotard and Zygmunt Baumann as among the principal ideological sources for modern totalitarianism and genocide. The postmodern imperative is for theory to explode all "essentialist" claims, and for this reason, modernist artists like Samuel Beckett, Paul Celan, and Kafka are seen as prophets.

Postmodern interpretations of subjectivity have indeed become tied to ever more specific and existential understandings of identity that contest the standardizing and universalizing power of the culture industry. But they also celebrate the fragmentation that followed the collapse of the social movements that had arisen in the 1950s and '60s. This leads such interpretations to conflate culture and politics, identity and solidarity, subjectivity and resistance, and enables them to turn intuition into a criterion of truth. Where modernism sought to explode immanence in favor of transcendence, however, postmodernism also denies transcendence. It rejects the possibility of depicting either a narrative account of reality or a liberating alternative. According to Jacques Derrida and Michel Foucault, indeed, categories and discursive formulations can only prove partial with regard to their truth content. Utopia vanishes—only subjectivity remains.

Distinctions between fact and value ring hollow. Generic and disciplinary boundaries between philosophy, criticism, and art become arbitrary as well. The crucial innovation of the postmodern, indeed, is that language hides rather than illuminates the existing imbalances of power. Giving primacy to discursive truth is, therefore, already to accept the paradigm in which power manifests itself. Attempts at epistemological coherence, acknowledgments of the primacy of discursive truth, and any reference to objectivity for matters of judgment are seen by postmodernists as misplaced responses to a purely arbitrary procedure that buttresses the status quo. With the ability of the culture industry to transform all meanings into its own codes, or significations, the attempt to impose standards is both impractical and utopian. Mass society renders rationalistic concerns irrel-

evant as it generates fad after fad, perspective after perspective, commodity after commodity, all the while domesticating whatever liberating moments have been engendered. Foucault insisted that the traditional metaphysical subject should be "decentered," so that the threatened experiential moment of subjectivity can serve as the focal point for resisting power and the (rational) paradigms that hide its exercise.

"Essentialism" may or many not deserve, using Gayatri Spivak's phrase, "strategic" support. Either way the ethical ability to distinguish freedom from license is compromised. Solidarity becomes an instrumental rather than a moral aim, and it is the same with reciprocity. At the end of the day there is only the incessant need to deconstruct consensual meanings and highlight the multiplicity of possible significations that any object or text can display. In a sense, then, postmodernism fosters the desire to play with reality and consistently alter its signified character. But this kind of activity is only possible in terms of privileging an experiential desire beyond political exigency and discursive rationality. Any attempt to constrain such desire justifies rebellion, so that ultimately rebellion becomes nihilism. If all categories are arbitrary, all theories merely relative in their truth claims, and any commitment to deliberation merely an expression of power, then all responses to the given order become equally valid (or invalid).

Experiential desire rules: no reason exists why critique should assume primacy over acceptance of the given order. Radicalism becomes one style, text, or approach among many. If any object can produce a multiplicity of significations, all of which are equally valid, then why try to signify any purpose at all other than ambiguity? Irony assumes particular importance in fostering this goal precisely because it allows for distance from the real, isolation from others, and—ultimately—indifference. The postmodern encounter with the real is nihilistic in the most urbane way. Conformity becomes indistinguishable from nonconformity and deconstruction from reconstruction. Thus the inability to make a moral, political, or cultural judgment from the standpoint of positive norms is itself elevated into a fundamental aesthetic principle.

Modernists did not proceed in this manner. When they did engage in philosophical justifications for their cultural experiments, by and large, they sought to ascertain the "ground" of experience in what might be considered a phenomenological or quasi-phenomenological manner. Postmodernists, however, often pull a philosophical sleight of hand. Even though they deny the existence of essentialisms or categorical absolutes, they still accept the totally traditional perspective that such a foundation

can alone provide the justification for a truth claim. In rejecting the absolute, therefore, postmodernists take it far more seriously than they should. Postmodernists lack notions of historical tendency, or what John Dewey termed "warranted assertions," and therefore wind up being defined by the very essentialism that they oppose. The postmodern opposition to modernity, in short, is illusory. Its finest advocates exhibit a bad conscience. Such is the source of the crisis of political purpose that now plagues contemporary aesthetics, along with the need for constructing a new approach to cultural radicalism.

## Aesthetics, Modernism, and Emancipation

A new political aesthetic begins with a commitment to artistic tolerance. Such tolerance is not inimical to drawing the distinction between politics with its institutional preoccupations, or its need to specify imbalances of power, and radical aesthetics and forms of cultural activism whereby the sentiments of resistance are fueled. There is no need for jargon or convoluted arguments. It is enough to insist that art can evidence many tasks and that there is more than one way for an artist to fulfill them. The need no longer exists to choose between realism and modernism on the one hand, and postmodernism on the other. The old ideological concerns have been rendered irrelevant not by philosophical stratagems but by the conditions of contemporary cultural production. There is no longer anything inherently liberating about any particular style or mode of artistic representation. Representational realism as well as nonrepresentational approaches can serve diverse yet radical purposes. The political value of a work is no more reducible to its formal contestation of hegemonic modes of perception than to its presentation of a prescribed content. Divergent works can forward criticisms and possibilities in different ways. It thus becomes incumbent on a new aesthetic to derive categories that would further the portrayal and extraction of the diverse criticisms and hopes that artistic works may or may not evince.

Neither the social nor the political elements of a work reveal themselves self-evidently, and there is no single form that assures the critical and transcendent character of art. The culture industry not only presents the most diverse styles and commodities to various publics but also creates an interpretive climate that tends to undermine any work's potentially critical or utopian qualities. Yet there is no reason to assume that the culture industry will necessarily exhaust the critical and transcendent qualities of every

work. The culture industry may provide a built-in frame of reference for making aesthetic judgments. But it also allows for different types of contestation whose significance cannot be determined a priori—let alone in terms of privileging the repressed individual experience.

A new political aesthetic should at least prove skeptical of claims that the assertion of subjectivity necessarily constitutes a privileged form of resistance against the existing order. Art is predicated neither on narrative nor on pedagogic aims. Its subversive quality should not be inflated. Art has no predetermined or immanent purpose to serve, and its content remains indeterminate until criticism situates it within a project of resistance and liberation. Situating the work within a complex of interests and principles depends on the degree of objectification that the genre or style allows in terms of discursive categories. It thus made sense for thinkers like Arthur Schopenhauer and Nietzsche, who emphasize intuition and the "reality" behind discursive forms, to insist on the primacy of music. While it is useless to create a hierarchy of forms, still, there are differences in the "political" possibilities that music, painting, and literature can project. The degree of objectification serves as the degree to which any work is open to political interpretation. It therefore makes no sense for a progressive aesthetic to subordinate aesthetics to politics, or vice versa. The interest in resistance and liberation can neither be philosophically turned into an absolute of art nor mechanically identified with any genre—and its articulation always occurs with respect to the work in question.

Illuminating the critical insight into any work is possible only if the critic is willing to look for it in the first place. That is impossible if art is turned into the handmaiden of political revolution or identified with the abstract demands of cultural resistance. Interpretative tolerance is the hallmark of any new and radical aesthetic precisely because criticism of the status quo and the ability to project traces of utopia can take manifold forms and assume new meanings in new circumstances. The work of art thus remains unfinished. But it is no longer sufficient to remember Walter Benjamin's aesthetic injunction to "never forget the best." The best still needs to be created—and in different ways, that is the fragile and elusive point of intersection for a radical understanding of culture and politics.

# 3

## Experiencing Modernism

### A SHORT HISTORY OF EXPRESSIONIST PAINTING

### The Logic of Expressionism

Expressionism was an all-encompassing cultural movement. Its partisans influenced every type of artistic endeavor. But the term is laden with multiple meanings and confusion.[1] With the exception of a few luminaries like Franz Kafka and Alfred Döblin, moreover, its writers and poets are mostly forgotten. That is not the case with its painters. Their exhibitions are still international events, and figures like Ernst Kirchner and Wassily Kandinsky have become cultural icons. Expressionism arose in Munich and Dresden near the turn of the twentieth century and hit its high points before World War I with the exhibitions of its two most famous tendencies: Die Brücke and Der Blaue Reiter. Expressionism was not, however, simply a German phenomenon. Oskar Kokoschka and Egon Schiele were members of its Austrian branch; Paris boasted Chaim Soutine and his circle; James Ensor, who remains undervalued, probably best represents the Belgian contingent;[2] and a case can be made that the entire expressionist enterprise actually began in Norway with Edvard Munch.

Differences of artistic style, conception, and influence are also readily apparent. Many of the most famous painters—including Paul Klee, Emil Nolde, and even Kandinsky—insisted on their individuality and liked to deny that they could be identified with any movement. Expressionism lacked a specific program, or unified theory in the manner of the futurists or the surrealists. But it would be a mistake to lose sight of the forest for the trees. Common characteristics make it legitimate to speak about "expressionism," and Gottfried Benn, the great poet, was correct in viewing

it as the German variant of European modernism. Unifying expressionist painting is what Kirchner termed "the ecstasy of the first impression." Its artists privileged intensity along with an emphasis on intuition. Both were considered decisive in reaching the root of all things in their "essence."[3] Like the Jewish God, this essence of existence cannot be named. Universal in character, it reveals itself to our subjectivity beyond what can be objectively depicted. Expressionists sought to elicit this essence by intensifying the experience of the audience. The world would then look different—or, more importantly, feel different. Expressionist painters refused to take at face value what Martin Heidegger termed the " givenness" of reality. Their endeavor could highlight the joy of everyday life in the manner of, say, Karl Schmidt-Rotluff, or estrangement from it in the manner of Ernst Barlach. The "constant component of Expressionism" rested on an attempt to experience reality to the point of ecstasy.[4]

Bringing this about was not quite as easy as it sounds. Its most important representatives sought to evoke an immediate emotional response through the distortion and gradual elimination of what I would like to term the "consensual object." But this, in turn, demanded a conscious visual effort on the part of the audience. Testing the boundaries of representation privileged construction over content and called upon the viewer to provide the work with his own experiential meaning. Yet this created the concern with establishing the authenticity of the experience. In the same vein, while expressionists sought to elicit a feeling for utopia, their critique of representation stripped the "higher reality" of substance. Radicalism thus became suspended in the imagination. Only with awareness of the inner truth hidden behind appearances, or so expressionist thinking went, would the transformation and transfiguration of reality become possible. Revolution would thus imply something more radical than the mere introduction of a new economic production process, a new state, and a new ideology; politics thus took on new meaning, and being a revolutionary took on a new connotation.

Expressionists coined various terms for themselves: they were "cultural politicians," "politicians of the spirit," "objectless politicians," and the like. They sought to elaborate what Fritz Martini called the "higher relevance" of mostly dubious assumptions about society, and their role in transforming it, through a seemingly endless set of theoretical tracts published in an array of mostly short-lived journals.[5] Expressionists sought to depict new ways of experiencing reality and overcome alienation in a world where people are treated as things. Their apocalypse would empower individuality and usher in the reign of beauty. Expressionism embodied what Max

Horkheimer later termed in a different context the "longing for the totally other." Its painters may have been delusional in making what were often grandiose political claims, but they enabled the world to be seen in a qualitatively different light. Integrating the contributions of nonwestern art, or what has unfortunately been termed "primitivism,"[6] expressionists allowed their audience to imagine a different form of existence. They may not have identified an appropriate political agent or the constraints and preconditions for bringing this new world about. Nevertheless, expressionists liberated the imaginative faculties as well as the more human sympathies of their audience.

Franz Marc noted, "the wasteland of 19th century art was our nursery."[7] The same belief was repeated often by other leading artists. Spiritualism, subjectivism, and an attack on rationality may have influenced expressionist painting. But such painting was not defined by a "will to destruction," a lust to "depersonalize," or "an assault on human dignity."[8] There is little of the racism, bellicosity, and xenophobia of the Nazis or the ruthless cynicism and arbitrary dogmatism of the Stalinists. To view the assault on the consensual object as an attempt to eliminate individuality or to engage in "depersonalization" is to miss the point.[9] The phenomenological bent, the desire for essence, drove expressionists to shake the foundations of habitual experience and present a new "illuminated ego" (*leuchtendes Ich*). Kokoschka's famous *Tempest* (1914), in which he and his cradled lover—Alma Mahler-Werfel—are swept up in a tornado-like eruption of nature, for example, evidences not the obliteration of their individuality but the connection between their unique love and something deeper and more universal.

Some of the avant-garde were, indeed, swept up by forces that they never fully understood. Herwarth Walden was one of them. After turning toward communism and immigrating to the Soviet Union in 1933, he died in Stalin's camps. His journal *Der Sturm* had helped congeal the expressionist movement, and he organized countless exhibitions in his Sturmgallerie.[10]

Heinrich Vogeler endured years of the most miserable poverty in the fatherland of the revolution before wasting away in the gulag. An early influence on expressionism who helped form artist colonies at Worpswede and elsewhere, Vogeler identified with the poor and the downtrodden. He was a utopian visionary who understood little about politics, and who saw in communism a world of harmony and love. In this he was no different than many of his comrades who had a social conscience.

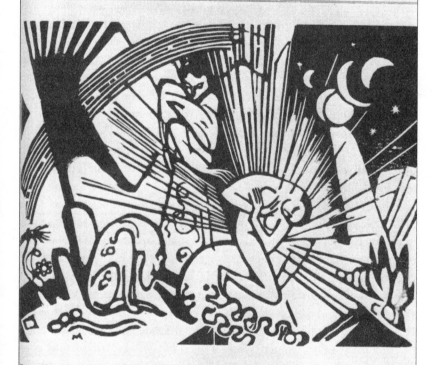

**FIGURE 3.1**  *Der Sturm* cover (September 1912, no. 125/126).

Expressionists were extravagant and often wrongheaded. But they showed a deep compassion for the lowly and the insulted. They desired to make life richer and more dynamic. Expressionism had little use for kitsch and less for the cultural philistine. The real enemies of civilization feared the space for individuality opened by its artists and what Kirchner called a "beauty beyond purpose or morality."

## Influences

Expressionism was fueled by a host of disparate influences. Some of its predecessors experimented with new styles and old techniques in the rural suburbs of Germany. For the most part, however, the revolt against academic art took shape in the cities. The various secession movements that were organized against the artistic establishment in Dresden, Munich, Berlin, and Vienna were not only a protest against imperial taste and Victorian ideals, but also a conscious attempt to make connections with a burgeoning international avant-garde. In this regard, the Berlin Secession of 1901 had a particularly important role to play. Its members embraced a German form of impressionism that led them to secede from the Royal Academy of Arts and various mainstream salons.

The Berlin Secession rejected the idea that German painting should foster a national pedagogy and depict important scenes from German history in traditional forms of representation. Max Liebermann was the most gifted representative of the Berlin Secession and Julius Meier-Graefe, the art historian and critic, its most intelligent advocate. Their compatriots have largely been forgotten, and many German impressionists later drifted into more conventional or neoromantic styles. But the fact remains that the cosmopolitanism of the Berlin Secession, its respect for the most divergent artists and its tolerance of the most different approaches, profoundly influenced the cultural climate in which expressionism would come to thrive.[11] Left-wing activists like Käthe Kollwitz were defended as surely as nationalist painters like Carl Vinnen, whose *Protest of German Artists* (1911) condemned expressionism for its internationalism. Efforts to introduce the foreign, the unknown, and the exotic were precisely what rendered the Berlin Secession suspect in the eyes of a European public whose nationalism was everywhere on the rise.

Its members attacked the prevailing academicism in collaboration with what was often called the invasion of French postimpressionist painting. Paul Gauguin and Vincent van Gogh, the symbolists and the Nabi group,

and Gustave Moreau and the fantastic Odilon Redon would prove very significant. These artists realized that there were psychological, unconscious dimensions of reality that deserved to be aesthetically investigated. They also sought to convey the idea that painting had no need for the consensual object. Thus Maurice Denis—a member of the Nabi group—noted drily in 1890, "It should be remembered that a picture . . . is essentially a flat surface covered with colors which are assembled in a certain order."

Expressionism was ecumenical: it was inspired by manifold attempts to experiment with form and explore the inner life. Henry van de Velde and the most radical representatives of art nouveau, or what in Austria and Germany was known as Jugendstil,[12] experimented in applied designs for book decorations, stained glass, and even architecture, employing radical techniques culled from a variety of sources. Egyptian and Japanese art, especially the color print with its spatial illusions and delicate use of line, had a profound impact on their lithographs, and their experiments with the two-dimensional woodcut profoundly influenced the expressionists. All the important representatives of Jugendstil rejected the mainstream preoccupation with historical themes and baroque forms of ornamentation. The most advanced among them walked the line between pure utility and art for art's sake, or they sought to fuse "fine" and "applied" art. Their work placed primacy on the use of line, which Van de Velde conceived as an "elemental force" like color, and the creation of decorative forms that were abstract in the sense that their symbols multiplied yet rendered universal the significations of any object. Thus, in a way, the Jugendstil artist sought to be useful and place a unique stamp on the coming transformation of society.

Paula Modersohn-Becker embraced these ideas. She was among the artists who had settled at Worpswede, a little town on the outskirts of Bremen, whose name would identify the group that included Fritz Mackenson, Otto Modersohn, Heinrich Vogeler, and Clara Westhoff, a fine sculptress in her own right who later married Rainer Maria Rilke. They sought an escape from the anomie and alienation of urban life, academic restrictions, parochial mores, and the bourgeois way of life. Worpswede painters with their lyrical landscapes, their depictions of storms, and their drab colors that were meant to create melancholy feelings in the viewer became quite popular. Modersohn-Becker's use of flat color areas in works like *Portrait of Rainer Maria Rilke* (1906) separated her from the other painters at Worpswede and even led to criticism by her one-time mentor, Mackenson. He did not anticipate how technical choices would prove crucial in the transition of the representational to the nonrepresentational in expressionist

art. Uninterested in merely depicting the lyrical qualities of nature, in contrast to her friends at Worpswede, Modersohn-Becker sought to penetrate its "inner quality" with the justification that "the object itself is feeling." Whether this philosophically makes any sense or not, her concern was with resisting the exploitative and dehumanizing elements of modernity and highlighting the better natural instincts in works like *The Good Samaritan* (1907) and *Poorhouse Woman at a Duck Pond* (1904). Indeed, Else Lasker-Schüler's typically expressionist notion of a "poor little humanity" comes to mind in Modersohn-Becker's paintings of peasants, mothers and children, inmates of the Worpswede poorhouse, and individuals who supposedly stand in an organic union with nature.

None of the Germans, however, achieved the emotional power of Edvard Munch. Works such as *The Cry* (1893), *The Kiss* (1897), *The Dance of Life* (1900), and especially *The Clenched Scream* used visual expression to express sound, feeling, and movement in a new way. Munch would arguably provide the single most important impetus for expressionism. Painters involved with the Berlin Secession, Jugendstil, and Worpswede never illuminated the anguish of the individual quite so dramatically, provided existential-psychological insights of equal depth, or offered that mixture of radical distortion and inner dynamism that marks the work of Munch. The best of them included Gustav Klimt, who introduced a new preoccupation with the languorous and the erotic, and Schiele and Kokoschka, for whom the liberation of sexuality later became a dominant—arguably even obsessive—theme. Nor could the German forerunners of expressionism compare with Van Gogh and Gauguin. Worpswede painters often unintentionally mimicked the Dutch landscapes of the seventeenth and eighteenth centuries. They shied away from Van Gogh's daring use of impasto and primary colors to illuminate nature, the provincial town, peasants, and flowers. They were unprepared for Gauguin's radical reduction of the canvas to the flat surface and the plane. Their revolt was more subdued. None of the Worpswede painters ever received a review similar to what greeted an exhibition by Oskar Kokoschka in the Austrian newspaper *Die Zeit* in 1908: "Well Herr Kokoschka, your tapestry designs are revolting. A mixture of fairground images, primitive Indian painting, ethnographic museum, Gauguin gone mad—I don't know. And yet there's nothing for it: I have to admit that I have not witnessed such an interesting debut for years."[13]

Contesting the ideologies of reaction, exhibiting their feeling for humanity, making use of their cosmopolitan inclinations, and inventing new aes-

thetic possibilities led to important contributions by these forerunners to expressionism. Perhaps their work was sometimes overly sentimental and other times coldly abstract. But their empathy for those whom Rousseau had called the "simple souls" created an openness to traditions and voices that had previously been dismissed by academic painting and the champions of civilization. They recognized the artificiality of binary distinctions like fine and applied, or high and low, art. They sought a new organic unity in their aesthetic efforts, whatever the different forms that unity would take, and their experiments with color and line were radical in the best sense. They created the preconditions for the new energy of conception that was gaining force among the expressionist avant-garde. This, indeed, was no small accomplishment.

## Die Brücke

*What is great in man is that he is a bridge with no end.*

—Friedrich Nietzsche

Die Brücke was the first important trend associated with expressionism. Its motley collection of artists came together in Dresden in 1905 under the prodding of Ernst Kirchner. Some of them, including Karl Schmidt-Rotluff, Max Pechstein, and Emil Nolde would become legendary figures in German painting. All members of the group, however, were concerned with distortion, color, and the contributions of premodern art. None of them had much sympathy for the sentimentality of Worpswede, the concern with utility of Jugendstil, or the impressionism of the Berlin Secession. Emil Nolde, arguably the most talented and certainly the most radical of the new rebels, made this clear. He was uninterested in the sweet representation of nature or emphasizing the gentleness of preindustrial life. He was left cold by the softening of primary colors and the concern with being "true to life" that marks Modersohn-Becker's *Self Portrait* (1906), with its dreamy gaze and its pleasure in the languor and laziness of natural existence. Nolde never placed the city dweller in a rural environment where his inner goodness, or internal peace, could reach fruition. He took a stand against all of this. He also sought to differentiate German art from that of the French. Thus he could note: "We do not want to reproduce Nature. That is just what we do not want. We want to put color and light in the picture in the way people feel color and light. Neither do we want to reproduce space, but to unite everything in a plane."[14]

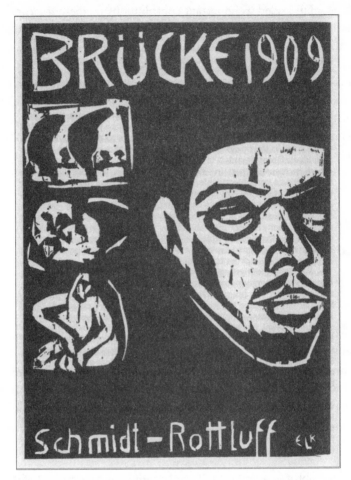

**FIGURE 3.2** Portrait of Schmidt-Rottluff, in *Brücke* (1909) by Ernst Ludwig Kirchner.

Die Brücke was caught between the premodern and modern. Kirchner's works serve as a case in point. His sculptures, with their often medieval and Asiatic influences, serve as a counterpoint to his famous street scenes. These dynamic paintings highlight the decadence of city life through their distortion, rapid brush strokes, and "unnatural" color combinations. Only Kirchner among the members of Die Brücke had been trained in the academy. All of them, however, viewed themselves as bearers of freedom and life against the entrenched art establishment. They took pride in the unfettered voice that they could give to their innermost feelings and in the fact

that they were uncorrupted by civilization. So, too, they sought to overcome the modern division of labor through what may be seen as a new dilettantism. Many of them wrote plays and turned out manifestoes and poetry. Most were concerned with recreating what they considered the organic unity of life, and much of their work—even when it dealt with urban settings—was marked by the intrusion of nature, foliage, and flowers. They exaggerated reality through taut and austere sculptures, planes of color, and the breaking down of the figure-ground distinction. Indeed, the use of line and the practice of splitting the painting into planes often served to foster anxiety or angst in the audience, along with a sense of those constraints on the expression of genuine emotion that modernity produced in "everyman."

Paintings by the artists of Die Brücke evince angular distortions and dramatic exaggerations of expression that bring to mind Grünewald, El Greco, and African art. The figure of a person, the consensual object, is thus transfigured by radical technical innovations. This results in what more than one critic has called the "conquest of the ugly." The distortion of the real, its exaggeration, indicts the reality of ugliness, anguish, and fear, and in so doing becomes beautiful. The preoccupation with authenticity becomes palpable in the paintings of Die Brücke. Its artists grasped (consciously or unconsciously) what was actually the cultural crisis of their time, and insofar as they did so, they resisted the standardizing and reifying elements of modernity. Terror, constraint, fear, and anguish by distorted and exaggerated characters elicit compassion on the part of the audience: its members are, supposedly, thereby transfigured. Insofar as the ugly becomes the universal point of reference, the real and ongoing price that is paid for civilization, the beautiful turns into the unreal, the nonrepresentational, and an illusion in which utopia glimmers. T. W. Adorno would identify just this portrayal of negation, or what is not, with the "truth content" of a genuine artwork.

Expressionist painters understood that reliance on distortion and projection of the nonrepresentational would not only generate feelings of empathy but also tempt the viewer to enter the work of art, to complete it and give it purpose. What ties everything together is the primordial that— according to numerous aesthetic treatises written by expressionist painters—exists in every individual. The primordial can be given many names, and philosophers competed with one another in providing concepts for the nonconceptual: Karl Jaspers spoke of the "godhead," Heidegger offered a new interpretation of "Being," and others of the "elemental," or "life." But,

whatever the formulation, the primordial can only be grasped through intuition—or, to use the term coined by yet another philosopher, Edmund Husserl, "the glimpse into the essence" (*Wesensschau*). The task of the artist is to strip away unessential encumbrances and create the conditions for an upsurge of emotional intensity. What expressionists wished to evoke in their audience parallels this philosophical preoccupation.

Their output was astonishing, especially when it came to prints. Two thousand were completed by Kirchner, one thousand by Ernst Heckel, six hundred and sixty-three by Schmidt-Rotluff, and eight hundred and fifty by Pechstein. It is fair to say that "never before had processes so closely tied to craft traditions been so cavalierly treated. The laboriously worked effects of conventional printmaking might as well have never been devised. For the first time in its five-hundred-year history the print looked the direct product of the immediate creative impulse."[15]

Making the audience experience this "creative impulse" was the ultimate purpose of Die Brücke. Its members wished for humanity to feel itself empowered by their art. Unlearning the more superficial habits of everyday life, renewing a world deadened by modernity, was what they sought to bring about. Kurt Hiller put the matter well in his famous work *Erhebung* (1919) when he wrote, "Not the quality of art matters, but its intensity." The principal purpose of art is thus to contest the settled habits of perception and experience in everyday life. Or, to put it another way, art must smash through the mask—a hallmark of modernist painting in general and expressionist painting in particular—that divides the falsity of an inauthentic external world from the truth of authentic inner life. Beneath the distinct roles and expressions of modern life, the inner world offers a simultaneous interplay of emotions—hate, love, etc. Expressionists sought to unearth this simultaneity by exploding the dead reality of everyday life through their color play, their use of distortion and exaggeration, and their encounter with what Jean-Michel Palmier correctly termed an "interior malaise."

Unfortunately, though, it was somewhat unclear whether the masses were experiencing this malaise in the same way as the artists. This uncertainty led to frustration on the part of an avant-garde ostensibly concerned with the downtrodden and the excluded. It is hard to convey how strange their works seemed to everyday people. Exaggerated emotions, distorted objects, odd colors, unfamiliar scenes, and effects meant to convey ugliness were all out of place and beyond—quite simply—what painting was meant to be. Die Brücke shook the ramparts of representation along with the values of established artistic traditions. Its artists were justified in believing

that they had opened new avenues of aesthetic experience. But they were mistaken in believing that appreciating their works was simply a matter of courage or "inner education." Their frustration with the philistine sometimes turned to contempt for the masses with whom they were seeking to identify. And the masses felt it. Modernists were anticipatory with respect to their concern with alienation and reification, which were not yet recognized as political matters or even as sources of meaningful rebellion. The masses considered such preoccupations as expressions of privilege. Workers saw the bohemian as a parasite, and the artist's inflated rhetoric about a new man as just that. Die Brücke spoke to a new community bound by feeling—but that new community was a figment of its imagination. Its members' notion of solidarity was actually directed to them rather than the proletariat or even humanity. The journal of Die Brücke—only one issue appeared—had a title that makes this apparent. It comes from a line by Horace: *Odi profanum vulgas* (I hate the common herd).

## Der Blaue Reiter

Expressionism was first interpreted by right-wing critics and artists as yet another derivative of French modernism, and the incarnation of what, elsewhere, I have termed a cosmopolitan sensibility. Emil Nolde may have insisted that his work was a form of German art, but the nationalist and protofascist Carl Vinnen saw matters more clearly. Germany experienced an influx of foreign painting even before World War I. Cézanne, Picasso, André Derain, Robert Delaunay, and a host of others were being championed by famous collectors and dealers like Paul Cassirer, The rigid divisions made today between modernist movements did not exist at the time—or, at least, not in the same way. The lines between expressionism, fauvism, futurism, and the rest were still blurry. As late as 1918, in fact, the well-known critic Hermann Bahr included Henri Matisse, Georges Braque, and Picasso, along with certain futurists and Fauves among the expressionists.[16] Modernist works of this sort caused confusion for the public and for critics as well. They were used to classical themes, a balanced canvas, a broad palette, tempered colors, nuanced tones and hues, and—above all—the consensual object. What traditional audiences received from this international cultural rebellion was unsettling, alien, and yet all of a piece.

Der Blaue Reiter exemplified this situation. In 1909 Gabriele Münter bought a house in Murnau, south of Munich. There she and Wassily Kandinsky painted the countryside, studied painting the reverse side of glass

(*Hinterglass*), and read Nietzsche along with new expressionist poets like George Heym, Else Lasker-Schüler, and Georg Trakl. Those who visited the couple in Murnau—Alexei von Jawlensky, Marianne von Werefkin, and Alfred Kubin—would, along with Franz Marc, become the core of Der Blaue Reiter. Like the Worpswede group and Die Brücke, Der Blaue Reiter evidenced an interest in premodern art and handicrafts. Its famous *Almanac* (1912) would include Russian folk art, embroidery, Japanese and German woodcuts, votive paintings, children's drawings, and Egyptian shadow play figures, as well as Hinterglass. At the exhibition of the New Artists Union (Neue Künstler Vereinigung) in 1909, which did not yet highlight the name Blaue Reiter, paintings by the Murnau group appeared alongside works by Maurice de Vlaminck, Georges Rouault, and a host of other foreigners.

One year later the first Blaue Reiter show took place. The name came about—or so the story goes—during a discussion over coffee in which Marc noted that his favorite color was blue and Kandinsky mentioned his frequently used horse-and-rider motif. Feeling became the object of the work. Arnold Schoenberg, in this vein, insisted that the enduring element of a portrait derives from its expression of a hidden reality, rather than from its depiction of a person. Colors were mostly understood in metaphorical or symbolic terms, and each was believed to generate a particular emotive quality equivalent to a given musical tone. Yet line was also given primacy in works by virtually all the major representatives of Der Blaue Reiter. Most were influenced by Cézanne and the cubists, who were intent on deconstructing the object; the nonrepresentational experiments of the Russian suprematists; and the dynamic quality of futurists like Boccioni. A particularly important influence, however, was Robert Delaunay. The use of color planes in his studies of the St. Severin Church and the Eiffel Tower had a marked effect on the animal paintings of Franz Marc. That was also the case for *The Sunny Path* (1913) by August Macke, in which color planes highlight the tension between the pensive mood of the characters and the unacknowledged dynamism of their surroundings.

Der Blaue Reiter privileged those experiences supposedly preserved from the civilizing process. Premodern and exotic motifs appear in the Tunisian Light Exhibition of 1911. It featured paintings by Macke and Paul Klee, composed during the artists' travels in North Africa, and their luminosity shocked Berlin audiences. Klee and others also noted how children created directly from their immediate perceptions rather than from any concern with mimesis. Macke compared this immediacy with the art

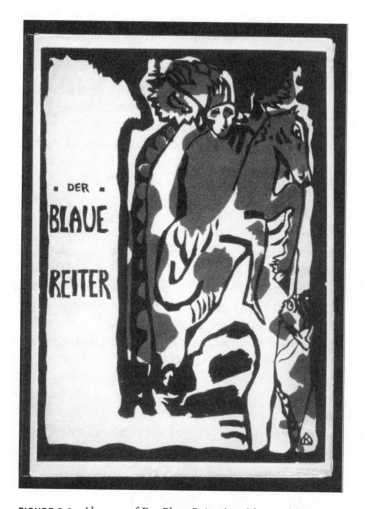

**FIGURE 3.3**  Almanac of *Der Blaue Reiter* (1914) by Wassily Kandinsky. © 2012 Artists Rights Society (ARS), New York / ADAGP, Paris. Photo: Philippe Migeat. Musee National d'Art Moderne, Centre Georges Pompidou, Paris, France.

*Photo Credit: CNAC/MNAM/Dist. Réunion des Musées Nationaux/ Art Resource, NY*

of the aborigines. The mentally ill were also viewed as having an artistic voice. Naivete was considered a positive attribute. An aura of simple faith and a fairy-tale quality pervade the paintings of Gabriele Münter. The cries of horses in the rain conjure up images of bullets and bombs—perhaps anticipating World War I—in *Fate of the Animals* (1911) by Franz Marc. His

use of animals represented a hermeneutic attempt to expand the range of both experience and empathy. Marc liked to claim that "each animal is the embodiment of a cosmic rhythm," and nowhere is the expressionist spirit more evident than in *The Blue Horse.*

Ernst Bloch liked to reminisce about the First German Autumn Salon of 1913 organized by Herwarth Walden in Munich, where this painting was first exhibited. With great fanfare, Bloch described the astonishment of those who came to watch the bohemians and laugh at their art. One typical bourgeois was apparently in a fury and, with Bloch surreptitiously listening in, exclaimed to his wife, "How dare he paint a horse blue! There is no such thing!"

The story gives a sense of how far art has come since then and how radical these artists really were. Few critics prior to World War I recognized the utopian aspirations of these expressionists, their romantic roots, or how they refashioned old dreams in new ways. The "beautiful illusion" now blended with lost innocence and immediacy. All the more telling then is the shock of the colors, the effects of distortion and exaggeration, and the stridency with which these painters called on their audience to see the world differently. That demand became ever more insistent. Consensual determinations of reality were steadily eroded by dynamic uses of color to elicit feelings of subjectivity. Der Blaue Reiter forced the viewer to conceptualize the painting as a creator of meaning, or an artist, would. The line of division between painter and audience collapsed in the demand that the audience "experience a work so that its form affects the soul" (Kandinsky). Each revelation would strengthen the observer's capacity for empathy. Heightening the moment of experiential subjectivity, freeing the imagination, and breaking the constraints of objective reality would supposedly allow each individual to identify emotionally with others—intensely.

## Human Feeling

Solidarity—not the solidarity of the movement or the party, but spiritual or experiential solidarity—was a primary aim of expressionist painting. It assumed good will and an experimental sensibility. The utopian unity projected by expressionist painting between the good, the true, and the beautiful harbored not only a critical character but also humane elements of joy and wonder that were alien to the provincial sensibilities of the cultural philistine. The expressionist call to intensify experience and transform quotidian existence rubbed him the wrong way. But the liberal bourgeoisie looked at

things differently. It was exhausted by World War I and the revolts that had taken place following the German defeat. Calm had returned after the failure in 1923 of the communist-led uprisings in Hamburg and Thuringia and the Munich Beer Hall Putsch led by Hitler and General Erich Ludendorff. The Weimar Republic was in place, the extremist parties lost votes, wages rose, and the mark stabilized. In this context, the effusiveness and emotionalism of prewar movements—no less than the extravagant satire of Dada—seemed almost quaint.[17] The outsider was turning into the insider.[18] Expressionism became popular among the liberal bourgeoisie: it appeared to offer an escape from what has been called "the hard edginess of things." Whatever the subjective intentions of the expressionists, their preoccupation with abstraction and the problems of the self objectively reflected the interests of an establishment "whose chances of survival depended upon the readiness of the masses to pass over the concrete reasons for their suffering."[19]

New artistic radicals took stock of their past. Former expressionist painters like John Heartfield and George Grosz found a home in the Malik Verlag of Wieland Herzfelde and, while choosing to work with the German Communist Party, created the political tendency within a new movement known as the New Sobriety. They used sketches, cartoons, and posters to indict the young republic and a burgeoning political reaction whose partisans sought revenge against enemies abroad and defeatists at home (Jews, pacifists, communists, socialists, and the anarchist literati). A new generation rejected the inflated humanism and exaggerated utopianism of the Wilhelmine era in favor of a more political sense of solidarity and a more realistic understanding of social change. The New Sobriety facilitated the entry of expressionism into the drawing rooms of bourgeois society in the aftermath of World War I.[20] But the old use of distortion, the contempt for the cultural philistine, and the assault on the decadence of everyday life remained. The formal debt of New Sobriety to expressionism was, indeed, greater than many critics would care to admit.

Cool detachment, world-weariness, and an often cynical confrontation with everyday life marked the New Sobriety. Dix, Grosz, and Heartfield lacerated the false heroism, the hypocrisy, and the provincial nationalism that contributed so much to the onset of World War I. Their style differed from that of earlier modernist movements. But these artists, too, were humanists, and whatever their revolutionary inclinations, they were inspired by a pacifist sensibility. They also exhibited the old passion in their condemnation of decadence and bourgeois society. For all that, however, the New Sobriety sought to rehabilitate the consensual object.[21] *The War* (1924) by

Dix is a series of fifty extraordinary etchings of World War I that starkly depict worm-eaten skulls, splattered intestines, foot soldiers with the faces of demons, civilian victims, rotting animals, anguished faces (reminiscent of Edvard Munch), prostitutes and drunks, platoons with gas masks, and troops in defeat. Dix's magnificent series is arguably the great testament of political painting in the Weimar Republic. Other members of the New Sobriety sought to highlight the cynical, exploitative, and decadent reality of urban life. Crippled war veterans, pathetic proletarians, ugly and greedy prostitutes, and fat war profiteers populate the great street scenes of George Grosz in collections like *Ecce Homo* (1923).[22]

These artists treated the decadence of bourgeois life with scorn, and they never believed that "life is a cabaret!" They depicted a world of class conflict, competing ideologies, and social upheaval of the most dramatic sort. Distortion, exaggeration, and simultaneous use of multiple images in works like Grosz's *Eva* (1918) and *Cross Section* (1920) were all employed to heighten feelings of outrage and disgust. That is also the case with the best photomontages of the underrated Hannah Höch and, of course, those of John Heartfield, like "The Hangman and Justice"(1933), as well as his various covers for the communist magazine *Arbeiter Illustrierte Zeitung*.[23] These artists sought to find the political element within the frozen moment of life, and they gained a critical distance from reality by often pitting the techniques of expressionism against the intent of the expressionists themselves.

New Sobriety did not retreat into the past. Its artists employed the most modern technical advances in their particular genres. This was as true for musician-composers like Paul Hindemith and Hans Eisler—the brother of the communist party leader Ruth Fischer—as for playwrights like Brecht and photomontage artists like Heartfield. These political artists sought to link the proscriptive with the descriptive, and if it led them to identify with the communist movement, it also made their work more interesting and vibrant than that of the less political artists within New Sobriety. They provided a response to the prewar styles. The works of Dix, Grosz, and Heartfield were grittier, tougher, and more engaged with a world shattered by war, inflation, and global reconfiguration. They were contemptuous of the pathos and emotional effusions often associated with expressionism. But they retained a transformative desire. Their critique of the cultural philistine, too, was launched from the perspective of the new man.

The passing of expressionism was not due solely to the new climate of sobriety. Radicalism was still simmering beneath the surface, but it took a new form. The "Bolshevization" of the Communist Party in 1924 by Ruth

Fischer and Arkady Maslow created an even more authoritarian style that rested on rabid support for the Soviet Union. So, too, among conservatives and fascists, hatred of the Weimar Republic, the "November criminals," and the Jews bled into hatred for all cosmopolitan forms of artistic innovation. Groups like the Thule Society fostered a mix of anti-Semitism, xenophobia, and military spirit while the Communist Party waited with baited breath for Stalin's next encyclical. Right-wing hopes for a regenerated and racially pure people's community (*Volksgemeinschaft*) complemented left-wing visions of a classless society. Utopian ideals and political passions abounded. But they were militaristic, mired in revenge, insistent on conformity, contemptuous of individualism, devoid of humanistic aspirations, and obsessed with nationalism and party dogmas. They had nothing in common with the expressionist spirit. The totalitarians knew their enemy, and their hatred only hardened over time—which made sense, since what the totalitarians called "degenerate" art ultimately served to highlight their own barbarism. Expressionist painting, whatever its political limits, did what great art always does: it made room for freedom.

# 4

## The Modernist Spirit

### ON THE CORRESPONDENCE BETWEEN
### ARNOLD SCHOENBERG AND WASSILY KANDINSKY

Arnold Schoenberg and Wassily Kandinsky were authentic politicians of the spirit who changed the most elemental assumptions of their respective cultural domains. Each chose to imagine the possible rather than simply assume it. Each illuminated the realm of experience in his own way and, in the process, contributed to an education of the senses. Their intense, if brief, correspondence is consequently of aesthetic and historical importance. It clarifies not only the remarkable interplay between music and painting in their art but also the attempt of the cultural vanguard to break down the barriers between them. Schoenberg and Kandinsky had their differences. But they were ultimately opposing expressions of a single spirit. Their correspondence illuminates the radical vision of modernism—and that of the age as well.[1]

Arnold Schoenberg was eight years younger than Wassily Kandinsky. The father of the composer had died early in life, and the son learned banking before turning to music as a profession and entering the world of Viennese bohemia. Schoenberg was ambitious; believing it would help his career, he converted from Judaism to Protestantism in 1898, only to convert back during the 1930s as a form of political protest. This may explain his unprovoked outburst against the supposed anti-Semitism of Kandinsky, about which he had been informed by Alma Mahler-Werfel,[2] and which essentially brought the correspondence between the two artists to an end in 1923.[3] In any event, from the beginning Schoenberg participated in the bohemian subculture of Viennese modernism. It was in the famous Café Griensteidl that he encountered Alexander Zemlinsky, the mentor of Gustav Mahler, who became his first teacher in composition and whose sister he married in 1901.

**FIGURE 4.1** Arnold Schoenberg (1925). © Arnold Schönberg Center, Vienna / Alfred Carlson.

*Courtesy of the Library of Congress, Music Division, LC- USZ62-52575*

His new wife, for her part, soon enough had a tumultuous affair with the young expressionist painter Richard Gerstl, who committed suicide when she broke it off. This was when Schoenberg began painting, and the scandalous context helps explain the obvious erotic frustration, the anxiety-ridden character, and the romantic impulse of his art during this period. Notoriety accompanied him from the start—along with a lack of money. Gustav Mahler became his friend, taught him that music must express the authentic personality of its creator rather a general understanding of the "beautiful," and tried to help financially by anonymously buying some of Schoenberg's

paintings in 1910. A few years later the young composer swallowed his pride and accepted a grant from the city of Vienna, firmly ruled at the time by its anti-Semitic mayor, Karl Lueger. Yet Schoenberg rejected a professorial position at the University of Vienna in 1912. He stated, in good bohemian fashion, that he did not wish to be tied down. Nevertheless, something else influenced his decision.

Vienna was known both for its classical past and for the assault on it. The city boasted composers like Mahler and those of Schoenberg's musical inner circle, including Alban Berg and Anton von Weber.[4] But it was also the city in which Hugo Wolf, whose highly sentimental works so enchanted Rosa Luxemburg, had just died. It was the city in which *The Blue Danube* (1866) still ruled supreme, and in which archreactionary critics like Hans Pfitzner could decry Schoenberg's "atonal chaos" and later liken his works to cultural bolshevism.[5] Vienna mixed grand historical tradition with the experimentalism of the modernists and the provincialism of the narrow-minded petty bourgeois—as becomes so clear in the wonderful novella by Ödön von Horváth, *Der ewige Spiesser* (1930). Schoenberg's attitude toward the city of his birth was thus ambivalent. It would always remain, for him, "our beloved and hated Vienna."[6] His music reflected the city's cultural complexity and was rooted in the legacies of Mozart, Beethoven, Brahms, and Mahler. Indeed, beginning with Schoenberg's *Verklärte Nacht* of 1899, in which he first moved away from the major-minor key system, his music involved a constant interchange with these predecessors.

The situation was different with Kandinsky. He had emigrated from Russia to Munich, often called the sister city of Vienna, known for its easygoing style, its liberalism, and its bohemian subculture prior to World War I. But there were no comparable giants of painting in its history. Kandinsky thus viewed his art as a rupture with the canon. It was also only natural that he should have understood Schoenberg's project in the same terms when he first heard the radically innovative Second String Quartet, op. 10, and the Three Piano Pieces, op. 11, written between 1907 and 1909—works that would prove so important for the composer's later serial compositions. Alexei von Jawlensky, Marianne von Werefkin, and Gabriele Münter attended the same concert as Kandinsky. They were prominent members of the Neue Künstler Vereinigung of Munich, whose three exhibitions of 1909–11 had introduced the German public to Picasso, Braque, and Derain.[7] The association, however, was dominated by a host of mediocre painters employing impressionist techniques, and at the time, under the influence of Franz Marc, Kandinsky had decided to break with it in order to pursue a

**FIGURE 4.2**  Photo of Wassily Kandinsky (c. 1913).

more antirepresentational path. No wonder then that these major painters should all have been drawn to the Viennese maestro already engaged in an attempt to "emancipate dissonance" through atonality.

Wassily Kandinsky only began painting at the age of thirty. The son of a privileged family, he had decided on an artistic career when he gave up his law practice and the opportunity for a professorial position at the University of Dorpat. The years prior to his encounter with Schoenberg were marked by the production of work in any number of styles.[8] Most striking perhaps are the paintings influenced by the poetic quality of Jugendstil, the German version of art nouveau, during its most radical period, as well as the color experiments of the Fauves. The bright and lively works of these

early years were often marked by a symbolism derived from exotic visions, fairy tales, and Russian legends. Paintings like *Das bunte Leben* (1907), which anticipated Kandinsky's later nonobjective experiments, are indicative. There, on a black background, are images of knights riding through an indeterminate landscape populated by lovers, in which a festival of an indeterminate *Volk* is taking place. Pastels identify what remain of the natural objects, while their interiority emanates a brightness enhanced by the clash of primary colors. It is legitimate to compare Kandinsky's canvases of this time to Schoenberg's most important expressionist works, including *Pelleás und Mélisande* (1903), as well as to compositions like *Gurrelieder* (1900) and the song cycle built on Stefan George's *The Book of the Hanging Gardens* (1910), which Schoenberg only completed in 1911 and which introduced the atonal style and the emancipation of dissonance.

In the same way that three-point perspective served as the foundation for traditional painting, what is generally known as classical music rested on the diatonic scale and the tonic triad, or the defined key. Wagner, Johannes Brahms, and Mahler had all contributed to freeing dissonance, or movement, from this defining structure, just as stylistic revolutionaries like Manet and his impressionist followers, including Monet (especially in his haystack series), sought to free aesthetic experience from reliance on the representational object and three-point perspective. James Joyce, Marcel Proust, Robert Musil, and Virginia Woolf transformed narrative; they structured plot around the diverse associations of inner life, and transvalued the literary canon in accordance with the logic of their expositions. Verhaeren and others were, in a similar vein, exploding linguistic constraints in the name of free verse while Alfred Jarry, Frank Wedekind, Ibsen, Strindberg, and (later) Brecht were—each after his fashion—engaged in challenging classical theater's Aristotelian presuppositions. Thus Schoenberg's and Kandinsky's works appeared in tandem in an international context rife with modernist assumptions.

Each had heard of the other. But Schoenberg had already produced his first "free atonal" compositions before he ever met Kandinsky, who had also begun experimenting with nonrepresentational modes of painting before their encounter in 1911. The wonderful painting *In an Oriental Vein* by Kandisky appeared in that same year. 1911 also marked the publication of both Kandinsky's *Concerning the Spiritual in Art* and the writing of Schoenberg's *Theory of Harmony* (1922), which he dedicated to Mahler. It was also the year that Kandinsky began planning the justly famous Blaue Reiter exhibition, to whose almanac Schoenberg would contribute

**FIGURE 4.3**   *In an Oriental Vein*, color woodcut (1911) by Wassily Kandinsky.
© 2012 Artists Rights Society (ARS), New York / ADAGP, Paris.

*Courtesy of the Library of Congress, Prints and Photographs Division, LC- USZ62–72260*

two drawings and an essay entitled "On the Relation to the Text" (1912). Schoenberg and Kandinsky were many-sided in their aesthetic interests. Both sought to overcome what they considered the "artificial" divisions between different forms of artistic expression. Both also shared a belief in what the painter termed the "inner necessity" and the composer the "inner compulsion" underlying all artistic activity. This impulse generated by the all-embracing "spirit" of art was what Kandinsky used to justify his insistence on the connection between music and painting. He liked to play the cello, and the titles of many works such as *Great Fugue* (1896), *Scherzo* (1897), and *Composition IV* (1908) refer to his belief in the translatability of the genres. Nor was the boundary between music and painting any more fixed for Schoenberg. He had already begun to paint when they met, and  in 1916 he entitled one of his Five Pieces for Orchestra, op. 16, "Colors" (*Farben*). Indeed, this work can be seen as a forerunner of the "sound-color" (*Klangfarben*) compositions that have become common for contemporary postserial music.[9]

Belief in the translatability of artistic genres led to a concern with their unification. Kandinsky and Schoenberg, like many other modernists,

thought that the spirit of art inherently contested the division of labor. Wagner's ideal of the total work of art became an ideal for Schoenberg in *The Lucky Hand* (1910) and Kandinsky in *The Yellow Sound* (1912). These works have rarely been performed and actually evidence far more hyper-romantic, indulgent, and pretentious qualities than many might care to admit. Each, however, turns the component elements of an opera against one another in order to increase the sense of estrangement as well as the active participation of the audience. Their lack of theme, narrative, and plot also constitute an assault on the fixed and finished product of the creative impulse. Illuminating this nonrepresentational spirit by eliminating all external trappings is a technique common to both Kandinsky and Schoenberg. The painter, for example, reduced the work of art first to color and then, following his association with the Bauhaus in 1922, to a preoccupation with geometric forms that defined colored shapes on glowing planes. *Small Worlds IV* (1922) can be seen as an important transitional work that would ultimately lead Kandinsky to new inventions, like his magnificent late work *Around the Circle* (1940). This shift is reflected in Kandinsky's aesthetic theory, as *Concerning the Spiritual in Art* makes way for *From Point and Line to Plane*, published in 1926. A parallel development took place when Schoenberg moved from his initial experiments in free atonality to the famous twelve-tone technique, where each tone is dependent on the other, in his Suite for Piano, op. 25 (1921). Indeed, for both artists the aim remained the same: to convey the unique sensation.

The "inner voice" alone should speak. It is what gives meaning to the work's character and quality. But this voice cannot be grasped by just anyone. Schoenberg thus wrote to Kandinsky on January 24, 1911: "There is no question of my works winning over the masses. All the more surely do they win the hearts of individuals—those really worthwhile individuals who alone matter to me. . . . One must express oneself! Express oneself directly! Not one's taste, or one's upbringing, or one's intelligence, knowledge or skill. Not all these acquired characteristics, but that which is inborn, instinctive."[10] Both Schoenberg and Kandinsky were preoccupied with the inner life, the expression of unconstrained singularity. Neither was concerned with developing a fixed and finished system. Both, in fact, refused to prize any particular style for its own sake. And this made it possible for them to keep their radicalism intact beyond the changes their styles underwent. Each believed that the inner necessity motivating him would change as the world changed. Each was unafraid to adapt as different forms of modernism became integrated into the cultural framework of modernity.

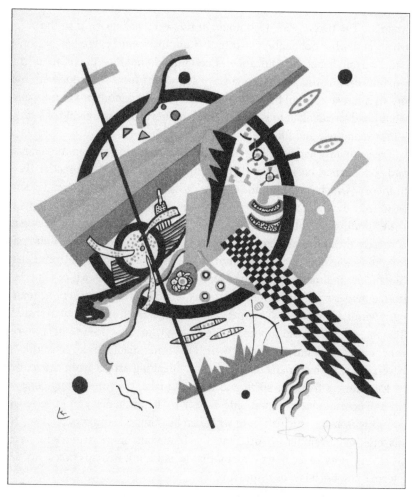

**FIGURE 4.4** *Small Worlds IV*, lithograph (1922) by Wassily Kandinsky.
© 2012 Artists Rights Society (ARS), New York / ADAGP, Paris.

Economizing or suspending artistic effects like melody, which supposed-
ly obscured the "subcutaneous," or the spirit, was Schoenberg's aim from
the very first. Giving every tone its uniqueness, and only later making each
structurally dependent on the others in a given row is an expression of this
impulse. The twelve-tone technique, in this vein, has its roots in the early
work, and what Schoenberg wrote to Kandinsky on September 28, 1913,
had a certain general significance: "I certainly do not look down upon [the
*Gurre-lieder*] as the journalists always suppose. I have not improved, but
my style has simply got better so that I can penetrate more profoundly into
what I had already had to say earlier and am nevertheless capable of saying
it more concisely and fully."[11]

Free atonality had initially rendered the distinction between dissonance
and consonance, harmony and chaos, meaningless. If not in practice then
in theory (which is telling), these terms lost their antinomial character and
assumed a dynamic relation to one another. Schoenberg would have agreed
with Kandinsky's statement that "today's dissonance in painting and music
is merely the consonance of tomorrow." Their art evidenced an "anticipa-
tory consciousness" even as it illuminated, using another term from Ernst
Bloch, "the hollow space" of the age. An "atmosphere," a spirit of expecta-
tion, emerges from the emptiness that is reflected in the music of Schoen-
berg with its "noiseless dynamite, long anticipations, suspended arrival."[12]
This interpretation also applies to Kandinsky, who saw colors as metaphori-
cal equivalents of mood states by which the inner reality of the artist might
be experienced by an engaged audience. Breaking art off from the world
of appearances frees the spirit and thereby makes the inner experience of
life the central object of aesthetic concern. The immediacy of experience
brings with it an anticipation of what can be. Thus Kandinsky could say in
his letter of November 16, 1911, that "I feel more and more strongly in every
work an empty space must remain, that is, not bind! Perhaps this is not an
'eternal' law, but a law of 'tomorrow.'"[13]

## The Spirit in Action

Schoenberg and Kandinsky had little respect for expertise in the narrow
sense. In keeping with the assault on the beaux arts academe by the Vien-
nese Secession, both learned their crafts outside the established institu-
tions. Like so many other modernists, they too sought to express them-
selves beyond their primary field of cultural endeavor. They also tried to
break down the barriers between artistic production and consumption by

calling on their audiences to experience new feelings elicited by swirls of colors or discordant sets of sounds and, so to speak, provide the work with their own unique stamp. They saw inner necessity as driving both the artist and the audience. Thus Kandinsky wrote in *Concerning the Spiritual in Art*: "Color is generally a tool to affect a direct influence on the soul. Color is the key. The eye is the hammer. The soul is the piano with many chords. The artist is the hand, which through this or that touch purposely creates vibration in the soul."

Just as Kandinsky's paintings demand of a viewer the willingness to experience a given mood, Schoenberg's music "asks of the listener that he or she spontaneously co-compose its inner movement and, instead of contemplation, challenges him or her to engage simultaneously in praxis."[14] Precisely insofar as these artists aimed at eliminating the unifying point of reference, in terms of the musical triad by the one and the consensual object by the other, their works sought to elicit a new connection between the artist and the audience. The meaning of the work ever more surely rested on the sense of subjectivity it generated. "Self-perception" was, as Kandinsky expressed it in his letter of January 26, 1911, "the root of the 'new art', or art in general, which is never new, but which must only enter into a new phase—Today!" The music of Schoenberg, no less than the painting of Kandinsky, dared the audience to find out whether unique forms of experience were still possible in the standardized world of modernity, whose nascent culture industry was already seeking the lowest common denominator in order to maximize profits.

Other artists and cultural producers immediately grasped the innovative techniques introduced by Kandinsky and Schoenberg. An unattributed editorial for the journal of the Viennese Secession, *Vers Sacrum*, in fact noted: "It is jokingly asked today whether artists only work for artists. We answer, quietly, yes! But with the noble title of artists we name not only the people [who] carry around palettes, brushes, but rather those who try to also emapthize anew [*nachempfinden*] or also recreate [*nachzuschaffen*] art. We live from the belief that their number is growing."[15] Yet Kandinsky and Schoenberg would surely have been amazed at the millions who now enjoy their art. They were, after all, part of a self-selected avant-garde that was becoming seemingly more radical from day to day. Gustav Klimt, Egon Schiele, and the artists of the Viennese Secession of 1897 may have exerted a certain influence on the new visionaries. Their use of line led directly to cubism, while their etherealizing of the represented object served as a source for expressionism. By 1911, however,

their deep psychological preoccupation with sexuality and the decorative quality in so much of art nouveau had seemingly become domesticated.[16] New heroes were already entering the scene: Marinetti, Kokoschka, and a host of others. The Viennese version of art nouveau, popularly known as *Secessionstil*, could still shock the good bourgeois. Nevertheless, it had already grown too stale for the tastes of revolutionaries like Kandinsky and Schoenberg.

Their experiments stood apart from the conflict raging between those artists concerned with the "functional" and others with the "ornamental" that had so dominated the aesthetic discussions in Vienna as the century drew to a close. Representatives of both tendencies already had been integrated into the status quo. Schoenberg and Kandinsky moved forward by looking back to the nineteenth-century romantics who claimed that the aim of art was less the depiction of some narrative or the imitation of nature than the expression of certain feelings or fantasies. The inner image remained for them the foundation of painting. On April 9, 1911, Kandinsky complained in a letter to Schoenberg: "How immensely fortunate (though only relatively!) musicians are [to be engaged] in their highly advanced art, truly an *art* which has already had the good fortune to forgo completely all purely practical aims. How long will painting have to wait for this? And painting also has the right (= duty) to it: color and line for their own sake—what infinite beauty and power these artistic means possess!"[17]

In contrast to painting, however, music had never been forced to define itself in relation to an objective referent. But that did not make its internal rules of construction any less strict. Quite the contrary: historically produced conventions hardened in music perhaps more drastically than in any of the other arts. Embarking on a new artistic direction was no easier for Schoenberg than for Kandinsky. The latter explained his motivation nicely in a letter to his friend on February 6, 1911, by noting that "the human tendency toward the fossilizing of form is shocking, even tragic." On August 19, 1912, Schoenberg responded:

> We must become conscious that there are puzzles around us. And we must find the courage to look these puzzles in the eye without timidly asking about the "solution." It is important that our creation of such puzzles mirror the puzzles with which we are surrounded, so that our soul may endeavor—not to solve them—but to decipher them. What we gain thereby should not be the solution, but a new method of coding or decoding. The material, worthless in

itself, serves in the creation of new puzzles. For the puzzles are an image of the ungraspable. And imperfect, that is, a human image.[18]

Progress now becomes identified less with some teleological unfolding of history or linear development of science than with a growing inner awareness of existential questions concerning life's meaning. Artworks can never fully articulate it. At best they can only offer intimations, or what Karl Jaspers termed "traces" of the "all-encompassing," "the essence of essences," or "the god-head." The ungraspable constantly eludes what the inner compulsion calls on the artist to grasp. There is only the growing knowledge of an unending quest for self-expression and self-perception, evidenced through the invention of ever more complicated techniques. Thus Kandinsky stated in a letter of August 22, 1912, that "'inner necessity' is just a thermometer (or yardstick), but one which leads to the greatest freedom and at the same time sets up the inner capacity to comprehend as the only limitation on this freedom."[19]

External time devolves into le durée of Henri Bergson, what Edmund Husserl defined in 1905 as the internal consciousness of time, or what Heidegger later called "temporality." Inner time is divorced from clock time, and the "hollow space" of subjectivity denies any spatial constriction. Mediation between the inner and outer worlds is no longer possible. Experience of the sublime escapes definition by any category or concept. That is the sense in which modernist art becomes autonomous. No longer is there an objective or representational referent for understanding the work. Where Kandinsky's explosion of the object produced a burst of colors that evoked a cacophony of emotions, Schoenberg sought to subject traditional music to a rigorous and rational critique. But he was no less revolutionary than his friend. Thomas Mann correctly noted that with Schoenberg the "effect is just the converse of rationality. Over the head of the artist, as it were, the art is cast back into a dark mythological realm."[20]

Both Schoenberg and Kandinsky resisted the looming triumph of instrumental rationality. They had only contempt for a disenchanted world, and attempted to reenchant it. The ambition to do so is exhibited by Schoenberg's great opera Moses and Aaron (1928) and his oratorio Jacob's Ladder, which he composed in 1906, as it is by the nonobjective compositions of Kandinsky.[21] Religious preoccupations stayed with Schoenberg throughout his life. Meanwhile, Kandinsky embraced the theosophy of Madame Blavatsky, whose iconography and mysticism helped him find his nonobjective avenues to the absolute, or spirit.[22]

Kandinsky and Schoenberg wished to retrieve a forgotten past. The contributions of non-western societies informed their work. To be sure, colonial peoples were, following Schiller, identified with the childhood of civilization and a golden age. Like children, the insane, and animals, they were embraced for their supposed innocence and seen as uncontaminated by the worst elements of modernity. In spite of this ethnocentrism, however, the products of nonwestern and premodern art were taken seriously. Early Russian iconography influenced Matisse, Japan touched Van Gogh, and Tahiti inspired Gauguin. Medieval sculptures had a profound aesthetic impact on Ernst Barlach, and the Byzantine mosaics at Ravenna contributed much to *The Kiss* (1908) and other works of Gustav Klimt's "golden period." The interest of modernists in the instinctive, primordial, and mystical gave an international stamp to their project. Their combination of cosmopolitanism and nonconformism led them to challenge European standards for evaluating art to the point where "the arts of subjugated backward peoples, discovered by Europeans in conquering the world, became aesthetic norms to those who renounced it. Imperialist expansion was accompanied at home by a profound cultural pessimism in which the arts of the savage victims were elevated above the traditions of Europe."[23]

Modernism treated western conventions as little more than constraints. Kandinsky and Schoenberg invented their own traditions. They joined the other great artists of this cultural vanguard in innovatively employing the contributions of manifold figures and cultures often lost within what had become rigidified and Eurocentric notions of art history. Their views of Africa, Asia, and Latin America were often naive, ill-informed, and sometimes even self-serving and exploitative. Nevertheless, modernism looked beyond Europe for inspiration and—perhaps for the first time—gave art a global imprint.

## Antinomies of the Spirit

The world of modernism was still young when Schoenberg was starting to compose and Kandinsky was beginning to paint. They shared certain presuppositions concerning the "inner" genesis of art, its experimental confrontation with convention, and its explosion of a consensual point of reference for the work. Schoenberg undoubtedly agreed with a letter from Kandinsky of February 6, 1911, that stated: "This human tendency toward the fossilizing of form is shocking, even tragic." Both believed that art was grounded in life. Both sought to break down rigid oppositions between the

abstract and the concrete, matter and spirit, and to deny any fixed characteristics of sensory experiences like hearing or seeing. Both viewed the spirit as translatable from one medium into another, and Kandinsky, in particular, considered it possible to hear colors and see music. In all these ways it is legitimate to ask: "Does not the dissolution of the portrayed object correspond to the dissolution of traditional tonality in music? Does not the emancipation of colors and forms (their collisions and disproportions) correspond to the emancipation of dissonance? And do not both correspond to the dissolution of grammar and syntax, which began about the same time."[24]

Both Kandinsky and Schoenberg were radicals, and they knew what they wished to transform. They confronted their respective genres with an eye toward a permanent revolution of creativity wherein the subjectivity of the viewer or listener would be constantly pitted against the world of artistic conformity. But they did so with different means and for different ends. Kandinsky may have spoken respectfully about Schoenberg's often dreamlike portraits and landscapes, so reminiscent of Edvard Munch, but he was suspicious of the extent to which they retained a representational or organizational frame of reference. The assumptions they held in common, furthermore, often meant something different to each of them. Kandinsky wrote Schoenberg on January 18, 1911, for example, that "the independent life of the individual voices in your compositions is exactly what I am trying to find in my paintings. . . . Construction is what has been so woefully lacking in the painting of recent times, and it is good that it is now being sought. . . . I am certain that our own modern harmony is not to be found in the 'geometric' way, but rather in the anti-geometric, anti-logical way."[25] In his letter of August 19, 1912, however, Schoenberg stated that *The Yellow Sound*, which apparently shared so much with his own *Lucky Hand*, was actually "the opposite of construction. It seems that he who constructs must weigh and test. Calculate the load capacity, the relationships, etc." The composer saw the work of his friend less as a product of construction than a "renunciation of conscious thought" and the expression of an "inner vision."[26]

Kandinsky and Schoenberg were antinomial expressions of modernism in its golden age. Kandinsky sought only an empathetic feeling of immediacy on the part of the onlooker. Like others who had come from the Viennese Secession,[27] he would have been thrilled to receive appreciation from a child. Especially in his early work, it was the immediacy of experience that he sought to convey. With Schoenberg it was different; he conceded

nothing to immediacy and made every possible demand on the intellectual faculties of the listener. Schoenberg noted in his letter of January 24, 1911: "I believe that it will eventually be possible to recognize the same laws in the harmony of those of us who are the most modern as in the harmony of the classics; but suitably expanded, more generally understood." Kandinsky had a different take on the matter. He understood color as reflecting a particular mood, which an artist simultaneously seeks to express and elicit, and for which any limiting line serves as a constraint. The situation is different for music. The twelve-tone scale constitutes a stringent compositional form capable of giving each tone its singularity by reorganizing musical expression. This was precisely what Thomas Mann understood as the subversive preoccupation with organization on the part of Adrien Leverkuhn, a blending of Nietzsche and Schoenberg, who served as the main character in *Dr. Faustus*. In contrast, even Kandinksy's later geometric paintings were never "organized" in the sense that "the musical phenomenon reduces itself to the elements of its structural interconnections."[28]

Both may have concerned themselves with the "unlogical," or what Schoenberg termed the "elimination of the conscious will in art." But for Schoenberg, this elimination required the logic of composition that he formulated in *The Musical Idea and the Logic, Technique, and Art of Its Presentation* (1910). The "emancipation of dissonance" necessarily presupposes the harmony it denies. Even with regard to the early atonal work, in this vein, Schoenberg's music is arguably more analogous to the cubist paintings of Picasso or Braque than to those of Kandinsky. These cubists, in creating the illusion of reducing three dimensions to two, clarified the assumptions behind not just deconstructing the object but reconstructing it as well. Surface and depth blended together and the canvas became a set of transparent fragments. But the object never entirely disappeared; it was merely transfigured. The same holds for the new music. The emancipation of dissonance only makes sense with reference to a preexisting notion of harmony, even if its value has been undercut and its function transformed. Thus, perhaps in spite of Schoenberg's own wishes, his work retains a positive and objective point of reference.[29] Kandinsky's paintings lack any such referent or moment of positivity. That is also the case for much of the later work in which he rejects the broad expressionist brushstroke, the dramatic black line, the dabs of paint, and the shaded colorings of the abyss in its manifold dimensions. Kandinsky may have moved from color to line. But the step was not as great as it initially appears.[30] Geometry merely provides the autonomous laws and axioms within which col-

or gains its effect and the imagination can play. The materials renounced are still never explicitly defined, and his interest in form remains of the immaterial sort originally represented in the early works like *Little Pleasures* (1909) and *Black Lines* (1913).

Kandinsky was never concerned with multiplying the representational possibilities of the object in the manner of Schoenberg, whose assault on the triad in the name of a "free atonality" expanded the tonal combinations employed in prior forms of music. Kandinsky was far less preoccupied with the logic of composition than Schoenberg, who has often been called a "conservative revolutionary" (without any political connotations). Tradition played a stronger functional role for Schoenberg, who sought to "break through the limits of a bygone aesthetic," than for Kandinsky, who believed that the act of aesthetic production, the sense of inner necessity, would reveal what was salient from the past. Kandinsky rejected all "coloristic balancing acts," traditional techniques, or immanent attempts to transform the visual inheritance of the past. He was intent on making an absolute break, whereas Schoenberg, by way of contrast, considered his twelve-tone system to be the "legitimate heir" to the classical seven-tone system.[31] The composer was not, of course, some tradition-bound reactionary. He surely would have agreed with Kandinsky that it is "wrong for the teacher to instruct the pupil in art in the same way a sergeant-major instructs a soldier in the use of firearms. . . . Rather his task is to open before his students' eyes the doors of the great arsenal of resources, ie. means of expression in art, and to say: Look!"[32]

However, for Schoenberg, it was also a matter of teaching students "to express themselves."[33] Knowledge of harmony and counterpoint were necessary for him in a way that the knowledge of classical anatomy was not for the painter preparing an assault on representation. Schoenberg's work was built on the edifice erected by Brahms. He insisted that, before learning "the new music," his students should learn the old. Schoenberg would never have accepted Kandinsky's claim that "once painting no longer recognizes organic-anatomical construction, ie. consistently rejects it in favor of linear-painterly construction, does it not follow that one should exclude from one's instruction all the preliminary exercises practiced by earlier schools, in particular the mastery of organic-anatomical construction?"[34] The precise use of compositional rules was essential for Schoenberg, while for Kandinsky, artistic creation was inherently intent on shattering anything capable of constraining its spirit. The composer employed an unyielding logic, and he considered beauty a mere by-product of the truth generated by art.

It was different with his friend. The beautiful was both the means and the end of the work, and for this reason, it could only exist as a fleeting illusion and momentary experience that was still more real than reality itself.

The loneliness, repressed eroticism, and anxiety evident in so many of Schoenberg's self-portraits, with their use of flat surfaces, direct expression, and bare landscapes have little in common with the brightness and joyful expression of colors in the work of Kandinsky. The playfulness and utopian wonder of the liberated imagination in Kandinsky's paintings find no parallel either in the music of the maestro or Schoenberg's still-representational paintings like *The Red Gaze* (1910). Kandinsky always understood that his art was building an experiential bridge with the viewer; Schoenberg understood his music as a "cry for help." The inability to grasp the sublime only heightens the momentary intimations of its existence. Just as Schoenberg's work evidenced an *irratio of the ratio*, Kandinsky's forwarded the *ratio of the irratio*. The concern with freedom demands the preservation of form, just as the preoccupation with a lived fantasy seeks form's end. The works of Schoenberg and Kandinsky, in this sense, oppose one another within a unifying frame of reference. They complement as well as reflect one another. They are not the same. And that is as it should be: genius is always unique.

# 5

## Modernism in Motion

### F. T. MARINETTI AND ITALIAN FUTURISM

Futurism was perhaps the most self-consciously political of all modernist movements.[1] Few others were as broad in scope and as forceful in their demands for a sweeping transformation in the style and quality of everyday life. From painting to language, architecture, men's clothing, cooking, and "lust," there was barely an aspect of culture that the futurists did not interrogate. No later avant-garde group was more intent on contesting the reified aspects of modernity. The futurists became enmeshed with what they opposed. But their aesthetic projected a new experience of existence that reflected the transformations of time and space produced by airplanes, automobiles, electric lights, trains, telephones, and telegraphs. They embraced speed with reckless abandon, and their first manifesto of 1909 spoke of setting fire to the library shelves and flooding the museums. Futurist politics was pitiless and inhumane, chauvinistic, bellicose, irresponsible, and nihilistic. Nowhere does the troubling combination between aesthetics and politics emerge with greater clarity than in the career of the founder and organizer of the movement as a whole, Filippo Tommaso Marinetti.

Marinetti's manifestos evince neither the political intelligence of Lenin's polemical pieces nor the aesthetic relevance of André Breton's. But his charisma fascinated the European avant-garde. Even more than other right-wing cultural gurus of the avant-garde like Gabriele D'Annunzio, Ezra Pound, and Stefan George, who were all major poets, Marinetti's art was his personality. Through his flamboyance, the scandals that he orchestrated, and the controversy that followed him wherever he went, he spread the ideas and works of truly gifted artists beyond the confines of an Italian

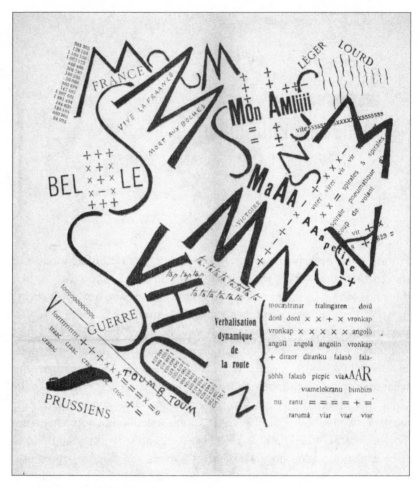

**FIGURE 5.1**   *After the Marne, Joffre Visited the Front by Car* (1919) by Filippo Tommaso Marinetti. © 2012 Artists Rights Society (ARS), New York / SIAE, Rome.

*Photo Credit: The Getty Research Institute, Los Angeles (87-B6595)*

elite to a larger, international public. Marinetti recognized talent. He was also generous in supporting such artists as Umberto Boccioni, Carlo Carra, Luigi Russolo, and others for years at a time. His magazines, including *Poesia* and *Lacerba*, enabled Marinetti to unify disparate artists and create a network of sympathizers for their art. He believed the artistic imagination should take its cue from new developments in society: *Street Light* (1909) by Giacomo Balla was inspired by the first electric street lamps in Rome. The

futurists saw themselves as an avant-garde with a transformative purpose, and Marinetti as their impresario. He had no use for punctuation; nouns were to follow one another in staccato fashion. Words would become expressive of music and colors. Bombastic, egotistical, and aggressive— Marinetti was able to capture a cultural sensibility in a few words. Thus he greeted the modern age with his famous claim that a racing car was, in fact, "more beautiful than the *Victory of Samothrace.*"

Several of futurism's most arresting characteristics include its obsession with technology, its desire to break with the past, its emphasis on the "manly" and the death-defying, and its wish to *épater le bourgeois.* Marinetti's more staid contemporaries were always outraged. In his view, however, that was as it should be. Scandal was part of his repertoire as he engaged in public duels and dropped leaflets on unsuspecting passersby, first from rooftops and then from airplanes. Marinetti disdained Italian cultural life as it appeared to him around the turn of the twentieth century. Other nations were experiencing extraordinary advances in technology, urbanization, and industry. By contrast, Italy seemed content with having had a Renaissance: its bourgeoisie appeared to languish in a lazy decadence. That image is the key to understanding the cultural politics and fascist proclivities of Italian futurism.

Marinetti and his comrades fanned the war fever that establishment parties never fully recognized, even after the close of World War I. Heroism without purpose mixed with contempt of the young for the old, the traditional, and the habitual. Marinetti's shrewd use of scandal turned the futurists into celebrities. Their love of danger and aggressiveness made them into adventurers. Futurist soirees became antineutrality demonstrations at the onset of World War I—and notoriety became an end unto itself

This was all very different from the style fostered by the Italian Socialist Party, in spite of its revolutionary self-understanding. Futurism was militarist; social democracy was antimilitarist. Futurism spoke to the unleashing of the irrational; social democracy embraced process. Futurism viewed itself as the avant-garde of national cultural renewal; social democracy saw itself as the political agent of the working class. Futurism envisioned the apocalypse; social democracy was (ultimately) content with reform. Futurism was marked by an anarchist sensibility. Its members had little use for organizing and even less for parliamentary politics. The futurists blended their assault on traditional institutions and capitalist values with a cult of war and contempt for egalitarian ideas like the classless society. Italy appeared to Marinetti and his friends as an anachronism: an image that blends the liberal, humanist, and cosmopolitan traditions of the North

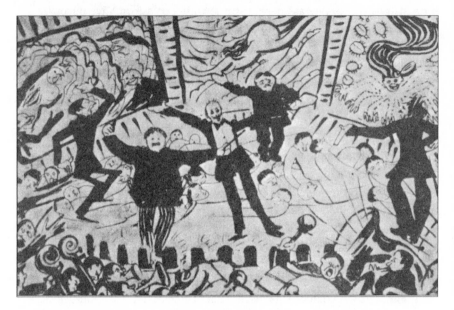

**FIGURE 5.2**  *A Futurist Evening in Milan: On the Stage Will Be Seen Boccioni, Pratella Marinetti, Carra, and Russolo* (1911) by Umberto Boccioni.

with the barbaric social and economic stagnation—where the title of Carlo Levi's famous novel *Christ Stopped at Eboli* (1945) tells the story—so rampant in the South. Against the former, fascism launched its antihumanistic and hypernationalistic elements, and against the latter, anarchism directed its attacks on authority and tradition. The intersection of these two radically opposed ideological outlooks made it impossible for the futurists to respond to the dynamic changes occurring around them with any degree of political coherence. Nevertheless, perhaps, this same lack of coherence made for the artistic achievements of futurism.

Its artists were thrilled with what Marinetti termed the "frenetic life of the great cities and the exciting new psychology of nightlife; the feverish figures of the *bon viveur*, the cocotte, the apache and the absinthe drinker." All of this stands in marked contrast to the settled habits and routines of everyday life that bourgeois society fostered though its indulgent individualism and preoccupation with deliberation and common sense. Horrified by "all the slovenly and facile commercialism," the futurists were inspired by the extraordinary inventions and technological discoveries that occurred around the turn of the twentieth century. Artists like Boccioni

were nauseated by the sterile and classical themes of the past. They sought new themes instead, consonant with industrial life, and—above all—what Marinetti termed "the dynamic sensation." Where the futurists embraced science, and the use of geometric forms and mathematical determinations of speed, they did so to heighten the intensity of the moment and what the existentialists would later call the "extreme situation." Sustained movement and dynamic sensation would abolish the dreary and stolid world of the cultural philistine—to the point where, in works like Boccioni's *The City Rises* (1910), the old-fashioned bourgeois notion of individuality would vanish as well.

Creating a new form of individuality was the task the futurists set for themselves. A form of catharsis was needed to purge society of its rust, the languor born of its accumulated traditions, and to allow the individual to manifest his heroism and his desire for adventure. Marinetti was one of many who, around the turn of the century, believed that war might serve as an antidote to boredom, and he became an advocate of war as the "world's only hygiene." He also considered the artist to be the savior of humanity, since only he could fully understand and articulate mankind's new experiential needs. Marinetti was no hypocrite. Years before World War I, in which he served honorably, he covered the Italo-Turkish conflict of 1911 as a war correspondent. Then in 1912 he went to the Balkans, where his experiences became the basis for well-known poems such as "The Battle of Tripoli."

The world of the past had nothing to offer. Marinetti revered nothing. He asked: "What is there to see in an old picture except the laborious contortions of an artist throwing himself against the barriers that thwart his desire to express his dream completely?" The futurists looked instead to Cézanne and the cubists. Marinetti radicalized their formalism and their commitment to "art for art's sake." Out of these ideas came a belief in the license of the artist to do what he wished in the pursuit of experience. Marinetti also embraced the use of distortion by the expressionists. He admired their attack on aesthetic conventions, and their bold desire to intensify experience. But he took it all more than a step further. Looking back with an ill-contained fury on the Renaissance, Marinetti called for the expulsion of the nude from painting. He had no use for naturalism either. Art should oppose life as it was habitually lived. Marinetti believed that art was valuable only insofar as it expressed the desire for adventure and the intense momentary experience.

Marinetti turned the new into a fetish. He worshipped change for its own sake and, thereby, unconsciously glorified the world of capitalism, its

incessant development of new commodities, and its ultimate employment of planned obsolescence. At the same time, ironically, the futurists were vehemently critical of bourgeois materialism. Their entire outlook was thus defined by a kind of romantic anticapitalism that left liberation identified with the "elastic freedom" of a dynamic chaos. So it was that the new turned into a ritualized need and the defining characteristic of spontaneous creative experience. Nowhere is this more noticeable than in Antonio Sant'Elia's "Manifesto of Futurist Architecture"(1914) where he claims that "the fundamental characteristics of Futurist architecture will be its impermanence and transience. Things will endure less than us. Every generation must build its own cities." The new has no ulterior or instrumental purpose. The will, whim, or choice of the individual becomes the only point of reference. The futurists and Marinetti thus took Nietzsche's cry literally: "Do whatever you will, but first be such as are able to will!"

The only way to realize this mystifying will was through a "gratuitous act" that, by its very lack of rationality, would transcend all practical aims and so become the product of the "highest will." Such an act places the individual beyond all constraints and all concerns with reciprocity. The gratuitous act exemplifies the extreme situation in which it is impossible to determine when unconscious compulsion ends and lucid volition begins. Marinetti spoke of it as projecting "beyond the unity of time and space, and beyond the distinction of things." The gratuitous act crystallizes the moment of what Bergson termed "creative intuition" that escapes sociological or logical analysis. Nietzsche would have understood it from the perspective not of those who chatter about the will but those who first render themselves able to will. There is something inhuman about all of this. Marinetti admitted as much when he wrote that the individual is worth no more than an electric light bulb. That is the point behind the gratuitous act. In a sense, the possibility for such an act derives from "the death of God" and the eradication of absolute standards of judgment. In cultural terms, the gratuitous act expresses the cult of the self and the great refusal of all authority and instrumental rationality. In political terms, however, it celebrates the arbitrary power that fascism would institutionalize.

Marinetti took up the gratuitous act as a guiding principle. It should be evident, by now, that the gratuitous act gave rise to a tradition. Its beginnings are to be found in Dostoyevsky's *The Possessed* (1872), but André Gide first gave the idea a satirical twist in *Lafcadio's Adventures* (1914). It soon became a theme in surrealist thought—Breton claimed that the perfect surrealist act involved shooting wildly into a crowd—while Jean-Paul Sartre

and Albert Camus made use of the notion in *Nausea* (1938) and *The Stranger* (1942), respectively. Charlie Chaplin often used it to counter his more sentimental tendencies and express his deeply antiauthoritarian attitudes for humanistic purposes. But where the great artists were all horrified by the idea, and where Breton was content to exploit its shock value, Marinetti embraced it with fervor. His play *Le roi bombance* (1909) claimed that the gratuitous act marked the artist who would confer a new breath of meaning on society and who thereby would justify himself as the one who could lead a state. Here, indeed, the artist anticipated the fascist statesmen, including Benito Mussolini and Primo de Rivera, who liked to insist on sacrifice for its own sake rather than for any material purpose. Nevertheless, Marinetti expressed the hopes of many modernists for a revolution that would place the state at the disposal of the artist.

The gratuitous act fuses the artistic imagination and the personal quest for adventure into a grand politics. The work of art becomes a spectacle that only the self-defined elite can properly experience. The rest are unable to understand it. For Marinetti, however, the work of art was not supposed to be "understood." Why should the philistine understand, if the futurists themselves "didn't want to understand. . . . [And] woe to anyone who says those infamous words to us again!" The philistine bourgeois could only understand that which wasn't worth explaining. If the break with the past was to be complete, it had to call into question and deny both rational cognition and rational communication. Language? Marinetti wanted to explore a new mode of communication through his "words in freedom." Feelings? It was time to discover a new unsentimental way of perceiving objects and oneself as well. Art? It could only reflect a world that the past controlled. "True art," as the painter Carra liked to say, would begin with futurism.

The futurists didn't want to understand because they had already understood—intuitively, irrationally, spiritually—and this understanding was strengthened by the community of feeling that their art had engendered. But precisely because of their isolated social position, and their intense egoism, what the avant-garde sought to communicate expressed great verve and dynamism. Marinetti and the futurists always detested the placid and the sober; their desire was to infuse a dazzling, vibrant excitement into society at large. The sparkling gaiety that informs so many futurist works receives theoretical explanation in minor pieces like the "Futurist Manifesto of Lust" (1913) by Valentine de Saint-Point and the "Futurist Manifesto of Men's Clothing" (1913) by Balla. This sense of gaiety and experimentation is one of the movement's most endearing and progressive traits.

Marinetti drew the battle lines against the staid and the provincial. He sought to project a vision of youth for an apocalypse that would result in a new man, a "multiplied man." This multiplied man with his "multiplication of values" would contest the stultifying specialization caused by the division of labor, the dead routine of everyday life, and all forms of instrumental rationality. Aesthetically, as the futurist musician Francisco Pratella put it in his "Manifesto of Futurist Musicians" (1910), a perception would arise "capable of enriching any fact with a more imposing personality." This vision had no place for sentimentality, eroticism, or humanity. As Marinetti and his friends conceived of it, the multiplied man with his multiplied values, inspired by a dynamic of ceaseless change, would "never know the tragedy of old age! To this end the young modern male, finally nauseated by erotic books and the double alcohol of lust and sentiment, finally inoculated against the disease of Amore, will methodically learn to destroy in himself all the sorrows of the heart, daily lacerating his affections and infinitely distracting his sex with swift casual contacts with women."

Such ideals would later become part and parcel of fascist ideology. Originally, however, the futurists were not sure of their audience. Since they rejected the status quo and lacked a coherent view of the world and even of the future that they wished to impose, and since they didn't wish to be understood—because complete understanding would already imply a bond to the given state of things—they could not choose a single group or class to direct their appeals to. So they lingered in the abstract. Marinetti decided to speak to *all* Italians, just as in his famous pamphlet "Let's Murder the Moonshine!" he had spoken to all Venetians. Because the futurists spoke to all, but chose no one, they—albeit unintentionally—became an integral part of the society they were reacting against. They may have been antagonistic to it, subjectively. Objectively, however, the futurists functioned in it very nicely. Marinetti abstracted the concept of the bourgeois from any determinate social context, leaving it devoid of class content. His bourgeois was the cultural philistine—only this time with a liberal tinge. It was the same with the proletariat. Like Nietzsche, he feared the political intrusion of the working class because of its mediocrity and herd mentality. And so, in Marinetti's view, the proletariat became the "proletariat of gifted men." Soon enough Mussolini would evidence his own self-selected elitism and redefine the proletariat once again: this time in terms of a "proletarian nation."

The cultural image of the bourgeois emerges splendidly in the impressionistic picture Marinetti painted of prewar Italy. This philistine is enrap-

tured with the glories of an ancient past, an effete cosmopolitan, a dilettante obsessed with eroticism and sentimentality, with "tango-teas" and appearing chic. Resting on the laurels of a bygone age, he is decadent and diseased, no longer capable of creating anything except by virtue of foreign influences. Moreover, this bourgeois philistine is a hypocrite: while espousing his rationalist materialism, he still accepts a respectable Christianity. Liberalism, rationalism, and the rest Marinetti saw as relics of the past. Intuition, instinct, aggressiveness, and pitilessness were what history now demanded. *Speed* would annihilate the decadent existence of a present infatuated with the past, an existence informed by the contradiction between culture and politics, life and art, that the futurists wished to resolve.

How that might occur was irrelevant. An aesthetically abstracted result of the new technology, speed would open a wealth of new possibilities. It would serve as the fundamental principle for a futurist aesthetic whose inspiration would, according to Boccioni, derive from "the barbaric element of modern life." Unlike other avant-garde movements, the futurists always started out with the realistic object. Yet "absolute motion is a dynamic law inherent in an object. The plastic construction of the object must here concern itself with the motion which an object has within itself, whether it be at rest or in movement." These words from Boccioni's "Absolute Motion + Relative Motion = Dynamism" (1914) underpin his attempts to abolish finite lines and the self-contained statue. Absolute motion would also make possible the experience of "dynamic sensation" in the spectator's encounter with the work.

Rendering an object dynamic would transform the experience of the spectator and simultaneously undermine the routine, boredom, and commodity fetishism of capitalist production. As an artistic concept, the principle proved free and invigorating, providing one of the theoretical grounds for modernism. The futurist emphasis on speed, the fluidity of urban reality, and technological dynamism would ultimately influence major writers like Alfred Döblin and Vladimir Mayakovsky as well as experimental filmmakers like Dziga Vertov. Even after joining Mussolini, Marinetti kept good relations with the Russian futurists. They may have disagreed over the liberating quality of war and the value of a classless society, but they were all agents of the new. Italian futurism was embraced in Russia. Kasimir Malevich— among the greatest of twentieth-century Russian painters—compared Marinetti with Picasso, and Marinetti got along well with Mayakovsky and Vladimir Tatlin. In Italy and in Russia there was the same desire to sweep away the vestiges of the past—albeit for different reasons and in different ways.

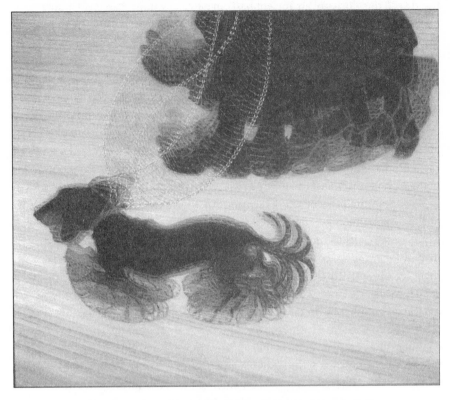

**FIGURE 5.3**  *Dynamism of a Leash in Motion* (1912) by Giacomo Balla.
© 2012 Artists Rights Society (ARS), New York / SIAE, Rome.

*Photo Credit: Albright-Knox Art Gallery / Art Resource, NY*

Futurism helped express the new existential relation between man and his world in terms of a new experiential perception; thus, as Boccioni explains in the same pamphlet, "a horse in movement is not a motionless horse which is moving but a horse in movement, which makes it another sort of thing altogether, and it should be conceived and expressed as something simply varied." Time and space, subject and object, take on new dimensions in the attempt to create the aesthetic ideal of pure motion. In their quest to blend culture and politics, however, Marinetti and the futurists were not satisfied with the aesthetic. They wished to extrapolate the notion of speed, as a guiding principle, onto the social realm. Or, to put it more simply, speed was to take the place of fate and finally force men—

now finally united in a new community of feeling and experience—to know the moment fully. Through speed even the philistines would see that "they must stake their lives on a single cast, not on the lookout for cheating croupiers or trying to control the wheels."

Speed, motion, and incessant activity for the sake of activity—the constituents of the multiplied man—are also constituents of the fascist style and outlook. Introducing the vigorous and the dynamic necessarily calls for conditions in which, as Marinetti writes, "the sick and weak [will be] crushed, crumbled, pulverized by the vehement wheels of intense civilization. The green beards of provincial back alleys [will be] shaved clean by the cruel razors of speed." Progress has nothing human about it: the dignity of times past is a thing of the past. The sublime not only escapes articulation but obliterates all ethical concepts and humanitarian norms. Existence itself is propelled into a situation in which there is no past. Even the "best" should be abolished. There is only the present, without the future or the past, along a self-negating horizon. Duration comes to mean as little for an individual as for a machine. Speed and annihilation become ends in themselves. The individual, again, is worth no more than a light bulb. Reification reasserts itself, as becomes clear in *Futurist Painting: Technical Manifesto* (1910), so that "the suffering of a man is of the same interest to us as the suffering of an electric lamp which, with spasmodic starts, shrieks out the most heartrending expressions of color."

Marinetti thought he was being ruthless, believed he was being concrete, and insisted that his was a higher politics. But, in fact, the only way that any of this made sense was metaphorically. He was engaged in an aesthetic version of politics, and ultimately, he recognized the need for an organizational agent to put his vision into effect. Then, in 1914, Marinetti encountered Mussolini, who was in the process of turning from a socialist into a prowar nationalist. Both understood the masses as material to be formed by men of action. A bond was established between futurists and fascists. Marinetti became part of that nationalist-militarist contingent from which the Blackshirts were recruited. As events unfolded, perhaps to their own surprise, the futurists found themselves part of a world-historical political project. They were no longer to be lightly dismissed as crazy bohemians or simply relegated to the aesthetic realm. But the alliance was between unequal partners. Marinetti began to distance himself from fascism as early as 1920. His insistence on the new and hatred for the philistine contradicted the fascists' pseudoclassical kitsch and their pseudorevolutionary populism. The multiplicity of experience sought

by the futurists also called into question the insipid collectivism demanded by the fascists. Then, too, Marinetti's apocalyptic politics were at odds with the compromises Mussolini made with traditional conservatives and even the Catholic Church. While the Blackshirts were on the rise, Marinetti's unreflective apocalyptic radicalism served them well. He may have sounded effusive about war, like in the old days, when Italy invaded Abyssinia. But *Il Duce* never really took his friend all that seriously.

Once in power, Mussolini clamped down and futurism toned down. Marinetti forgot that power was to be exercised and that, for the politician, speed was not an end in itself. He and his friends became less visible, and the movement declined, even aesthetically, as its leaders started to concern themselves with tamer experiments like "tactilism." Just when the political program of futurism was seemingly being fulfilled, it was being aesthetically nullified. The avant-garde movement—the community of outsiders—became institutionalized and academic. For a movement that prided itself on its dynamism and contempt for the stabile, this spelled its demise. Thus following the fascist seizure of power, only a dim memory remained of the early years, about which Marinetti recalled that "an immense pride was buoying us up, because we felt ourselves alone at that hour, alone, awake and on our feet, like proud beacons or forward sentries against an army of hostile stars glaring down at us from their celestial encampments."

# 6

## Ecstatic Modernism

### THE PAINTINGS OF EMIL NOLDE

Emil Nolde was perhaps the most brilliant of all the German expressionist painters. That he disliked being called an expressionist only makes sense: his insistence on his uniqueness was part of his mystique. As his friend Martin Gosebruch recalled, "He towered above us like someone from another world, affecting us all the more deeply by the testimony of his life and work."[1] Nolde appeared as a solitary genius, an uneducated peasant who somehow knew what the educated could not know, who saw what the prophet saw, who felt what others could not feel.[2]

A man obsessed by his urge to create, unconcerned about the public and the social whirl, the servant of an inner demon that guides his art—such is the image of Emil Nolde.[3] The great power of his painting, however, has often been used to whitewash his activity as a charter member of the North Schleswig branch of the Nazi Party and as a supporter of the movement through its seizure of power.[4] Dogmatic leftists have sought to reduce his art to his politics. His admirers, by contrast, wished to sever his art from his ideological views.[5] More of his paintings and prints and sketches were destroyed by the Nazis than those of any other artist: 1,052 in total.[6] But that does not end the matter. Provincial beliefs and values are evident in his art. They form a kind of reactionary residue that is ceaselessly in conflict with the work's experimental quality. Nolde always portrayed himself as a simple man of the earth, inspired by art's calling, whose "highest wish would be that people [would be] swept away by my work, like children running after a military band. Like that, in a roaring exultation. I would like to sweep people away with me."[7] That was his exit strategy.

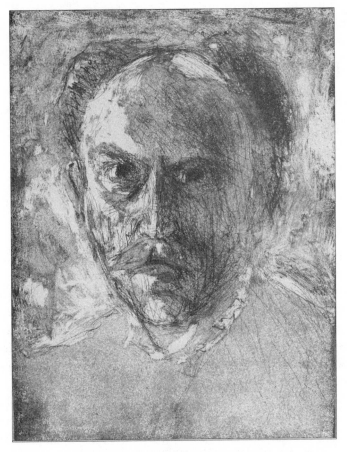

**FIGURE 6.1**  *Self-Portrait* (1908), by Emil Nolde. The Art Institute of Chicago. Photography © The Art Institute of Chicago.

*Courtesy of the Library of Congress, Music Division, LC- USZ62–52575*

Nolde always saw his painting as representative of "German art" and embraced the spirit of this burgeoning Nazi movement, but never understood what was happening around him. He was genuinely amazed that the Nazis attacked his work after having gained power. Perhaps, since colors and not words are at issue, the political problem can resolve itself. Whatever the reactionary residue of his ideas, after all, how can they reveal themselves in landscapes, watercolors, paintings of masks and dancing? Even if certain prejudices become evident in Nolde's religious paintings,

for example, most viewers probably remain unaware of them. His works are enjoyed by many who remain uninterested in his political involvement. The ability to elicit such enjoyment is a measure of Nolde's artistic success, which in turn invites analysis of the specific aesthetic choices that he made. Many painters have relied on color as the basic vehicle of their art. But Nolde employed a palette that grew starker and simpler through the years. His concern with color is actually the technical expression of an attempt to find an experiential ground that links man with nature and the individual with the collective. Exploring that aesthetic aim may teach us something about politics and the way in which Nolde's art becomes a fragment of living history; as experienced by a changing audience, it retains a past that the present often effaces.

## The Birth of Color

Impressionism came late to Germany, at a time when Nolde had already embarked on his path, and it was a relatively pallid affair. He and others raised complaints about the insidious character of foreign influences on German painting. But the new style actually had a peculiarly German flavor. Embraced by the Berlin Secession and artists such as Lovis Corinth, Max Slevogt, and Max Liebermann—whom Nolde would consider a bitter enemy—German impressionism evinced a mixture of despair and longing that stood in contrast to its French counterparts, who emphasized light, atmosphere, and the moment of sensation. Nolde never believed that his German contemporaries could provide an alternative to the French impressionist masters who influenced them so profoundly. He had little use for the attempt to dissolve color into light. He instead saw the need for a new and vigorous German art that would break with the supposed "sweetness" and "superficiality" of the French. Popular painting in Germany was not even worth considering: it was mired in the academicism of Franz von Stuck and the sentimental naturalism of Ferdinand Hodler. Neither seemed capable of inspiring the renewal of German art that Nolde envisioned.[8]

Such was the artistic situation during the Gründerzeit. Emil Hansen was born in 1867 in the town of Nolde in the provincial region of Schleswig-Holstein. Coming from a traditional and religious environment, which had just undergone a pietistic revival, Nolde's affinity for mysticism, nature worship, and primitivism is not difficult to understand. The last three decades of the nineteenth century were a time of tremendous industrial expansion

and urbanization. This period saw the rise of a modern working-class move-ment, the beginnings of mass society, and the introduction of modern life. Thus Nolde wrote in the first volume of his autobiography: "The period from 1871 to the turn of the century, the *Gründerzeit,* with its economic boom, was fateful for the more refined old cultural and popular values; they were ignored, squandered, destroyed." [9]

The Gründerzeit began the subversion of traditional small-town life and the values of those peasants and artisans with whom Nolde claimed solidarity. These classes felt threatened by both a vigorous bourgeoisie and an emerging proletariat; where they feared being ruined by the one, they feared becoming like the other. This fear extended to the worldviews of the dominant classes with their crass materialism, lifeless rationalism, rootless cosmopolitanism, and faith in science and progress. The crisis was deeply felt by Nolde, who changed his name at the turn of the century to tie him-self to the town and land of his birth. The themes that preoccupied him were similar to those that preoccupied Nietzsche, Dostoyevsky, and a host of others: the individual standing alone, the prophet confronting the mass-es, and the search for faith in a disenchanted world. Nolde opposed modern forms of thinking with a ferocity fueled by fantasy. His work would evoke a feeling of nature's irresistible power, still latent and simmering beneath the edifice of civilization, material progress, and an undifferentiated herd that had lost its spiritual identity.

Nolde wished to invigorate that spirit. He, too, sought a concrete expe-rience that opposed both idealism and materialism.[10] His unique vitalism crystallized the intersection between modernism and fascism. Disconsolate in a modern world, contemptuous of mass society, Nolde sought to anchor his spiritual existence. His art was one long attempt to find the elemental life force that could be experienced. Or, to put it another way, he sought to secure his identity in a new, xenophobic community of feeling. Thus Nolde wrote: "The place in a man where the most varied qualities, raised to their highest powers, harmoniously unite is the ground upon which the greatest art can blossom forth: at once a natural man and a man of culture, simulta-neously divine and an animal, a child and a giant, naive and sophisticated, full of feeling and full of intellect, passionate and dispassionate, gushing life and silent calm."[11]

Nature is the source of this ground. Seeking to express its dynamic qual-ity was the starting point for Nolde's project. He sought to capture the intui-tive moment through which nature is experienced.[12] His works are harmo-nious in the sense that there is nothing static in them. The individual does

not blend into nature, but rather gains an intuition that fosters his instinctual feelings and thus his identity. Gustav Schieffler correctly characterized the artist's work as "quite absolute but also quite subjective."[13] Nature was regenerative for Nolde. But this primordial power required illumination. Like other expressionists, including Ernst Barlach, Nolde envisioned a spiritual regeneration. Unlike most other expressionists, however, he believed that Nazism was the vehicle for bringing this about.

This theme of spiritual renewal was already evident in an early set of postcard drawings that earned the impoverished Nolde enough money for him to concentrate on his painting. These postcards, including *Der wilde Pfaff* (1894) and *Nordabhängige im Lötschental* (1896), became quite popular. They combined a peculiar blend of kitsch, caricature, and modernism. In these works, where hikers are portrayed in a simple, jocular fashion and are overshadowed by the Alps, out of which faces emerge, Nolde's early search for the link between man and nature evinced an awareness of artistic developments in Munich and Vienna. In the first postcard, for example, a Jugendstil element appears in the faces of two women that emerge from the craggy mountain cliffs; these are beautiful women, asleep, their vibrancy lying dormant, encompassed by the Alps and yet separate from them. In another postcard the ruddy, robust face of a peasant is juxtaposed with the smiling face of a sophisticated woman; the contrast is purposeful, the modish hat of the woman against the peasant cap, the perfect teeth against the weather-beaten face, the alluring look reciprocated with a frowning stare.

In the first postcard the hikers are climbing to these women, and along their trek they assume different poses; beneath them and the mountain a candle burns brightly. In the second postcard the hikers are walking away from the sophisticated city woman with regimented movements. One image is artificially transposed onto another. The aesthetic vehicle for generating unity has not yet been found. This will await the single picture that marks Nolde's breakthrough, his small watercolor *Sunrise* (1901). In this work, which highlights a bleeding red sun—a literary image first found in Georg Büchner's *Woyzzeck* (1829), a favorite of the expressionists, and then also in Bertolt Brecht's *Drums in the Night* (1922)—color becomes the fulcrum for the image and the viewer's experience of it.[14] Not nature in the abstract, a static representation reflecting the existence of fixed scientific laws, but rather nature as an explosion emerges in this painting with its red sun and red streaks in a brown sky that defines the landscape.

Nolde's modernism was directed against the anomie and anonymity of urban life that seemed to epitomize modernity.[15] With its cosmopolitanism,

individualism, and sophistication, the city crystallized what he despised. He saw urban life as eroding simplicity, faith, and intuitive wisdom and "deracinating" the individual.[16] Again and again Nolde speaks of how the land marks its inhabitants and how the visages of the inhabitants mark the land. This was all tied to a feeling of a modern world in which experience was imperiled. In the same way as a person surrenders to God, according to Nolde, the individual should surrender to nature; then, like a mother and her child, nature will embrace her own product. By understanding singularity as oneness with nature, by highlighting an inner ecstasy, Nolde's work sought to manifest the "pulse-beat of the entire world."[17] Fear of the new and anxiety over a growing loss of "rootedness" helped generate the "blood and soil" beliefs that predisposed Nolde to the Nazis.

An elective affinity exists between Nolde's aesthetic views and his political commitments. It is indicative that, for him, the experiential grasp of nature should mark German art. German nationalists traditionally viewed the French as the purveyors of a rationalist, superficial, decadent civilization in contrast to the "deeper," more spiritual German *Kultur.*[18] In opposition to such rationalism, Nolde emphasized the irrational while seeking out the primitive and the childlike, whose organic bond with nature remained uncorrupted. This concern with the uncorrupted is a theme that runs through German expressionism, receiving elaboration in Paul Klee's children's drawings and Marc's animal paintings. The lack of corruption, based on an innocence preserved from civilization, allows for an immediacy of experience that gives birth to joy, fantasy, and exaltation of a dynamic sort.

Thus in the quick brush strokes that mark *Wildly Dancing Children* (1909), the dance takes on the frenetic abandonment of a ritual—while another child stands outside, happily looking on, holding an infant. In the dabs of the brush a broad palette of colors mesh, while the circular motions of the dance define the painting's movement beyond the painter's strokes. The child holding the baby is unafraid of the dynamic movement that confronts her. It is the same with the little girl who curiously looks at an enormous, threatening bird in the charming yet equally haunting woodcut entitled *The Big Bird* (1912). The innocent has nothing to fear; her innocence draws her to experiences from which the sophisticated might shrink. Happy, open, or perhaps overcome by the mood that nature incarnates at a given instant, the child takes on the romantic quality associated with premodern life. Or, as Nolde put it: "primitive men live in their nature: they are one with it and part of the entire universe. I sometimes have the feeling

that only they are real people, while we are something like deformed marionettes, artificial and full of presumption."[19]

The new was seen as having much to learn from primitive societies. Pre-rational, uncivilized, and "free," the new cultural perspective should make it seem as if "the primeval springs were flowing once again."[20] These primordial forces served as the inspiration for a modern creativity that was akin to that of the primitives, whom the civilized despised. So, when it served Nolde's purposes, a cosmopolitan outlook could prove enlightening. Nolde was fascinated by nonwestern art, and he made pilgrimages to Africa and China.[21] Of course, his concern was less with the actual cultures than what they might offer his art. Nolde used the other to confront a stultifying tradition and daily routine at home and the disenchantment of the world ushered in by modernity. It was all part of a general outlook. Thus, "the love for the extraordinary which existed in me at that time has always remained with me. My interest in what is foreign, primeval and primitive was especially strong: I had to get to know the unknown; even the nocturnal, depraved inhabitants of the great city stimulated me like something exotic, and the Jewish types in my later religious pictures may have come into being in part from my following this drive."[22]

## Forming an Identity

Nolde used nonwestern art to help affirm his German identity. There is something ironic about this: he considered himself a radical, but in this case he merely gave traditional prejudices a neoromantic twist. Kant, Hegel, and others within the Enlightenment tradition had viewed Africa and China as lacking history, congenitally irrational, and devoid of civilization. Nolde simply turned these ethnocentric prejudices upside down. What was negative now became positive. Western colonial stereotypes were never challenged. Nolde's new art would affirm the prototypical qualities of the German race by intuitively embracing what had supposedly been preserved from civilization (at least as the French defined it). It would prove both fully German and, given its primordial character, absolute. Illustratively, in *Urmenschen*, completed in 1901, two naked savages peer into the distance with an anguished amazement as a woman holds her child tightly to her. (A drawing with the same title from 1895 harbors a different theme.) Chaotic lines of color—somewhat reminiscent of Munch—testify to their anxiety. The world of modernity lies in the distance; this is the world of fear, an imperialist world that will undermine all that they are. Nolde understood

that his epoch was marked by imperialism. As he wrote: "We are living at a time when all primitive conditions and primitive peoples are perishing; everything is being discovered and Europeanized. Not even a small area of original primitive Nature with primitive people remains for posterity. In twenty years everything will be lost. In three hundred years scientists and scholars will ponder, torture themselves and dig, groping to grasp a tiny part of the treasure that we had, the unspoiled spirituality that we so thoughtlessly and shamelessly destroy today."[23]

Precolonial life was idealized: its shadows—disease, hunger, brutality, and the nightmare quality of myth—were disregarded. Where the imperialist viewed the primitive as a beast of burden, Nolde saw the savage as the incarnation of what is primordially human. Given the context, perhaps, that can be seen as step in the right direction. But still, Nolde carried out the critique of imperialism from the standpoint of imperialism itself. His infatuation with the primitive was connected to his spiritualism. Like many other expressionists, he confronted rationalism and materialism with vague yearnings after God and salvation. Nolde was not concerned with the ritualistic trappings of formal religion. Instead, he wished to experience the "essential" quality of religious life.[24] Nolde sought transcendence, exaltation, and mystical unity with God. These desires fuel his great religious paintings of 1909–11. The ability of the simple man to experience the sublime, the moment of exaltation, was what Nolde sought to depict, and in so doing, he broke with the Christian tradition of religious representation. His faith in an experiential foundation, or ground, for religious experience enabled him to blend Norse fairy tales, exotic rituals, and Biblical settings. Magnificent works such as the *The Last Supper* (1909), *Maria Aegyptica* (1910), and *The Entombment* (1915) fuse ecstatic exoticism with the sobriety of the Gothic. Nolde put the matter quite succinctly when he wrote, "I believe in the religion above religions."

Two traditions come into play. The first is that of Die Brücke, whose major artists such as Ernst Kirchner and Erich Heckel looked back to Grünewald and El Greco. From these artists, as well as from their acquaintance with nonwestern art, the Brücke painters took their inspiration for simplicity and the linear distortion of reality. The severity of their woodcuts are important in this respect, but no more so than their use of planes in pictorial compositions and the stark expressive quality of their figures. In 1906 Nolde was invited to join Die Brücke, and he worked with its members for about six months. He quit when, rightly or wrongly, he felt pressured to conform to its artistic style, collective practice, and discipline.[25] The other tradition is

that of the postimpressionists, including Vincent Van Gogh, Paul Gauguin, Edvard Munch, and James Ensor. Nolde always viewed Van Gogh and Gauguin, in a line descending from Edouard Manet, as the dynamic strain within French art that opposed the sweet and sentimental works of Pierre Renoir, Monet, and other impressionists. The immediacy of their vision and their developing emphasis on color impressed Nolde. Thus *The Last Supper* (1909) and *The Golden Calf* (1910) are reduced to a few color planes in which the colors balance one another to render a uniform effect.

In *The Last Supper* the sense of a mass crowding around the master's table emphasizes Christ's spirituality lifting Him beyond the flesh. Like *Doubting Thomas* (1911–12), this work fuses the Gothic and the ecstatic in an almost theatrical moment of revelatory self-knowledge. *The Golden Calf*, meanwhile, evidences what would become Nolde's trademark, the free play of dynamic color, which serves as the "ground."[26] In *Candle Dancers* (1912), the figures are what Max Sauerlandt termed "puppets come alive," activated by an inner frenzy. Other religious paintings depict the inanimate transfigured into the spiritual by light-giving colors that only render starker a set of characters frozen in their revelatory experience. Emphasis on the inner expression marked Nolde's work in the years prior to the First World War. The spirit is pitted against the body in some of these works, and this demarcation is symbolized in Nolde's use of the mask. The distorted faces seem similar in his religious paintings. But they are inflamed by an inner energy, radiating beyond the body, which is crystallized as a glowing mask. Behind the mask is the singularity of the character's experience. But the mask becomes the bridge to the audience, which can intuit the hidden feelings—and identify with them. Nolde believed that the absolute and universal ground of ecstatic revelation makes such an intuition possible. His friend Sauerlandt noted shrewdly that "from the beginning what made the modern artist in Nolde take these wild grotesques so deeply seriously is the mystical power of feeling that leads, in the best of these carvings, to a baroque intensification of expression far beyond any banal form of reality, an intensification that touches something common to all mankind, beyond any individual connection."[27]

In spite of Nolde's self-proclaimed artistic nationalism and reactionary politics, his artistry derives from his cosmopolitan sensitivity to the most diverse cultural traditions. He saw himself as unifying a constellation of mutually exclusive artistic approaches and engaging in a revolutionary use of color. Yet his "religion above all religions" was an illusion from the beginning. His revelatory source of unity provided not individuality but individuation.

His characters are usually left languishing in a frozen moment. The fulfill-
ment of individuality demands its abandonment, and the feeling of singular-
ity involves its loss. The Nazis played this existential con game to much bet-
ter effect. Nevertheless, if reactionary and protofascistic elements pervaded
Nolde's work, why should the Nazis then have condemned it?

## Dangerous Liaisons

From the totalitarian point of view it is not enough to espouse certain
themes or oppose certain enemies. Advocacy and attacks must be under-
taken in the right way. To make clear the normative ideals and political pol-
icies of their new *Reich*, and to satisfy the tastes of the philistine, the Nazis
embraced kitsch and "heroic," or pseudoclassical, styles of painting. Nolde's
work militated against all of this. He was a modernist who employed dis-
tortion and primary colors, and who highlighted decidedly nonclassical
themes and emotions. His work only indirectly accommodated Nazi values;
it never preoccupied itself with any particular political line, and its depic-
tion of anguish and frenzy could only embarrass or alienate what the Nazis
saw as a healthy and contented Volk. Nolde's autobiography also showed
little concern with politics, and his cosmopolitan employment of the most
diverse cultural sources surely irked the Nazis. As regards his support for
them, indeed, the confusion was all on Nolde's part. He misunderstood
them and the value of his art to them. What attracted him to the totalitar-
ians? Nolde was parochial and fearful of how modernity was destroying the
world he loved. Nolde also probably identified the blood and soil rhetoric
of the Nazis with his own half-baked ideas and his hatred for the impres-
sionist establishment in Germany.

Certain Jews were involved. Ongoing battles with Max Liebermann,
Paul Cassirer, and other stalwarts of the Berlin Secession of 1910 led Nol-
de to title the third volume of his autobiography *Jahre der Kämpfe* (Years
of Struggle) in 1934. The reference to Adolf Hitler's 1925 work *Mein Kampf*
(My Struggle) is obvious. Attempts to protect Nolde from accusations of
anti-Semitism are pointless. It doesn't matter whether he had a few Jew-
ish friends or painted Christ and his disciples as Jews. His paintings mostly
depict Jews as cunning, dirty pagans and as the scourge of Christ. *Jahre der
Kämpfe* calls for keeping the races separate, warns against miscegenation,
and treats the "foreign" and "Jewish" influence on German art with an irra-
tional contempt. Oskar Schlemmer, an important painter in his own right,
noted in a 1935 diary entry, "Just read Nolde's *Jahre der Kampfe . . . he is*

*the* German artist whom the National Socialists would make their standard bearer, if they knew what they were doing."[28]

Nolde was an anti-Semite. He believed in German art and blood and soil.[29] But that was not enough for the Nazis; his paintings were not what they wanted. Goebbels and his friends liked the traditional forms of genre painting. They also had no use for complex themes. The Jew had to be painted black and the Aryan white. Art was ultimately seen by the Nazis as an exercise in propaganda. But Nolde's use of distortion and complex foregrounding in his depiction of the Jew, though often cruel and stupid, undercut the possibility of unambiguously identifying him with absolute evil. His paintings were not the stuff of which the Volk was made. Nolde liked to note the admiring comments of simple townsfolk on his works. But his art was not created to suit the tastes of the provincial, the peasant, the petty bourgeois, or the cultural philistine. His *Homewrecker* (1911) depicts the "slut" as the most honorable personage in the painting, while his *Maria Aegyptica in the Sailor's Tavern of Alexandria* (1912) is an assault on hypocritical religious morals through the depiction of crude sexuality. While the Nazis were on the rise as a pseudorevolutionary movement, artists like Nolde and Benn were useful in terms of their antibourgeois stance and the climate of opinion that their works helped to create. Once the Nazis were in power, however, these radical painters lost their utility. The Nazis knew whom they were dealing with. Goebbels and the boys must have smiled contemptuously at this woolly-headed idealist—what the Germans call a *Schwaermer*—with his strange characters, fabulous colors, and imaginative power, who had so completely misunderstood their enterprise.

Nolde wished to break with tradition, but the Nazis did him one better. They were experts at transforming traditions by taking works and symbols out of context: it is no accident that they left Goethe's oak tree in the middle of Buchenwald. They did what they wished—might constituted right—but allowing unfettered creativity, even to one of their own, was another story. Insofar as Nolde's work generates new perceptions and aesthetic possibilities, and to the degree that it transfigures the past and highlights the individual's experience, in their own terms the Nazis were right in viewing him as "decadent" and "degenerate." When Nolde wrote a letter to Goebbels protesting his inclusion in the Degenerate Art Exhibition of 1937 and the withdrawal of his right to paint, there was no reply.[30]

None of this makes Nolde a martyr. That he was hounded to abstain from painting is unfortunate. But others were forced into exile or died in concentration camps. His persecution, which has become part of the myth

surrounding him, should be put into perspective. That the Nazis turned on him does not excuse his own assault on civilization in the name of the barbaric, the irrational, the intuitive, and his own version of blood and soil. The regeneration of the German Volk came about, but not in the way that Nolde liked. So, like Benn and others, Nolde embarked on an "inner emigration." There, in his little cottage in Seebull, he produced in secret the wonderful watercolors, fantastic monsters, and gouaches with their superimposed images that constitute his "unpainted paintings." The color surfaces are more striking than ever in these works. In *Great Poppy* (1942), for example, the object of the work becomes the color red. In paintings such as this one, and in the finest of the watercolors, Nolde is still grasping for the absolute, the spirit of nature and man, but this time through the final, unobstructed purity of color. In "Marginal Notes," from his book *Unpainted Pictures*, he emphasizes his attempts to develop forms from color alone. Nolde believed that every color harbors its own "soul," and that color serves as the ground of painting from which all its other attributes derive.

Nolde painted feverishly during the war: there are 1,300 unpainted paintings. As the prospect of a German defeat became ever more real, he must have felt despair and fear in the isolated village of Seebull. Monsters, emanations deriving from the depths, and strange shapes appear in some works. Others evidence new expressions of religiosity along with a desire for forgiveness and friendship. Yet the old ideological delusions remain. The mysticism, the irrationalism, the reliance on instinct, the attempt to merge with the dynamic force that supposedly sways nature and man— Nolde still believed it all. There is something tragic in the likelihood that— at the moment of his greatest achievement—he had learned nothing either from the past or from his own persecution. Truly, in a way that his friend Max Sauerlandt would never have understood, Nolde—a great artist and perhaps a greater fool—"is who he was and was who he is."[31]

# 7

## Modernism, Surrealism, and the Political Imaginary

*The imagination is perhaps about to reclaim its rights.*

—André Breton

Surrealism had the longest tenure of any avant-garde movement, and its members were arguably the most "political."[1] It emerged on the heels of World War I, when André Breton founded his first journal, *Literature*, and brought together a number of figures who had mostly come to know each other during the war years. They included Louis Aragon, Marc Chagall, Marcel Duchamp, Paul Éluard, Max Ernst, René Magritte, Francis Picabia, Pablo Picasso, Phillippe Soupault, Yves Tanguey, and Tristan Tzara. Some were "absolute" surrealists and others were merely associated with the movement, which lasted into the 1950s. The intervening years saw a shift from the original concern with the purely intuitive to a somewhat more rational—and perhaps more political—standpoint. But there were always journals intent on providing philosophical justification for surrealist artistic experiments, including *La Révolution Surréaliste* and *Le Surréalisme au Service de la Révolution*. These were also edited by Breton. His novel *Nadja* (1928) is in this regard far less important than his countless essays, speeches, and manifestoes. Other writers offered important pronouncements and views about the character, interests, and politics of surrealism. Nevertheless, André Breton was its leading light, and he offered what might be termed the master narrative of the movement.[2]

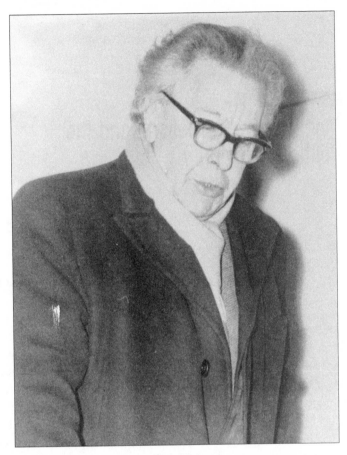

**FIGURE 7.1**   André Breton (1962). Photo: Associated Press.

*Courtesy of the Library of Congress, Music Division, LC- USZ62–52575*

No other modernist trend had a theorist as intellectually sophisticated or an organizer quite as talented as Breton. No other was as international in its reach and as total in its confrontation with reality. No other fused psychoanalysis and proletarian revolution. No other was so blatant in its embrace of free association and "automatic writing." No other would so use the audience to complete the work of art. There was no looking back to the past, as with the expressionists, and little of the macho rhetoric of the futurists. Surrealists prized individualism and rebellion—and no other movement would prove so commercially successful in promoting its luminaries.

The surrealists wanted to change the world, and they did. At the same time, however, the world changed them. The question is whether their aesthetic outlook and cultural production were decisive in shaping their political worldview—or whether, beyond the inflated philosophical claims and ongoing esoteric qualifications, the connection between them is more indirect and elusive.

## Influences

Surrealism was fueled by a romantic impulse. It emphasized the new against the dictates of tradition, the intensity of lived experience against passive contemplation, subjectivity against the consensually real, and the imagination against the instrumentally rational. Solidarity was understood as an inner bond with the oppressed. Surrealism took shape around 1924. Its influences reach back to Baudelaire, Rimbaud, Alfred Jarry, and Guillaume Apollinaire.[3] Ultimately, however, the surrealist enterprise rests on one basic claim: "To each according to his desire!" Intent on heightening human powers and making each person cognizant of his or her repressed feelings, the surrealists appropriated cubism and Dada to explode the established habits and perceptions of everyday life. But the latter was surely closer to their heart. Cubism was already established when surrealism was born, and that made it a target. Breton surely smiled at Picabia's 1920 Dadaist "portrait" of Cézanne as a montage of a stuffed monkey. The surrealists also had no interest in reducing reality to its elemental geometric forms. But they did employ an invention of Picasso and Braque's: the collage composed from different shards of reality. The cubist collage elicited a reconstruction of the canvas—and the meaning of the work. The arbitrarily constructed character of everyday life was thereby rendered manifest. The associative moment within the cubist collage ultimately led the surrealists to look beyond the real—not simply "above" it, as the word *sur* literally implies. They were concerned with deepening our understanding of what comprises reality. Breton called for the "great refusal" of what is taken for existence in order to evoke and cultivate the dream element within the experience of everyday life. In jokes, slips of the tongue, and unpremeditated actions surrealists insisted that hopes for liberation were protected from the "reality principle." Even if the surrealists ultimately rejected the clinical aspect of psychoanalysis, it only makes sense that they should have been led to Freud and his *Interpretation of Dreams* (1899).

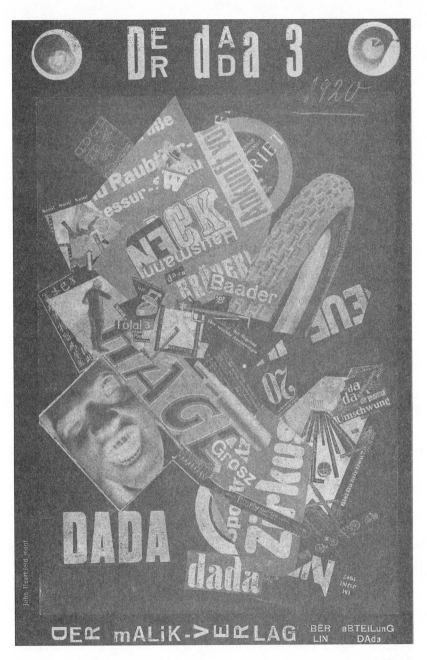

**FIGURE 7.2** Cover of *Der Dada* 3 (1920) by John Heartfield. © 2012 Artists Rights Society (ARS), New York / VG Bild-Kunst, Bonn. Ryerson and Burnham Libraries, The Art Institute of Chicago. Photography © The Art Institute of Chicago.

But first there was Dada. Committed to anti-art, addicted to the outrageous and the satirical, Dada began at the Cabaret Voltaire in Zurich in 1916. Switzerland was neutral during World War I, and Zurich's geographic proximity to all the European combatants made it a center for dissidents and resisters of all sorts. Lenin lived across the street from the Cabaret Voltaire, where after learning of the capitulation to the war fever by international social democracy, he suffered a near breakdown and then began a close study of Hegel.[4] Famous writers preaching pacifism like Hermann Hesse, Romain Rolland, and Stefan Zweig were in Zurich as well. But they were already established. The young and unknown artists with a radical temperament were brought together by Hugo Ball, who invented the "sound poem," and Emmy Hennings. These new artists were of different nationalities: Tristan Tzara and Marcel Janco came from Romania, Richard Hülsenbeck from Germany, Jean Arp from Alsace—and there were many more. As Lenin and his few comrades ruminated on revolution, and pacifists sought to dampen chauvinist attitudes, the young rebels blended these two positions with bohemian contempt for the civilization that had produced the conflict.

"Dada" was a meaningless word supposedly picked arbitrarily from a children's dictionary either by Tzara, Arp, or Ball.[5] The term was meant to reflect the meaninglessness of language and rationality in a world that had become meaningless—and that needed this meaninglessness thrown in its face. The Dadaists complied. Its founders had as little interest in psychoanalysis as they did in historical materialism or anything systematic. They instead looked for inspiration to poets like Arthur Rimbaud and Paul Verlaine—whose relationship was satirized in Bertolt Brecht's first play, *Baal* (1918)—and Apollinaire, who sought a language of immediacy devoid of syntax, punctuation, adjectives, or embellishment. But what made the Dadaists famous was a kind of performance aesthetic that poured scorn on established aesthetic conventions as well as the audience. Entering such a performance might involve walking through a huge urinal only to find a Dadaist "poet" declaiming poetry composed of nonsense words that were arbitrarily strung together, while another poet talked loudly over him. Unscripted Dadaist "dance" might follow in concert with improvised Dadaist "music" that was little more than noise or the thumping of a drum. All of this constituted a new kind of performance art predicated on shock and immediacy—and spiced with what Tristan Tzara termed "Dadaist disgust" for the established order of life and art.

Dada mirrored a world gone mad with its own madness: its pranks, jokes, irony, playful barbarism, rejection of society, celebratory individualism, and

expansion of the material and methods employed by the visual arts all served its protest (and served to define the political limits of that protest). The aesthetic violence directed by Dada against art was meant to yield anti-art. Defined by what it opposed, indeed, anti-art was soon bound for the museum. Certain members of the movement were explicitly political from the beginning, such as George Grosz and John Heartfield. Few of the Dadaists, however, were ever connected with pacifist or even revolutionary elements of the international labor movement.[6] Few were particularly concerned with the important antiwar gatherings that took place at Zimmerwald and Kienthal in 1915–16, let alone the postwar proletarian rebellions that rocked Europe in the aftermath of World War I.[7] Dada was uninterested in organized political engagement. Its resistance was bohemian in style, vague in purpose, and without any connection to the masses. Indignation rather than resistance best defines the sensibility of the Dadaist, which emerged just as trench warfare was turning men into materiel and individual battles were costing the lives of hundreds of thousands of soldiers. Civilization thus did appear at an end—and Dada celebrated its passing. Nevertheless, for better or worse, it was ultimately "civilization" that lived and Dada that died.

Surrealism was Dada's heir. The new movement was more conscious of its aesthetic influences and more explicit in its political posture. The basic idea of surrealism is simple enough, and that defines its power. Everyday life or the habitual reality we experience is, according to Breton, a barrier to the expression of those manifold and unspoken desires encoded in dreams. Art should bridge the antithetical relation between reality and the dream—fuse them in the name of a new and superior reality, or the "surreal." What Walter Benjamin termed the "poverty of the interior" becomes the target of surrealism and its attempt to transform everyday life.[8] Evoking the consciousness of that poverty—or, to use another famous phrase from Benjamin, winning "the energies of intoxication for the revolution"—thus becomes the purpose of the surrealist enterprise.[9]

Creating the associative conditions for the exercise of the imagination—or, better, producing a kind of twilight or daydream—was seen as breaking down the wall between artist and audience. The audience becomes an integral part of the artwork. Montage is crucial in destroying the barrier between the normal and the abnormal. The juxtaposition of dissimilar objects in, say, the *Lobster Telephone* (1936) of Dalí does not provide a work whose meaning can be objectively determined by individual members of the audience. There is, in short, no "message." Shock may inspire viewers, but the signification each gives to the montage will differ. Insofar as this

BULLETIN INTERNATIONAL
DU
SURRÉALISME

Nº 3                                    Publié à Bruxelles
par   le   Groupe   surréaliste   en   Belgique
20 AOUT 1935                         PRIX : 1,50 Fr.

LA GACHEUSE

SOMMAIRE
1) LE COUTEAU DANS LA PLAIE.
2) André BRETON : Discours au Congrès des Ecrivains pour la défense de la Culture
Illustrations de René MAGRITTE et Max SERVAIS

**FIGURE 7.3**  *La Gacheuse* on the cover of *Bulletin International du Surréalisme* (August 20, 1935) by René Magritte. © 2012 C. Herscovici, London / Artists Rights Society (ARS), New York.

multiplication of significations is achieved, each member of the audience will complete the artwork in his or her own way. This purpose underpins automatic writing. Many might collaborate on a surrealist novel: one writer stays up all night, exists in the twilight, and lets the unconscious dictate his thoughts, while the next writer prepares to take up the pen once his friend collapses from exhaustion. The point is to subvert the idea that writing (or art) is reserved for the "writer" or the "artist." With automatic writing, indeed, anyone can write and everyone is an artist. Syntax, punctuation, and coherence—let alone narrative structure—are unnecessary. "In this regard, the will to open the floodgates doubtless will remain the generative idea of surrealism."[10]

The artist liberates the unconscious, creates the proper ambience, and thereby provides a free association of thoughts whose connection is determined by the reader in variable fashion from one moment to another.[11] Coincidence, chance, and the arbitrary thus become enduring themes of surrealist art and literature. Things will no longer be what they seem. Cartoons like Walt Disney's *Fantasia* (1940) can make mushrooms dance. Hashish, heroin, and opium can aid the creative process. Everything must be rendered transient and the objects of everyday life open to interpretation and reinterpretation. Breton made this clear when he wrote that "the earth, draped in its verdant cloak[,] makes as little impression upon me as a ghost. It is living and ceasing to live that are imaginary solutions. Existence is elsewhere."[12] Only from the perspective of "elsewhere" can the surrealist overthrow the established habits and perceptions of everyday life.[13] And such a task demands a concern with the "alienation of sensation," an obsession with "objective chance," and the use of "black humor."[14] Aesthetically expressing these concerns fosters a new solidarity between the artist and the audience, in which, following Lautreamont, "poetry must be made by all, not by one." Whether any of this has anything to do with dialectics, however, is another matter—one that deserves scrutiny.

## Interlude—The Myth of the Surrealist Dialectic

None of the surrealists, ultimately, had anything more than cursory knowledge of the dialectical tradition. Though Breton first published Lenin's *Philosophical Notebooks*, which highlighted the importance of Hegel for Marxism, Hegel had no influence on French intellectual and cultural life prior to World War I. Genuine intellectual interest in Hegel, indeed, began only during the 1930s when Alexandre Kojève—Wassily Kandinsky's cous-

in—gave his legendary lectures on Hegel's *Phenomenology of Mind* (1807).[15] The surrealists gained their knowledge about dialectics neither from the classroom nor from the political struggle; they learned about it in cafés. Unlike Hegel and Marx, the surrealists never considered freedom as the insight into necessity, and they had no use for basic dialectical categories like mediation and determination. Breton was content to insist on the mix, or twilight, that exists between the conscious and the unconscious, the real and the imaginative, the aesthetic and the political. Thus he wrote,

> Everything leads to the belief that there exists a certain point of mind at which life and death, the real and the imaginary, the past and the future, the communicable and the incommunicable, the high and the low, are not perceived as contradictions. It would be vain to attribute to surrealism any other motive than the hope of determining this point. It is clear, moreover[,] that it would be absurd to ascribe to surrealism either a purely destructive or a purely constructive character—the point at issue being precisely this: that construction and destruction can no longer be brandished against each other.[16]

Surrealism called for total revolution. It highlighted the blending of the real and the surreal. Critical consciousness requires something more, however, than the evocation of the surrealist twilight or insight into "the crisis of the object." The dialectical method is not intent on making reality more arbitrary in its associative possibilities, but of (thematically) rendering it more transparent and comprehensible. For Hegel and Marx, indeed, it was a matter of determining how the object was constituted in its historical specificity and how its workings might be rendered *consensually* visible.[17] Admittedly, Breton wished to move beyond philosophy and stated openly that "at the point where [the surrealists] found it, *the dialectical method in its Hegelian form was inapplicable.*"[18] But he elided the question of whether surrealism and the dialectical tradition began with mutually exclusive assumptions. He simply insisted that surrealism was the application of dialectical materialism to art.

Most critics took him at his word. Herbert Read, among the most famous English art critics of the twentieth century, saw surrealism as dialectically bridging the gap between aesthetic radicalism and a socialist outlook. A staunch defender of modernism and an anarchist who was later knighted, he tried to fit surrealism into a conventional rationalist tradition with which it had nothing in common. Breton and his friends were always explicit in their rejection of reason in any guise related to systems

or methodological coherence.[19] Read's identification of reality-dream and "supra-reality" with the famous thesis-antithesis-synthesis model offered by Hegel and Marx is also mechanical and misleading.[20] The same holds for using the "romantic principle," the primacy of imagination, as a form of agency. English philosophers bred in the analytic and empiricist traditions have always had a difficult time with Hegel and the idealist interpretation of Marx. Neither Walter Benjamin nor T. W. Adorno, however, had any such excuse. Both were deeply committed to the modernist enterprise, and they sought to justify surrealism in the same terms that they used to justify their own work.

Benjamin, in his 1929 "Surrealism" essay, praised Breton and his friends for providing the "dialectical optic that perceives the everyday as impenetrable and the impenetrable as the everyday." Benjamin was struck by the way surrealist novels fastened onto seemingly insignificant objects and, through montage, created an overarching "atmosphere" that generated a reinvigorated sense of everyday life. He later employed similar techniques in his vast and unfinished *Arcades Project* (1927–40), which sought to illuminate modernity by juxtaposing cited texts without authorial comment. Benjamin praised the surrealists for generating the kind of "intoxication" that might fuel revolutionary politics. Adorno was more skeptical. He shrewdly noted that surrealist constructions are merely analogous to dreams, and that people do not dream the way surrealists seem to think they do. What Adorno rightfully admired was how surrealism suspends conventional logic and "rules of the game of empirical evidence" in favor of a shattering—a regrouping and dissolution of objects. He was content to note that surrealist images merely express the "dialectic of subjective freedom in a situation of objective un-freedom."[21]

But this has nothing to do with political practice. Breton would surely have condemned such a metaphysical view of resistance. He wanted the total revolution and he wanted politics too. Neither Hegel nor Marx, however, believed that "existence is elsewhere" or that the struggle for liberation could be furthered by some indeterminate juxtaposition of dream and reality. They knew that the denial of necessity is the denial of politics—and, thus, of the dialectic.

## The Political Imaginary

Expressionism and Dada made way for the New Sobriety around 1921 in Germany. Utopianism and pathos, wild rebellion and satirical lunacy, made

way for a colder and more reflective outlook. Most point to the devastating impact of World War I, the improved economic situation in the aftermath of terrible inflation, and the calm that followed the failure of extremist uprisings. But France suffered as much, if not more, than any other nation from the Great War: the bloodiest battles were fought on its territory, one in four families suffered a death at the front, and victory was as costly as defeat. French economic life was also devastated by the war, and victory did little for the reputation of the Third Republic. Postwar protests were relatively tame in France, but like Germany, it saw the Communist Party emerge as a significant minority within its labor movement. Both countries experienced an economic recovery around 1924, seeming stability, and the return of the working class to its social democratic roots, or what Léon Blum termed "the old house." A movement like the New Sobriety should have taken over in France. But French bohemian and anarchist traditions changed the equation. Surrealism, instead, proved triumphant.

Imperial Berlin was not Paris; Germany lacked a bohemian tradition that in France was idealized in Henri Murger's *Scenes of Bohemian Life* (1847)—which served as the basis for Giaccomo Puccini's *La Bohème* (1896)—and extended over Georges Sand and Baudelaire to Rimbaud, Verlaine, and Apollinaire. Anarchism also had an importance in France that it lacked in Germany, whose socialist movement was the organizational model for Europe. The expulsion of a tiny, rambunctious minority known as "The Young Ones" from the German Social Democratic Party in 1894 deprived anarchism of any real political influence. With its emphasis on nonparticipation in parliamentary politics, by contrast, anarchist syndicalism had great power in the French labor unions, and many radicals were sympathetic to individual acts of terror, or what was known as "the propaganda of the deed." The anarchist tradition in France stretched back beyond the Paris Commune of 1871 to Gracchus Babeuf and the Conspiracy of Equals in 1796. Bohemianism and anarchism set the stage for surrealism and its overarching contestation of reality.

"Surrealism," wrote Breton, "asserts our absolute *non-conformism* so clearly that there can be no question of claiming it as a witness when the world comes up for trial."[22] The ultimate expression of nonconformism, of course, is the gratuitous act. Breton made use of the idea to *épater le bourgeois* with his notorious claims that "the perfect surrealist act would be to go into a crowd and start shooting" and that his ultimate desire was to "blow up" the Arc de Triomphe "after burying it in a mountain of manure." Bohemian radicalism fueled the surrealist attempt to pit the pleasure principle against the

reality principle. French anarchism highlighted the radical empowerment of the proletariat through unions and the general strike; it sought to abolish the state and break society's longstanding reactionary attachments to nationalism, religion, and militarism. Surrealism blended these two currents in a new theory of total revolution.

Breton and his friends openly attacked the rising chauvinism of the French Right in their "Open Letter to Paul Claudel" in 1925 and staged a mock trial for Maurice Barrès, a founder of the protofascist *L'Action francaise* and a famous writer. There is no reason to doubt that Breton joined the Communist Party in 1927 in a quixotic and romantic attempt to support the fading "Workers' Opposition" that stood for proletarian democracy and artistic freedom during the radical decline in Trotsky's influence and Stalin's tightening of the reins of power in the Soviet Union. Breton, along with a minority of his surrealist friends such as Benjamin Péret and Gérard Rosenthal, remained not merely subversive of bourgeois culture but also of all attempts to impose a proletarian art.[23] Identification with the outsider and the heroic underdog obviously played a role in all of this. Trotsky remained the surrealists' political muse.[24] Breton endorsed virtually all of his political choices: his pluralistic position on art, his call for a "united front" in the 1920s, his identification with the strikes that greeted the Popular Front of 1936 and opposition to its "continuation of politics as usual," his support for the anticommunist Unified Marxist Workers Party (POUM) and the anarchists during the Spanish Civil War,[25] his contempt for the Moscow Trials,[26] his view of the Soviet Union as a "degenerate workers' state," his loyalty to the original vision of 1917, and his commitment to international revolution.[27]

These are positions on which it is possible to agree or disagree. None of them, however, has anything intrinsically to do with surrealism. Supporters of Trotsky came with the most diverse aesthetic and political views. Many of the original surrealists like Aragon, Éluard, and Tzara (it is worth noting) ultimately renounced their bohemian past and became dogmatic adherents of the Communist Party. But there is a way in which the surrealists were always uneasy about their connection to political organizations, and the organizations were also uneasy about them. Aside from those who were abject in their surrender, in fact, there is a general truth to what Sartre said of Picasso with respect to his association with the Communist Party in the 1930s: "The party can neither swallow him down nor vomit him up." The Comintern understood the public value of famous artists like Picasso, who during the 1930s and '40s tempered the more radical surrealist use of

montage and old ideas about the unconscious and dreams in works like *Guernica* (1939). Indeed, the title serves as an avenue into the painting and sets the context for the feelings it evokes.[28]

Surrealism was aesthetically innovative, intellectually daring, and scandalous. But there is nothing intrinsically revolutionary or even political about any of this. Acting as the guilty conscience of society can be achieved through the naturalism of Émile Zola, Upton Sinclair, and Aleksander Solzhenitsyn just as easily—and perhaps more easily—than through surrealism. Breton was candid in noting that surrealism explores "the other side of the real." His own collages, montages, and " poem objects" highlight the "uninterrupted becoming of any object." They don't illuminate real conflicts of ideological and material interest between competing social and political forces. Surrealism interrogates the latent content of everyday life, questions the "givenness" of things, and expresses the disorientation that modernity produced in the aftermath of World War I. Dalí employed a host of innovative techniques like montage for just this reason in his most famous paintings as well as in the dream sequences he composed for Alfred Hitchcock in his commercial film *Spellbound* (1945).[29]

None of this had anything to do with politics. Surrealism generated a sense of fun and wonder in the audience. Its artists still evoke a sense of discomfort with reality and the feeling that things can be different. Surrealism may thus foster a psychological or subterranean desire for change. All this, however, requires no further justification. Neither a dialectical foundation nor a revolutionary politics is necessary in order to exercise the imagination. Surrealist art offers its own reward.

## Beyond Europe

> *Do you wish to see with your own eye, the hidden springs of the social revolution? Look at the frescoes of Rivera. Do you wish to know what revolutionary art is like? Look at the frescoes of Rivera.*
>
> —Leon Trotsky

Surrealism is still associated with "the great refusal." Herbert Marcuse and other cultural radicals of the 1960s embraced the term, originally coined by Breton: it sealed the identification of nonconformism with politics. Through the lens of the cult-like popularity of the situationists,[30] whose idea of politics rested on disrupting and reinventing the "spectacle" of everyday life, the surrealists only gained further revolutionary credence. Forgotten

were other artistic groups, whose members often overlapped with the surrealists in the bohemian cafés of Paris during the 1920s, and who understood anarchism and the revolutionary political character of their art very differently. That is especially the case with Latin American painters of the 1920s, who while deeply affected by indigenous sources like Jorge Posada, were also influenced by Cézanne and his (politically quiescent) cubist followers. The most politically important of them was Diego Rivera. But his wife, Frieda Kahlo, painted striking portraits and scenes of everyday life. David Alfara Siqueiros produced ominous propaganda paintings and left a host of unfinished murals. There was also José Clemente Orozco, whose singular works evidence not only a frustrated Christian vision of redemption but also a deep attachment to the fight of the oppressed and the experience of oppression in Mexico.

These artists, too, had only the most superficial knowledge of the political conflicts raging in the Communist International during the interwar period, never mind the theories of Marx, Lenin, or Trotsky.[31] Most drifted in and out of the Communist Party, and Siqueiros even played a prominent role in a plot to assassinate Trotsky. Others like Kahlo and Rivera, who became friendly with Breton, associated themselves with the bitter rival of Stalin who would become exiled in Mexico. Neither painter was obsessed with immediacy or the shocking effect for its own sake, as in the case of, say, the famous cutting of the eye in the film *The Andalusian Dog* (1929) by Luis Bunuel and Salvador Dalí. Conscious of themselves as "revolutionary artists" (in the dual meaning of the term) and banding together during the heroic years of the Russian Revolution, Rivera and his comrades were adamant in their rejection of both abstraction as an end unto itself—the pathos so often associated with expressionism—and any doctrinaire form of socialist realism. They expressed their politics and their dreams in their work (often using surrealist techniques), even as they blended unique mixtures of the personal and the political in a painterly anticipation of what would become known as "magic realism." This was especially the case with Kahlo, but also with Rivera, who introduced some of "the most important developments in murals since the Renaissance."[32]

Reinventing the fresco and evidencing a genuine desire to communicate the struggle of the exploited and disenfranchised, Rivera wished to "paint the revolution" on the walls of world capitals. He showed the constraints, limits, and explosive possibilities of change in the 124 panels decorating the Education Building and the National Palace in Mexico City, as well as those in the Agricultural School at Chiapingo.[33] *The Earth Oppressed* (1925), *Night*

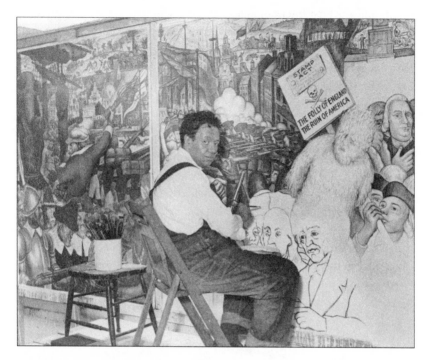

FIGURE 7.4   Diego Rivera, seated in front of mural depicting American "class struggle" (1933). *World-Telegram* photo by Ed Palumbo.

*Courtesy of the Library of Congress, Prints & Photographs Division, New York World-Telegram and the Sun Newspaper Photograph Collection, LC-USZ62-111157*

*of the Rich* (1926), and *Night of the Poor* (1926) were anything but beautiful, and critics coined a new word, *feismo* (uglyism), to describe them.[34] Works like these, precisely because they do not translate into book illustrations or wall posters, evidence the singularity of painting for a new age. They are not painted for the singular buyer or intended for the museum or private collection. They are painted so that anyone can see them, and insofar as they exist on public walls or public buildings, they alter the experience of everyday life. They are not self-referential in their revolutionary aspirations, but portray a lived collective experience through an individual vision. With his wonderful murals, Rivera brings about an encounter with history, fosters an anti-imperialist sensibility, and—perhaps above all—builds a sense of radical political tradition.

Rivera's dreams always enter the story and fashion the vision. But the associations are never free; they always have an objective referent: the Paris

Commune, the First International, or the Mexican struggles of peasant revolutionaries and the betrayal of their hopes. Rivera's magnificent historico-allegorical mural of Mexican history that began with *Before the Conquest* soon enough resulted in "not a painting but a world on a wall [that] became a treasure mine of iconography . . . [and that] an archaeologist of the future could use to learn more of Mexico, actual and legendary, than any other single monument in history would reveal of any other civilization."[35] In a somewhat more modest vein Rivera's *Communist Unity Panel* (1933)—destroyed at the behest of the buyers after it was commissioned to adorn Radio City Music Hall in New York—creates an objective referent for onlookers by depicting the great political figures of an international movement, including "Stalin the Executioner." Rivera and his comrades were concerned with the concrete hopes that still fuel the struggle of the exploited and the disenfranchised. Their artistry carries forward not only the dialectical legacy of Hegel and Marx but the most genuinely political legacy of modernism as well.

# 8

## Modernism Changes the World

### THE RUSSIAN AVANT-GARDE AND THE REVOLUTION

Amid the trenches of World War I, the broken promises of social democracy and liberalism, the crumbling empires, and the war profiteers there arose what was called the "wind from the East." The Russian Revolution, it was believed, would cleanse the putrid air and sweep away the rubble of a doddering civilization. The Bolsheviks had dared to do what other Marxists had only talked about: make the revolution. No one mourned for the czar or the Provisional Government of Alexander Kerensky, which lacked the courage to withdraw from a war that had obviously been lost or confront a burgeoning counterrevolution. Lenin had taken a more radical stand. He had opposed World War I from the beginning, insisted on transforming it into an international class war, called for peace at any price, and finally, in keeping with the image of the Paris Commune of 1871, put forward in *State and Revolution* (1918) the vision of "a state that is no longer a state in the proper sense of the word." His ideal was seemingly vindicated in 1917: the fight for utopia was underway.

Only three years earlier, Lenin had been in Zurich reading Hegel, the Bolsheviks were a minor sect, and all revolutionary hopes had seemingly been dashed. The Second International lay in tatters following the decision of its constituent social democratic parties in 1914 to support the war, in what came to be known as the "great betrayal." The twentieth century really began with the onset of World War I.[1] Ten million were killed and another twenty-five million were wounded or missing. Four empires collapsed: Austrian, German, Ottoman, and Russian. New sensibilities exploded, and revolution appeared on the agenda. Lenin and his Bolsheviks emerged from the conflict as far more than a sect. They inspired their devastated nation

to endure an economic blockade, and they proved victorious in a civil war waged against counterrevolutionary forces once aligned with the old monarchy and supported by an international military contingent culled from previously warring European nations. Their example sparked an international wave of uprisings that, over the next ten years, would engulf not only much of Europe but also China and other parts of the colonized world. In 1919 Lenin created a new Communist International, inspired by the desire to coordinate support for the civil war and what appeared to be a burgeoning world revolution.

Successful revolutions in Germany and other industrially advanced nations would have ended the intervention of those previously warring allies as well as support for the counterrevolution. Technological and economic aid might have lessened the burdens of underdevelopment in the Soviet Union and the growing paranoia and isolation of the new regime. International revolution was also a real possibility. Disgust with World War I had, since 1916, ignited working-class revolts in much of Europe. Especially given the brutal and retrograde character of the "Whites," many social democrats and anarchists the world over aligned themselves with the "Reds" in the civil war described so splendidly by Isaac Babel in *Red Cavalry* (1926) and Boris Pasternak in *Dr. Zhivago* (1957). So, for example, the principled Menshevik leader, Julius Martov, recognized that the revolution was "sick," but also that the Bolsheviks had significant support among the world proletariat and that the alternative might prove even more distasteful. It was the same with Rosa Luxemburg. Erich Mühsam grasped the spirit of the times when he wrote:

> The revolutionary activists of the whole world placed themselves on the side of the Russian Revolution. In Russia itself, the divisions between the various revolutionary tendencies had not yet reached fruition. A coalition of Bolsheviks and Social Revolutionaries ruled from January until March 1919. The anarchists fought . . . in common with the Red Army against the white generals of the counterrevolution. Especially abroad, in fact, the unity of all revolutionaries and the defense of the revolution assumed a near holy status. Only after the Bolsheviks succeeded in assuming power for themselves, after they began to persecute their previous allies, did it become possible even abroad to differentiate between the Revolution and the Bolshevik-Communist Party.[2]

1917 marked the *first* successful proletarian revolution, and the struggle to defend it during the bloody and barbarous civil war was imbued with

drama and heroism. The new man, or so it seemed, was no longer an aesthetic ideal but a practical possibility. An assault on the "givenness" of things and the ingrained habits of everyday life took place. Intensity, dynamism, and—above all—the unleashing of subjectivity became concrete. The Russian Revolution did not take place in an advanced capitalist society, as Marx had predicted, but in an economically underdeveloped backwater. Lenin and Trotsky might have justified their revolution by suggesting that it would occur at the "weakest link" in the world capitalist chain. But the truth is that their seizure of power constituted a palpable rejection of the logic behind Marx's "stage theory" of history. Orthodox Marxists like Karl Kautsky in *The Dictatorship of the Proletariat* (1918) insisted that revolution in a backward state without a working class majority could only result in terror. Antonio Gramsci, who would help found the Italian Communist Party, initially considered the Bolshevik seizure of power as a "revolution against *Das Kapital*."[3] The Russian Revolution was thus not the product of "iron necessity" but rather an *act of will*. This only increased the drama, even for those modernists with left-wing sensibilities who knew little about politics. Most would surely have agreed with the words of Franz Pfemfert, whose expressionist magazine, *Die Aktion*, was well known by the Russian avant-garde.

> If Bolshevism means dictatorship of a few national leaders over the revolutionary workers of all nations; if Bolshevism means: a campaign of lies by a few intellectuals against revolutionaries; if Bolshevism is bourgeois maliciousness, meanness, unscrupulous manipulation of facts for the benefit of a small clique of bosses—then, by all means, we would stand in opposition. But we understand under Bolshevism the authority of the working class, the dictatorship of the soviets, we understand under Bolshevism those soviets for which the revolutionary workers and peasants struggle, suffer, and die.[4]

Bolshevism exemplified in grand historical terms the centrality of agency by a vanguard (or avant-garde) and the utopian project in which modernists had been engaged from the start. In the heroic phase of the Russian Revolution (1918–21), it seemed that "the ceaseless quest for new solutions in the arts was neither deliberately inspired by the politicians nor yet restrained by them; it sprang rather from the impact of swift and sweeping social change on creative artists often of a somewhat manic-depressive temperament but speculative daring."[5] The transformation of everyday life did not always require succumbing to the official dogmatism. Many modernists saw in

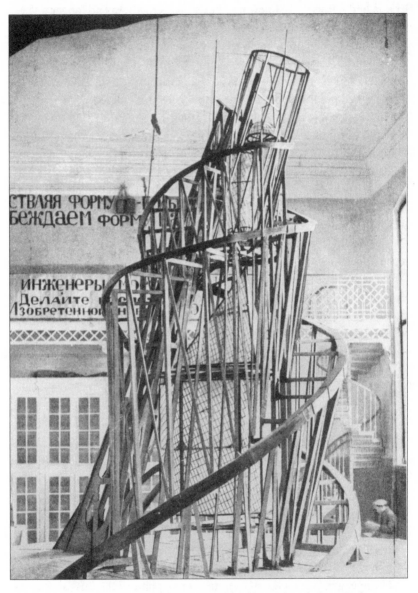

FIGURE 8.1 *Monument to the Third International* (1920) by Vladimir Tatlin.
© The Tatlin Estate. The Museum of Modern Art, New York, NY.

the revolutionary events the chance to realize the new world that their own works had anticipated prior to 1917. Enough of them joined the Communist Party. In their cultural and artistic efforts, however, the best of them were usually loyal to the idea of revolution rather than to the party as its incarnation. Their activities reflected the deeply humane aspirations of the original revolutionary undertaking, against which it would become possible to judge *critically* the grayer socialist reality. Russian futurists, constructivists, suprematists, and a myriad of other tendencies opposed what would become a growing infatuation with propaganda masquerading as art in simplistic forms that ranged from Proletkult to socialist realism. This array of modernists instead sought to create a new public sphere and a new cultural sensibility. That undertaking finds its most radical expression in Vladimir Tatlin's *Monument to the Third International.*

## The Transformation of Everyday Life

Russian modernism was shaped by a plethora of European styles.[6] Its most important representatives embraced the geometric cubism of Cézanne, the "lines of motion and the "dynamics of Speed" so important for the works of Italian futurists like Umberto Boccioni and F. T. Marinetti, and finally the distortion and nonrepresentational colorism of expressionism. Different tendencies highlighted one strain over the other. Mikhail Larionov and Natalia Goronchova, each after their own fashion, harkened back to the exaggeration and distortion of Die Brücke; Kasimir Malevich used color and line to evoke the "infinite;" and Tatlin in his *Painted Reliefs* began tightening the connection between the realms of the aesthetic and the real. Cubism, futurism, and expressionism set the stage for an assault on Russian academic painting. In combination, however, they did so in a unique way. Music, writing, painting, and film were all part of a transformative enterprise. Given the backwardness of imperial Russia, which was far greater than Italy, its avant-garde logically tended toward futurism. Russian modernists also embraced the scientific and the technological. But they had little sympathy for Marinetti's enthusiasm for war or, for that matter, his views of women.

The Russian futurists at their best showed scant regard for the exaggerated emotionalism, spiritualism, and "inner revolution" that so many of their European counterparts exhibited. They instead engaged reality critically by highlighting its repressed prospects for a new utopian order. This meant attacking the lingering feudal habits and aristocratic decadence so

beautifully illustrated by a dazzling literary tradition that stretched from Alexander Pushkin to Anton Chekhov. With the revolution came a flurry of cultural activities designed both to lift the cultural level of the masses and foster solidarity among them. The futurists were thrilled when the communists attempted to abolish money (worthless anyway following the collapse of the imperial regime), the nuclear family (seemingly eroded with millions displaced by the war), social status (meaningless in the revolutionary context), and military rank (useless given the disintegration of the old army). Russian modernists embraced the new communal forms of eating together, living together, and learning and working together. They participated in campaigns against anti-Semitism and other reactionary ideas with performances and exhibitions and innovative forms of poster art.

Old dreams imported from the European avant-garde about the new man seemed on the verge of turning into reality. In *Literature and Revolution* (1924), his defense of Russian modernism, Trotsky proclaimed that communism would ultimately "develop all the vital elements of contemporary art to the highest point. Man will become immeasurably stronger, wiser, and subtler: his body will become more harmonized, his movements more rhythmic, his voice more musical. The forms of life will become dynamically dramatic. The average human type will rise to the heights of an Aristotle, a Goethe, or a Marx, and above this ridge new peaks will rise."[7]

The heroic years of the Russian Revolution gave its artists a new sense of purpose. The avant-garde took art into the streets in ways that the radicals of 1968 could barely have imagined. They engaged in propaganda, but it was propaganda of a sort so different, so challenging, and so new that it was unlike anything ever attempted before. They turned the art museum—or, from their view, "mausoleum"—inside out. Ships, trams, fences, walls, all became what Mayakovsky termed a "living factory of the human spirit." It was a matter of transforming art into a critical yet productive social enterprise that spoke to the needs of the masses and in which they could take part. Thus, while its members lived in dire poverty, Russian modernism truly did set about fusing revolutionary art with revolutionary politics.[8] Public spectacles were organized in the form of mock tribunals and mass reenactments of famous revolutionary events like the storming of the Winter Palace, with arc lights and fabulous cubist sets and designs. Agitation boats like *The Red Star* sailed the rivers, and popular boat rides were organized with circuslike entertainments. Meanwhile, cultural trains with acting companies intent on producing avant-garde plays and performance

pieces crisscrossed the country. Educational brigades went into the small towns and taught everything from hygiene to new methods for planting corn. Modernist museums sprung up along with a multitude of exhibitions, makeshift schools arose, and open-air symphonies sometimes employed factory sirens. Mayakovsky was intent on "making the streets his brushes and the squares his palette." The unleashing of subjectivity lost its self-indulgent quality: it became concrete and the aesthetic dimension entered everyday life. The avant-garde concretely confronted consensual reality, if not its utopian beliefs and its denial of traditional rules, and went into coalition with Lenin's vanguard of "professional revolutionary intellectuals," which saw itself as the beacon of a new world. With the same indefatigable will shown by Lenin, Trotsky, and the Bolsheviks in reconstructing a decimated army to fight the counterrevolution and build a new state ex nihilo, the modernists sought to transform civil society through their artistic experiments and cast a utopian aura over the revolutionary struggle. Nowhere, indeed, does this utopian fusion become more apparent than in Tatlin's *Monument to the Third International*.

## Daedalus

In the classic German expressionist film *Metropolis* (1927) by Fritz Lang, a saintly character named Maria implores the working masses of the city to wait for a "mediator"—or perhaps less generously, a führer—to deliver them from their misery. She warns against any recourse to violence by telling the workers about the Tower of Babel. That cautionary tale has been told many times—and always for the same reason. It is the anti-utopian allegory par excellence, with discord and violence stemming from every attempt by humanity to take its fate into its own hands. According to the Old Testament, long ago, the peoples of the world tried to build a tower to heaven. They began doing so in order to glorify God. But, soon enough, the tower produced a desire in "man" to become like God and to reach His realm. Representing the Tower of Babel in *Metropolis* was a structure remarkably akin to Vladimir Tatlin's *Monument to the Third International*.

Tatlin was born in 1885 in Kharkiv. His father, whom he despised, was a railway engineer, and his mother a Romantic poet. After running away to sea, he returned to Moscow, where he studied painting and architecture. His career fused those of his parents. But the sentiments of his mother trumped those of his father. For Vladimir Tatlin, the founder of constructivism, did not simply bring industrial techniques and design to the arts,

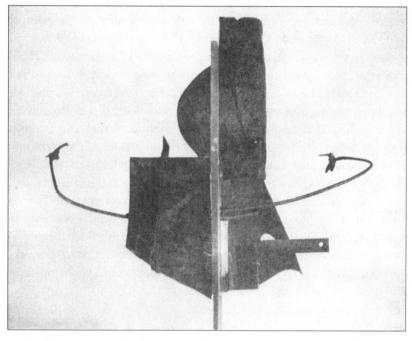

**FIGURE 8.2**    *Corner Relief* (1915) by Vladimir Tatlin. © The Tatlin Estate.

in the manner of Walter Gropius and the Bauhaus artists. Tatlin instead sought to render the utopian idea concrete through an aesthetically precise and innovative employment of technology. He was interested neither in conflating art with the exigencies of industrial society nor in "anti-art." Talin's intent was rather to transform social reality by broadening the possibilities of painting and sculpture. Profoundly influenced by the cubist works of Picasso, unconcerned with the reduction of color and line to something like Malevich's *White Square* (1918) with its dim linear outline, Tatlin initially sought to sculpt space, or bring "real space" to the canvas. Attempting to abolish the difference between sculpture and painting by mounting real objects with basic geometric shapes on canvas, in variations on cubist collage, his *Corner Relief* of 1915 became a sensation.

This was not a matter of playfully or ironically changing the meaning of preexisting objects, in the manner of Marcel Duchamp's Dadaist urinal or Picasso's handlebars placed over a bicycle seat that produced the image of a bull. Tatlin also had no interest in forging spiritual or emotive experiences without reference to external reality. He wished to reconfigure painting and

sculpture by insisting that they deal with real-world objects in real space and, by implication, real time.

Befriended by Anatoly Lunacharsky, the cosmopolitan and open-minded Commissioner of Education, Tatlin was encouraged in his incredible plan to create a monument to honor the Third International. Envisioned as twice the size of the Empire State Building, built on an iron structure that would lean angularly like the Eiffel Tower, its body would be composed of a huge glass cylinder, a glass cone, and a glass cube that would literally move along an asymmetrical axis.[9] The cylinder housing future congressional meetings would complete its revolution once every year, the cone meant for executive activities once a month, and the cube that would hold an informational center once every day. Radio transmitters and projectors lodged on top of the edifice would provide everything from reports on the weather to the most recent party slogans as a host of lights illuminated the often cloudy sky. The slant of Tatlin's monument in conjunction with the movement of its parts would produce a constantly changing silhouette—and give concrete meaning to the Italian futurist idea of an architecture constantly in flux. His work would incorporate the contributions of kinetic art and the mobile and culminate the constructivist enterprise. With its reliance on the simple use of a spiraling line, which asymptotically winds its way into the heavens, the building's radicalism would prove striking when compared with the thinking behind "heroic" propaganda posters like "Long Live the Third International" (1921) by Dmitry Moor and "The Sverdlov Hall"(1921) by Vladimir Favorsky.

Tatlin's gigantic monument was to serve as the symbol of communism, a testament to all the untapped possibilities of the collective imagination, expressive not merely of subjectivity but also of an international movement on the rise, and the international solidarity that a new order would fashion. Tatlin's work fused technology with utopia and sculpture with real space in attempting to aesthetically refashion urban life. The monument was conceived as a circular line moving up toward the heavens. It is a line without end that crystallizes the dashed utopian hopes emanating from the heroic years of the communist revolution, in which an assault was leveled against money, military rank, the state, and a host of customs.

A story is perhaps worth telling. Boris Nicolaevsky apparently encountered Nikolai Bukharin in the twilight years following Lenin's death, when Stalin was taking power. While reminiscing, Nikolaevsky asked his friend and former comrade why the Communist leadership should have encouraged the radical experiments of those early years. Bukharin supposedly responded:

"Because we didn't think we could succeed and we wanted to provide a monument, like the Paris Commune, to inspire comrades of the future."[10]

Tatlin's tower was never completed. Only sketches and a few models, built from wood and wire, remain. There were terrible shortages in the cities and famines in the countryside, and other priorities existed during the years of "war communism." Nevertheless, the great monument remained confined to the planning stage not simply because it was inherently unrealizable but rather because, soon enough, *the will to realize it* faded. Communism changed its face. Deep connections bind Stalin to the revolutionary aspirations of Lenin and Trotsky. But their use of terror differed in scale and quality with what came later. The dogma also became more sclerotic, artistic values more provincial, social relations more constrictive, and the goals less radical. Internationalism surrendered to a crude nationalism even before the Third International was liquidated in 1943. Stalin was the agent of "Thermidor," or those more conservative policies that broke with the liberating spirit of 1917. He substituted a crude caricature for the original "professional revolutionary intellectual" that was Lenin,[11] curtailed the radical experiments associated with the original communist project, and instituted what Karl Korsch legitimately termed "red fascism."

Tatlin's vision could not possibly have withstood these seismic shifts in the revolution. It is amazing that he survived the purges that swept like waves over his country over the ensuing decades and that drowned so many of his early artistic associates. Tatlin spent the years of unparalleled totalitarian terror engaged in aeronautical projects. He also designed theater sets, painted, and received various state honors. Many saw him as just another compliant artist in Stalin's own version of the culture industry—and there is some truth to that. Yet when Tatlin died in 1953 (the same year as Stalin), he was studying the biology of birds and speculating through drawings how human beings might learn to fly.

## Coda

But the realm of necessity did not vanish. The failure of the international revolution left the Bolsheviks in control of an essentially precapitalist nation, victimized by two wars and a pariah in the world community. Overcoming dire economic straits quickly, while securing national sovereignty against external and internal enemies, became the Bolsheviks' twin aims following their seizure of power. This served as their excuse for employing sustained terror against dissidents and building an enormous military-

industrial complex with a completely inefficient bureaucracy. They became ever more intent on industrializing the country, regimenting life and labor in the name of efficiency, and ultimately displacing utopian goals into the future while—through an increasingly dogmatic use of ideology and propaganda—guaranteeing their ultimate realization. The greater the disjunction between means and ends, the greater the use of ideology, propaganda, and terror to assert their connection. The question for those modernists sympathetic to the revolution was to what extent they would excuse these new policies. Oddly enough, it was precisely the old emphasis on revolutionary solidarity, utopia, and the liberation of subjectivity that provided the foundations for a critique of the new totalitarian reality.

Maintaining such ideological beliefs took great courage. A flood of artists joined the Communist International and enough modernists became rank apologists for the communist regime in the late 1920s and '30s. Some, like André Gide and Richard Wright, broke with the communists. But there were also the former avant-gardists like Johannes Becher, who denounced former friends; Ilya Ehrenberg, who squandered his prodigous talents; and Louis Aragon, whose poem "Feu sur Léon Blum" (written in 1931 at the height of communist sectarianism) virtually called for the murder of the great socialist who would lead the antifascist Popular Front in France.[12] There were the bohemian Stalinists—the tough guys with their cynical wit—like Dorothy Parker, Lillian Hellman, and Dashiell Hamett. There was perhaps the greatest historical novelist of the century, Lion Feuchtwanger, whose vanity was easily manipulated by Stalin, and also Brecht, who wrote in *The Measures Taken* (1930) that "the party has a thousand eyes and we have only two." There was Walter Benjamin, whose diaries from his travels in the Soviet Union during the late 1920s evidence not the least glimpse of what was going on, and Ernst Bloch, the greatest of all utopian thinkers, who justified the Moscow trials of 1936–8 in essays like "Jubilee for Renegades."

These modernists thought they were being loyal to the revolution. Or, so they claimed, they were being loyal to the communist movement in order to oppose fascism or support the antifascist popular front. But these artists trying to show themselves as political realists were not being realistic at all. They remained stubbornly blind to a new communist reality in which fostering the revolution meant far less than simple national interest. Stalinism betrayed whatever may have been deemed praiseworthy about Leninism. Enough has been said about these cultural apologists for a barbaric regime that buried every old cultural experiment from the heroic years along with most of the old, genuinely revolutionary vanguard.[13] Less has been written

recently about those modernists who attempted to explore the path not taken. There were bohemian radicals like John Reed, who authored the now-forgotten classic *Ten Days That Shook the World* (1919), which was made into a film by Sergei Eisenstein. There were underground revolutionary writers like Victor Serge, whose *Conquered City* (1931), *Year One of the Russian Revolution* (1930), and *The Birth of Our Power* (1937) showed with growing despair the degeneration of the radical experiments and solidarity that marked the new communist society. There was the great proletarian theater director and dramatist Erwin Piscator, who came to the Soviet Union, and less "political" avant-gardists like Dziga Vertov, who captured the excitement and dynamic spirit of the early years in *Man with a Movie Camera* (1929). Works such as these still excite the imagination and project the cultural sensibility of libertarian socialism. The irony is unavoidable. Those artists who were idealists, not those who ultimately became socialist realists, remain relevant for a new generation seeking to further freedom in a world where communism is an anachronism. The best of these artists leave us with the desire not simply to identify with a lost past but also to give meaning to its old hopes in a new way.

# 9

## Modernists in Power

### THE LITERATI AND THE BAVARIAN REVOLUTION

"All Power to the Soviets!" was the slogan Lenin employed to launch his revolutionary project in 1917. Visions of decentralized proletarian rule provided a kind of utopian legitimacy for the Bolshevik undertaking. As World War I dragged on, despair gave rise to its opposite. An almost universally unexpected "wind from the East" generated a new sensibility in the West. The Bolshevik Revolution in its "heroic" phase (1918–21) inspired modernists the world over. Those years in Europe were marked by dramatic upheaval, not least in Germany, where the November Revolution of 1918 brought about the abdication of Kaiser Wilhelm II and ushered in the Weimar Republic. Mainstream social democracy took over, and immediately, its leaders compromised with the stalwarts of the old imperial order. The prospect of a more radical order vanished. Factories were not socialized, and the reactionary officer corps as well as the old civil service remained intact. Discontent was rife. Elements of the bourgeoisie, the aristocracy, and the frayed lower-middle class (*Mittelstand*) seethed with resentment. Contempt for the new regime was also reinforced by the young communist movement, which refused to provide consistent support for any of the democratic regimes that appeared in Europe during the interwar period.[1]

Weimar would become known as the "republic without republicans." It lacked ideological and practical support from constituencies other than social democracy and a dwindling contingent of bourgeois liberals. There was also something pedestrian about the new republic that did not accord with the drama of the times. Weimar became its capital only because of its earlier association with Goethe, Schiller, and the legacy of German humanism. The modernist avant-garde wanted and expected more. Even Thomas

Mann was ultimately infected with its tendency to view politics meta-physically: he recommended that the new republic, which he grudgingly embraced in 1922, should strive to realize "the politics of Novalis" or, in other words, "make politics poetical."

The soviets—or workers' councils—offered the exploited and disenfranchised not a new state but a "withering away of the state." The world proletariat took note, and with the Bolshevik Revolution expectations soared. Some, like the expressionist painter Lyonel Feininger, found themselves carried away by messianic enthusiasms. Feininger forgot what revolution demanded and simply viewed it as an outpouring of joy, in works such as *Revolution in a Small Town* (1918), or spiritualized it, as in *The Cathedral of Socialism* (1919). George Grosz highlighted the need for a more regimented and disciplined solidarity in *Arise ye Wretched of the Earth* (1919). Even the more sober, however, were amazed by the spontaneous eruptions of workers' councils. The new man was seemingly now empowered, and his manifold potentialities were on the verge of being unleashed. Thus modernism blended with revolution.

Imperial Germany, like imperial Russia, witnessed the explosion of repressed passions, feelings of betrayal and apocalypse, amid the reality of defeat on the battlefield. Hatred for the ruling classes intensified among those who had suffered for four long years in the trenches. German workers and soldiers looked to Moscow. Inspired by the reality of defeat on the battlefield and the mutiny of sailors at Kiel, the Kaiser abdicated and the November Revolution of 1918 took place. The aristocracy and bourgeoisie feared for their status and their property. The military and bureaucracy felt betrayed by the defeat, while peasants and the petit bourgeoisie embraced the legend of a "stab in the back" perpetrated by Jews, pacifists, socialists, and communists on the home front. The situation was perilous and the possibility of civil war real enough. The Social Democratic Party of Germany (SPD) took power, and its uninspiring leaders proclaimed the Weimar Republic. Its dull and bureaucratic first president, Friedrich Ebert, supported by Gustav Noske, his provincial and ruthless minister of the interior (also known as "the bloodhound" for his ability to sniff out "the reds"), immediately entered into compromises with the old antidemocratic and reactionary forces. Leaders of the new regime thus refused to purge the military, judiciary, and civil service. They refused to liquidate the estates of the anti-Semitic and pitilessly conservative Junker aristocracy. They also refused to nationalize the great industrial concerns. In exchange for these concessions, the forces of

political reaction offered their (temporary) support to the new regime in quelling an insistent proletarian minority that sought a socialist republic based on workers' councils (*Räte*), if not on the more authoritarian tenets of Bolshevik theory.

Modernists sprang to the defense of the insurgents. They found themselves carried away by the masses as surely as the leaders of the Spartacus Rebellion in Berlin, led by Rosa Luxemburg and the chaotic Karl Liebknecht. This was particularly the case in Munich. During the nineteenth century its citizens had prided themselves on their liberal attitudes and an easygoing and tolerant style very different from that of the hated Prussians. As the twentieth century dawned, expressionist artists like Kandinsky and his friends settled in the sleepy suburb of Dachau, while major writers like Bertolt Brecht, Lion Feuchtwanger, and Oskar Maria Graf grew to maturity in the more urban bohemian districts like Schwabing. The antiauthoritarian and experimental atmosphere spawned by a modernist subculture permeated elements of the working class, and (almost by accident) in 1918 Kurt Eisner wound up leading a demonstration of two hundred thousand people, as well as ultimately heading a provisional minority government that set the stage for the heroic if short-lived Bavarian Soviet.

The ill-fated revolution of 1918 went through a number of phases, and it produced a number of cabinets and regimes. It was popularly known as the "government of the literati," and there is some justification for that. Eisner and his more radical comrades were, indeed, literati and they played an important role in events. The assassination of Eisner by the reactionary anti-Semite Anton Graf von Arco in 1919, while on the way to hand in his resignation from office, generated the call for an even more radical Bavarian Soviet. The short-lived Hungarian Soviet of 1919 had created much enthusiasm, and many believed that a similar action on the part of the Bavarian proletariat would inspire the Austrians to form yet another soviet of their own.[2] Radical democratic developments in other neighboring countries might then take place. Even if the material conditions for success were momentarily lacking, therefore, the summary declaration of a Bavarian Soviet on April 7, 1919, made a certain degree of political sense. Those who helped bring it about comprised a motley crew. Erich Mühsam and Ernst Toller were leading figures of the expressionist avant-garde. It was the same with Gustav Landauer. All of them were inclined toward ethical socialism and envisioned an antiauthoritarian cooperative. None of them was as ruthless as Eugen Leviné, the communist, who was a staunch admirer of Lenin. All of them, however, evinced an apocalyptic sensibility

and a desire to transform the cultural sentiments of humanity. They were all, ultimately, modernists in power.

## Kurt Eisner

Kurt Eisner is one of those historical personalities about whom many intellectuals have heard something but few actually know very much.[3] The prime minister of the short-lived Bavarian Republic of 1918–19 and an important figure in the prewar German Social Democratic Party (SPD), Eisner was an activist, polemicist, and skilled orator.[4] A friend of many famous writers and artists, he was also a genuinely popular figure with the working class. Eisner was one of the few leading social democrats who tried to link cultural modernism with a political project. He consistently placed the socialist ideal at the forefront of his literary effort, and he also always tried to reach a mass audience of working people. But he had no allegiance to the realist form. He desired a new art for a new class that would prove both playful and intellectually challenging. His literary writings constituted an experiment with allegories, parables, narratives, dramatic efforts, and— above all—the "social fairy tale." From the beginning, moreover, his concern was with creating a new political culture. Born in 1867, he called for a "people's theater" in 1889 and soon after helped found the avant-garde Free People's Theatre. An early admirer of Strindberg, he was one of the very few social democrats who showed a real understanding of modernism.

Eisner wrote the first study of Nietzsche to appear in German. *Psychopathia spiritualis* (1892) was a highly critical work that supported Enlightenment values. A staunch modernist and an advocate of cultural experimentation, Eisner nonetheless maintained that workers should receive the best of the classical heritage. He tried to bring the masses the best that multiple traditions had to offer. Thus he was ready to confront both intellectual snobbery and anti-intellectual populism with the call: "Turn the masses into an aristocracy!" Eisner was an early and consistent advocate of free education from kindergarten through university. Nor did that exhaust the matter. He considered socialism a "cultural movement" and the SPD a "pedagogic province," rather than a bureaucratic organization intent merely on garnering votes and legislating reforms. He intuitively understood how culture could educate the political sentiments. It thus seems fitting that one of his little fairy tales should have led to Eisner's imprisonment for insulting the Kaiser, which in turn brought him to the attention of the SPD leadership.

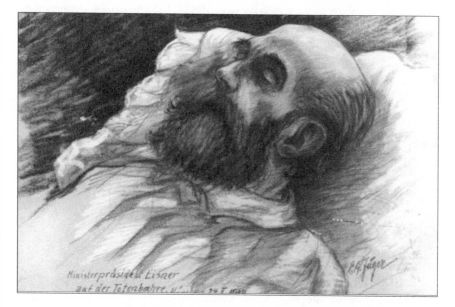

FIGURE 9.1   *Eisner on His Death-Bed (1919)*. Collection: International Institute of Social History, Amsterdam.

After his release, Eisner became an editor of the important party organ *Vorwärts*. But this took place just at the time that the revisionism debate was coming to a head between the reformist followers of Eduard Bernstein and the defenders of orthodox Marxism like Karl Kautsky and Rosa Luxemburg. Eisner earned the opprobrium of both sides in the conflict. He disagreed with those who favored economic reformism and insisted on highlighting the need for revolution. Yet the revolution he sought was predicated less on a concern with liberal republican institutions to supplant the monarchy than an ethical regeneration of the working class through a socialist public sphere. So where reformists in the labor movement attacked him as a wild-eyed radical, the more orthodox dismissed him as a naïve revisionist intent on linking Kant with Marx.

Eisner was prescient with regard to the coming war and principled enough, ultimately, to break with the SPD's nationalist policy on World War I. But he was never what most might consider a revolutionary, either in theory or practice. Eisner was carried away by the tumult following the German defeat in 1918. Opposed by the remnants of the old imperial order on the right and the authoritarian communist movement on the left, his Bavarian Republic lacked majority support from even the proletariat,

whose members were sharply critical of the SPD's proposed compromises with reactionary classes and institutions in Berlin.[5] Eisner had neither the temperament nor the outlook to confront the brutal violence employed by protofascist forces, the ruthless cynicism of the communists, and the instrumental timidity of a majority of the SPD. As with other political literati, including Landauer, Toller, and Mühsam, Eisner could neither delineate the conflicting interests, cope with the bitter infighting that characterized the new regime, nor fully differentiate between political insurrection and the spiritual renewal of humanity. He never wrote a great work of politics or aesthetics. As a cultural politician, however, Eisner rejected an increasingly fashionable cynicism and highlighted the need for solidarity among the oppressed. That marks his legacy and, in a sense, that is enough.

## Gustav Landauer

Gustav Landauer became the moral conscience of the Bavarian experiment following the murder of its most popular leader.[6] He was a socialist, a pacifist, and an anarchist whose nobility of spirit and commitment were noted by everyone who knew him. Born in 1870 in Karlsruhe, Landauer entered politics very young. "I was an anarchist," he liked to say, "before I became a socialist." And that was true enough. Landauer may have joined the labor movement, and he may have edited a journal called the *Socialist* around 1900. But he, too, had little use for the reformism of the SPD and quickly became a leading figure of an ultraleft faction, known as "The Young Ones," which was summarily expelled in 1894. Pierre-Joseph Proudhon and Peter Kropotkin played a far greater role in Landauer's thinking than Marx. His anarchist vision was directed less toward the institutions of the economy and the state than the human condition. He became interested in the "life reform" movement, and by 1902 his work had already influenced those involved with the journal *New Community*, to which any number of major Jewish intellectuals like Martin Buber would contribute. Indeed, this also was around the time Landauer formed what would become a lasting friendship with Erich Mühsam.

Landauer combined elements of the scholar, the politician, the bohemian, and the prophet. He was a noted historian of literature whose novels and fine essays on Hölderlin, Shakespeare, and the French Revolution brought him a wide measure of acclaim. His world was unbounded and that was also true of his wife, Hedwig Lachmann, who translated Oscar Wilde and Rabindranath Tagore. Landauer spoke of himself as a German and a Jew in essays

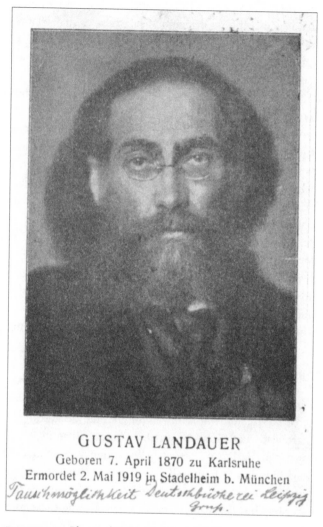

GUSTAV LANDAUER
Geboren 7. April 1870 zu Karlsruhe
Ermordet 2. Mai 1919 in Stadelheim b. München

FIGURE 9.2   Photo of Gustav Landauer. Collection:
International Institute of Social History, Amsterdam.

like *The Developing Person* (1913). But he deemed the whole of his personality to be more than the sum of its parts, just as humanity was, for him, more than the various nationalities and ethnic communities comprising it. A presumption of human goodness and a striving for utopian harmony, as well as a respect for the individual and love of community, informed his ethics. These beliefs also played a role in his somewhat less notable political

writings like *A Call to Socialism* (1911), which envisioned economic equality along with a new direct form of democracy, whose control by a newly educated working class would make violence dispensable. With this in mind, there is something particularly poignant about Landauer's arrest following the collapse of the Bavarian Soviet. The story goes that he spoke to his military captors about the goodness of humanity until, tired of walking and weary of his monologue, they summarily beat him to death.[7]

Baron von Gagern, the officer responsible for his murder, was never punished or even brought to trial. The story provides insight into the judicial workings of the Weimar Republic. It also provides insight into Landauer as a politician of the spirit. He always considered himself an educator who sought to evoke the best in his audience. His concern was less with institutions than with how people treated one another. He was a radical democrat. As minister of education in the Bavarian Soviet, in fact, Landauer introduced reforms that ranged from allowing any eighteen year old to become a full-time student at the University of Munich to setting up a "students' soviet" and abolishing examinations. His outlook is best understood by his striking claim: "Every Bavarian child at the age of ten is going to know Walt Whitman by heart. That is the cornerstone of my educational program."

## Erich Mühsam

Rimbaud had called on his generation to "change life." Erich Mühsam heartily agreed. Why not? Mühsam was for Germany, according to another famous anarchist, what Rimbaud was for France.[8] Born in 1878 to a Jewish pharmacist in Berlin, he was expelled from high school for socialist agitation. Mühsam felt himself an outsider from the beginning and naturally gravitated to the anarchist circles of Berlin and Munich.[9] Max Nomad described him as an inveterate sponger during these early years.[10] But *The Desert*, his first collection of poems, was published in 1904, and soon enough Mühsam began making his name as an author of cabaret songs, anecdotes, and sketches. He riddled social democracy with sarcasm in poems like the untranslatable "Die Revoluzzer" (1907), and important journals like *Die Weltbühne* and *Simplicissmus* published his work. "Let us make room for freedom" was a line in one of his poems.

And that was what he sought to do. In 1911 Mühsam became the editor of *Kain*, which he described as a "magazine for humanity." It was, of course, nothing of the sort. This journal based in Munich was experimental, sophisticated, and avant-garde. He wrote every line like his Viennese

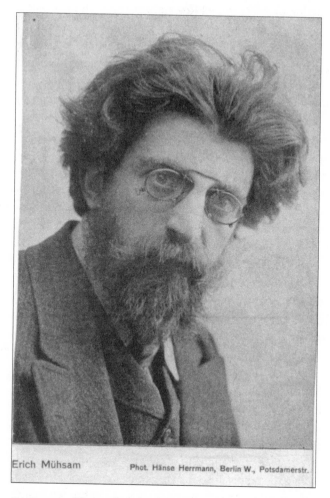

Erich Mühsam          Phot. Hänse Herrmann, Berlin W., Potsdamerstr.

**FIGURE 9.3** Photo of Erich Mühsam. Collection: International Institute of Social History, Amsterdam.

friend and modernist counterpart, Karl Kraus, the editor of *The Torch*. Mühsam defended his radical friends and castigated the status quo. He advocated pacifism, sexual liberation, and an apocalyptic notion of revolution. When World War I broke out, in fact, Mühsam published a collection entitled *Deserts, Craters, and Clouds* (1915) in which he made the plea, "Drink, soldiers, drink." Mühsam refused to serve in the army or register as a conscientious objector, and for this he was jailed. He came out against the National Assembly following his release in 1918 and sought to found

an Association of International Revolutionaries in Munich, which came to nothing, as its program was somewhat unclear. Organizational questions bored Mühsam. Never particularly concerned with the class struggle, in keeping with Landauer, he spoke to the "exploited" and even attempted to proselytize among the *lumpenproletariat*. Mühsam's vision of socialism, like that of Landauer and Toller, was essentially aesthetic and visionary.

Mühsam was taken alive after the fall of the Bavarian Soviet and condemned to fifteen years of hard labor. The sentence was commuted to five years. He continued his anarchist activities after his release, but grew more sober. His new journal, *Fanal*, no longer criticized social democracy as the main enemy, but targeted the Nazis. Mühsam spoke out against the abuses of the Weimar judicial system and supported organizations like Red Aid, which raised money for political prisoners and sought their liberation. In 1928 he wrote a play, "Reason of State," about the Sacco and Vanzetti case, and in 1929 an account of the Bavarian Soviet entitled *From Eisner to Leviné: A Reckoning*, in which his own humanistic values and hopes for the Bavarian Soviet are made clear. Even in that work, however, Mühsam could not adequately deal with the institutional and social reasons for the failure of the Bavarian experiment.

Mühsam was one of the best-loved figures of the Bavarian Soviet, and reports abound of workers and soldiers shouting his name and carrying him on their shoulders following his release from prison. He was a satirist, an ironist, and something of a clown. His first published piece in 1905 defended homosexuality, and he never shared the puritanism of his friend Landauer. Mühsam never showed favoritism toward any party and acted responsibly as a leading politician of the Bavarian Soviet. He sought unity, proved willing to compromise with the communists, and even appeared as their spokesperson on one or two occasions. All of this without surrendering his principles or his various utopian ideas for reform. Few were hated with the same degree of passion by the nationalist right, and its advocates continued to vilify Mühsam during the years of the Weimar Republic. This anarchist Jew somehow stuck in their craw.

Perhaps Hitler remembered the young bohemian who played chess in the famous Café Megalomania in Munich after the war and made fun of the future chancellor's drawings.[11] But Hitler was not one to forgive and forget. The ultimate philistine took his revenge. Immediately following the Nazi seizure of power, Mühsam was captured and then transported to the Oranienburg concentration camp. He could have escaped: his friends had supplied him with a ticket out of Germany, but he apparently gave it to a

young man, hunted by the Nazis, who was broke and without a place to go. That good deed did not go unpunished. Those who shared his life in Oranienburg told how Mühsam was tortured unmercifully, how his beard was ripped out, how he was pissed and shat on, how he was whipped and beaten almost daily, how his head was branded with a swastika, and how he was forced to dig his own grave, beaten yet again, and then pulled into a bathroom where he was finally strung up. Erich Mühsam died in 1934.[12]

## Ernst Toller

It was all a bit different for Ernst Toller. The most famous and perhaps prototypical leader of the Bavarian Soviet was born in Posen in 1893, and his autobiography, *I Was a German* (1933), speaks elegantly of anti-Semitism in Germany. Toller joined the military in a mood of "emotional delirium" to fight in World War I. After his release in 1916, in the wake of a nervous breakdown, he became a staunch pacifist and ultimately a socialist. After studying at the University of Munich and Heidelberg, where he came to know Max Weber and various other distinguished academics, Toller wrote his deeply autobiographical play, *Transformation*, in 1917. Dream sequences, abstract figures, and various other expressionist techniques are employed in this drama, whose main character experiences any number of changes, each of which liberates him from a prior ideological prejudice, until finally he finds redemption (*Erlösung*) in a utopian vision of revolution. Based on a fundamental faith in humanity, concerned less with workers than an image of the oppressed, this "revolution" would peacefully bring about a change in the very essence of man. Toller was—like Eisner—a member of the Independent Social Democratic Party (USPD), which had split from the SPD in 1916 over the latter's pro-war policy. The USPD, small and poorly organized in Munich, had aligned itself with the council movement, and Toller quickly became a leading figure in the Bavarian Soviet. His allegedly remarkable oratorical abilities surely didn't hurt; indeed, it was said that "he carried the people by the force of his own convictions. . . . They wanted a mission in life; Toller supplied them with one."[13]

The creation of the Bavarian Soviet was accompanied by the planting of freedom trees, the singing of Jacobin songs, and a great deal of libertarian rhetoric. The contemporary German writer Tankred Dorst in *Toller* (1968) essentially argued that the hero interpreted the events of 1919 in terms of the expressionist apocalypse depicted in his works. Whether or not this is

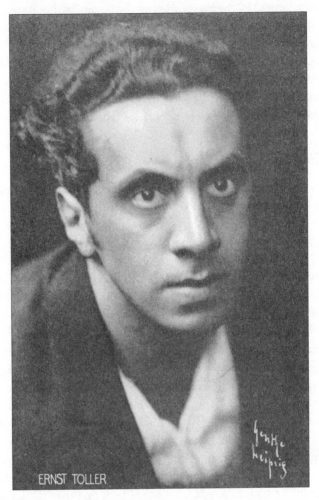

**FIGURE 9.4**   Photo of Ernst Toller. Collection: International Institute of Social History, Amsterdam.

the case, Toller clearly lacked a sense of priorities. While Bavaria was experiencing a food shortage in the aftermath of the allied blockade, his first speech to the soviet concerned the new forms of architecture, painting, and drama through which humanity might express itself more fully. Administrative services collapsed and the organization of revolutionary soldiers was a shambles; indeed, with a mixture of affection and sarcasm, Max Weber once remarked, "God in his fury has turned Toller into a politician." But Toller remains a great symbol for socialist libertarians. He was brave and

humane. He fought in the streets with the defenders of the Bavarian Soviet against reactionary forces, and he saved many hostages from the revenge sought by various communist leaders like Rudolf Engelhofer.

Toller was captured with the downfall of the Bavarian Soviet and spent five years in prison, part of the time—ironically—in a cell not far from the one occupied by Hitler in the Landsberg Castle fortress. There Toller wrote his beautiful collection of poems, *The Swallow's Book* (1923), which only increased his popularity. An ongoing attempt to unify individualism with solidarity connects *Man and the Masses* (1910) with later works like *Brokenbrow* (1926), which concerns an impotent war invalid abandoned by society. The pathos in the work of Toller grew along with his despondency. Even while using an innovative expressionist style and publishing in prestigious journals like *Die Weltbühne*, he always considered himself a "people's poet" (*Volksdichter*). Following his release from prison, Toller joined the German League for Human Rights and participated in various pacifist organizations, and also castigated the criminal justice system for its right-wing bias. Toller's play *Hooray! We're Alive!* (1927) is among the most trenchant criticisms of the materialistic and chauvinistic underside of the Weimar Republic. He was also, along with Mühsam, one of the very few intellectuals who immediately realized the danger posed by the Nazis and what differentiated them from other reactionary parties. Toller fled Germany when Hitler came to power. He went from Switzerland to France, England, and then finally to the United States. But he hated exile. He never made it in Hollywood, and feeling his powers diminishing, he despaired as Hitler won victory after victory. Toller, the pacifist and humanitarian, committed suicide in New York in 1939. He never saw the end of the regime whose ascent he predicted and whose character he despised.

## Eugen Leviné

Where Eisner, Landauer, and Toller died too early, their communist competitor for power in the Bavarian Soviet—Eugen Leviné—died just in time. He would certainly have perished, perhaps even more cruelly, under Stalin. Leviné was not quite the saint that his wife, Rosa Leviné-Meyer, portrayed in her biography. But he incarnated the best of the Bolshevik spirit. He was unyielding and dogmatic, but an honest intellectual and totally committed to the most radical utopian ideals of international revolution. Born on May 10, 1883, into a wealthy Jewish family in St. Petersburg, he was brought up in Germany, where as a youth he actually fought a duel against

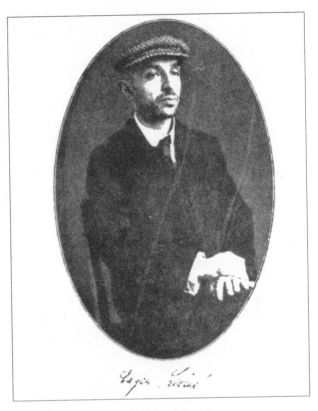

**FIGURE 9.5** Photo of Eugen Leviné. Collection:
International Institute of Social History, Amsterdam.

someone who had made an anti-Semitic remark.[14] In 1904 he returned to Russia, where he gained revolutionary experience and participated in the Revolution of 1905 before being arrested and severely beaten. After bribery secured his release, he moved back to Germany. There Leviné worked as a propagandist for the SPD and gravitated to the circle around Rosa Luxemburg before ultimately joining the Spartacus League. Leviné soon enough found himself in disagreement with his mentor. Enthralled by the Russian Revolution of 1917, in contrast to Luxemburg, he became ever more intransigent and took an ultraleft stance. He was critical of the temporary alliance between Spartacus and the USPD. He also vigorously opposed participating in the National Assembly and ultimately embraced Lenin's new Communist International. Believing the masses would follow an inspired vanguard, in keeping with the Bolshevik example of 1917, he and his close

comrade, Max Lévien, were instrumental in defeating the more cautious proposals of Luxemburg and the leadership of Spartacus, thereby paving the way for the failed rebellion in Berlin.

But, for all that, Leviné acquitted himself valiantly during the uprising. The police hunted him, and at the urging of Paul Levi, the new leader of the German Communist Party, Leviné was sent to Munich where he was to put the small and disorganized party cell in order. Levine's first article warned workers not to engage in any "precipitous" actions, and he opposed forming a Bavarian soviet. When the soviet was proclaimed anyway, Levine was appalled by its circus-like character and was successful in calling on the KPD to remain in opposition. He still opposed working with representatives of the SPD and recognized the lack of popular support for the soviet. The question is why Leviné should have called on the communists to reverse their position. He knew the soviet was doomed, and his policy surely did not find its source in Moscow. No Bolshevik emissaries were active in Munich. But the masses were on the march: they sought to defend Munich from counterrevolutionary troops.[15] Most likely, following Rosa Luxemburg, Leviné wished to provide a legacy for the next generation. In this he was no less utopian than his opponents. His communists may have introduced censorship and a military style, but they too sought to revamp the schools and proclaimed the famous Frauenkirche a "revolutionary temple."

All of this might have been a desperate attempt to mimic the heroic years of war communism in the Soviet Union. Even communist workers, however, soon enough turned against Leviné's disastrous policy. His temperament differed from that of Mühsam and Toller. There was nothing of the humanist literati about him, and Leviné's heritage is tainted by the useless shooting of hostages and arbitrary confiscations carried out by members of his party. For all that, however, he remained true to his beliefs. He participated in the street fighting, and his defiant death before a firing squad only testified to his courage. Indeed, with his cry of "Long Live the World Revolution," the tragicomedy of the Bavarian Soviet came to a close along with the most radical hopes of 1919.

With the repression that followed the Bavarian uprisings of 1918–19, Germany experienced a shift in its center of cultural gravity. Munich became a pillar of the reaction, and much of its modernist avant-garde relocated to Berlin. The revolution did not fail because of the "cultural politicians," but they bear part of the responsibility. Eisner and his comrades were unpre-

pared for political power. They spoke to the "people." But they were hated by the capitalist, the petty bourgeois, the peasant, the aristocrat—in short, by the philistines. The Bavarian Soviet never had a chance. Its leaders and supporters never appreciated the forces arrayed against them. An organized anticommunist witch hunt took place in the Weimar Republic from 1919 to 1923 and struck particularly hard in Bavaria, which only makes sense. The Munich uprising was the most radical attempt to subvert tradition and transform everyday life. Its cultural politicians considered themselves prophets of justice, equality, and democracy. They were romantics without much sense of the institutions necessary to sustain these values. Each condemned the decadence of the status quo and genuinely identified with the lowly and the insulted. Each prized the moment of action and sought to provide the masses with a new sense of their own possibilities. Each also exhibited exceptional bravery and remained true to his or her convictions. The names of Eisner, Landauer, Mühsam, Toller, and Leviné have faded. But it remains important to preserve a sense of their vision and their sacrifice. There was nothing phony or pretentious about these libertarian militants. They were naive and romantic even when they tried to be "political," but they paid the ultimate price. Their deaths helped open the door for the Nazi seizure of power in 1933.

# 10

**Exhibiting Modernism**

*PARIS AND BERLIN, 1900–1933*

Less and less is it Walter Benjamin's city, a city of boulevards, arcades, and bohemians. Paris is a thing of the past. It has changed in a manner that Benjamin only partially foresaw, and that change is exemplified in the Georges Pompidou Center, a massive yet oddly austere example of post-modern architecture, which in 1978 housed one of the most extraordinary exhibitions of recent memory: *Paris and Berlin, 1900–1933*.[1] The exhibition was an attempt to capture the cultural and political spirit of three crucial decades by focusing on the interaction between the two major cultural capitals of Europe. And it achieved its purpose. The exhibition's inadequacies are minor when compared to the scope and breadth of what was presented. Visitors could have spent days and not seen everything. From architecture to fashion, from avant-garde painting to industrial development, from literature to photography, from politics to the commodity production of everyday life, and from theater and cinema to urbanization, the age of modernism came to life.

Innovative techniques were employed in understanding the past, particularly in the use of video. In a room with twelve television screens lined up four by three, film clips were presented accompanied by the music of Hanns Eisler. Using negatives tinted red and blue, and with a differing tempo for two sets of six televisions each, history unfolded. There was footage of imperial Berlin, the Kaiser, and soldiers in the trenches. Newsreels showed the birth of the Weimar Republic, the Spartacus revolt, and newspaper headlines calling for the assassination of Karl Liebknecht. Other tapes recalled the Russian Revolution, the death of Lenin, and Stalin's triumph. And then there was the rise of fascism. All of this fit beautifully

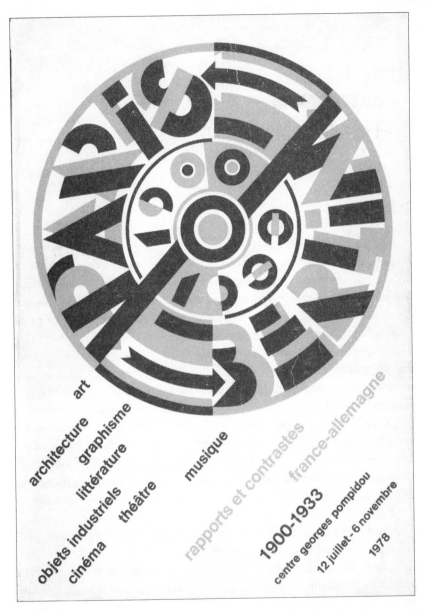

**FIGURE 10.1** Cover of the catalog (1978), *Paris-Berlin, 1900–1933*. Centre Georges Pompidou.

with the exhibits on World War I, worker's theater, propaganda posters, and the stark memorial to Rosa Luxemburg and Liebknecht. The exhibition presented a political context for the cultural transformation generated by modernism, It also introduced the audience to the great merchants, dealers, and entrepreneurs: Hermann Kahnweiler, who promoted Derain, Vlaminck and Picasso; Wilhelm Uhde, who accumulated an enormous collection of French avant-garde art; Alfred Flechtheim, who probably did as much as anyone to propagate cubism in Germany; Guillaume Apollinaire, poet, critic, and showman, who helped develop the scandalous demonstrations that put the avant-garde in the limelight. Another video was about Herwarth Walden, editor of the expressionist journal *Der Sturm*, who brought the most important modernists together in his Sturmgallerie, and who died miserable and forgotten in one of Stalin's camps.

*Paris and Berlin, 1900–1933* gave center stage to the cosmopolitan connections between artists; its political aim was to confront the chauvinistic views of modernism that had held sway in France since the aftermath of the Franco-Prussian War of 1871. The exhibition showed how the fashions, the concerns, and even the propaganda used by both nations during World War I were remarkably similar. It thereby questioned the feelings of cultural superiority that seem stereotypical for the French. For this reason, in fact, Michel Foucault expressed "violent amazement" at the exhibition and praised it for calling on his fellow citizens to confront their cultural identity.[2] The exhibition made it clear that the absence was the presence. Misguided French feelings of superiority were surely strengthened by historical neglect of Germany's contributions to modernism. *Paris and Berlin*, perhaps for the first time, brought those achievements to a larger public in France. Thus it left the fascist inclinations of great artists like Gottfried Benn, André Derain, Emil Nolde, and Maurice Vlaminck in the background. Modernism was portrayed primarily as a progressive, left-wing, and cosmopolitan enterprise that enraged the nationalists and reactionaries of both countries. Indeed, it is almost impossible today to appreciate how the French condemned cubism as *boche* after World War I began, even while German nationalists—including Nolde—railed against the popularity of French and "foreign" art in their homeland.

*Paris and Berlin* illuminates the ways in which the aesthetic innovations of modernists thrived on this transnational cultural exchange. Henri Matisse, Derain, and the Fauves influenced artists like Max Pechstein, Karl Schmidt-Rotluff, and many others in their new use of primary colors to contest impressionism. Robert Delaunay also had an important impact.

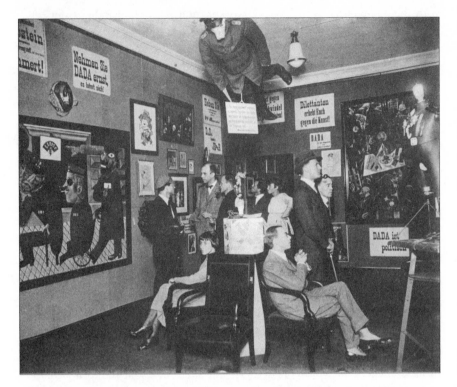

**FIGURE 10.2**   Opening of the First International Dada Fair in the bookshop
Dr. Burchard in Berlin. *Standing from left to right*: Raoul Hausmann, Otto
Burchard, Johannes Baader, Wieland and Margarete Herzfelde, George Grosz,
and John Heartfield. *Sitting*: Hannah Höch and Otto Schmalhausen (May 7, 1920).

*Photo Credit: bpk, Berlin / Art Resource, NY*

His emphasis on "the movement of color" in his *Saint Severin* and "win-
dow" paintings of 1909–10, along with his studies on the relation between
light and color, influenced August Macke, Franz Marc, Wassily Kandinsky,
and Der Blaue Reiter. Moreover, there was the influence of Fernand Léger
on the Bauhaus; there was Picasso, Tzara, and the French version of Dada.
The list of reciprocal influences would be a long one, and some fine articles
in the exhibition catalogue discussed them. Each of the major avant-garde
movements received its due: Fauvism, expressionism, Dada, new objectiv-
ity, constructivism, and Bauhaus. Exceptional works were presented, like
Erich Heckel's *Pechstein Sleeping* (1910) with its monochromatic use of red,
which shows the influence of the Fauves on Die Brücke. Also on display
was his extraordinary 1913 work *Day of Glass*, which, like Ludwig Meidner's

*Revolution* of the same year, served as a foreboding of the catastrophe to come. Marc's animal paintings were in evidence as well, along with August Macke's *Sunny Path* (1913), which clarified the influence of Delaunay. George Grosz was exceptionally well served with *The City* (1916/1917)—as was the talent of Kurt Schwitters.

*Paris and Berlin* favored some artists over others, and certain movements like art nouveau and surrealism were not adequately represented. A more important criticism, however, is that the exhibition did not display the art that the avant-gardes opposed. Thus there was nothing by realist painters like Adolf Menzel, academics like Franz von Stuck, or popular artists of the period like Hans Böcklin, Lovis Corinth, and Hans Thoma. Yet if modernism was not depicted in dynamic relation to either the tastes of the cultural philistine or the accepted aesthetic values of the enlightened bourgeoisie, insight was provided into the social conditions that engendered the radical aesthetic innovations of a period marked by the extraordinary expansion of technology, urbanization, and industrialization. Visitors were able to see photos of the workers' slums in Frankfurt and Berlin as well as photographs of large business conglomerates such as the German General Electric Company (AEG). In fact, a large amount of space was devoted to the manner in which art responded to these changes. Critical of the more traditional trends of their epoch, some modernists employed technology in advancing their ideas. Innovators such as Peter Behrens and the Werkbund group made their peace with capitalism and the growing technological society. On display were the tea kettles, electric fans, electric lights, tram cars, auto designs, and magazine advertisements that were designed with an eye for efficiency and function over a decade before Bauhaus. These developments were no less avant than the movement away from realism in painting and literature. In fact, this particular modernist trend probably had a clearer vision of where society was going than the more flamboyant Dadaists or expressionists. The new functionalist impulse, indeed, culminated in the Bauhaus movement led by Walter Gropius, which arguably was overrepresented in *Paris and Berlin*.

Many critics have interpreted the transition from expressionism and Dada to Bauhaus as a shift to academicism. Thus Kandinsky is seen as retreating from his concern with inner transformation and color to constructing and then juxtaposing geometric shapes, and Paul Klee as retreating from the radical implications of his children's paintings and his African light paintings. But the exhibition shows that such claims are exaggerated. Bauhaus was intent on reshaping life through new forms of architecture and

changing the accoutrements of everyday life. Russian futurists and Bauhaus participants exchanged ideas and learned from each other throughout the 1920s; they held conferences and exhibitions, and also published together. Bauhaus, too, stood on the left, and in fact, Mies van der Rohe produced a monument to Rosa Luxemburg and Karl Liebknecht. Its artists believed that art had not yet come to terms with the future, that rationalization was not being carried far enough, and that art's potential to intervene in everyday life was being ignored. Bauhaus wished to frame aesthetic questions in terms of function, reduce art to its geometric forms, and employ the advances of science with respect to the neon light, glass skyscrapers, housing complexes, and "modern" furniture. These developments were both radical and innovative. They marked a profound rupture with the staunchly traditional art and grandiose baroque architecture that was preferred by Kaiser Wilhelm II. Yet Bauhaus accepted the definition of efficiency and the understanding of function offered by bourgeois rationality. Arguably, Bauhaus wished to free technology for the arts, and turn "work" into "creation," while equalizing the status of the worker and the artist. By the same token, however, Bauhaus integrated art with instrumental rationality in order to liberate the individual from the drudgery of everyday life.

The modernist understood himself as the enemy of the habitual, staid, and conservative domains of everyday life in which the cultural philistine thrived. From the photographs and satirical sketches in the exhibition, it is clear that the French and German modernists saw the philistine as hypocritical and puritanical, nationalistic and militarist, parochial and self-satisfied. Certain artists like Paul Claudel, Maurice Barrès, Gottfried Benn, and Ernst Jünger considered the philistine as not nationalist enough, not militarist enough, not emotionally daring enough. Thus they turned to the pseudorevolutionary right. Others like Erwin Piscator, Ernst Toller, and Erich Mühsam turned to the left and attempted (for better or worse) to bring their work to the proletariat. But this only validates the original premise: that the most diverse modernists interacted with one another precisely because it was opposition to the status quo that unified them. This point becomes evident in the exhibition's display of books published by the Kurt Wolff Verlag. More than their American counterparts, German publishing houses retained distinct identities; the Malik Verlag published the communist writers and, in the same way, the Kurt Wolff Verlag was known for publishing avant-gardists. Their list is fascinating: Barrès; Benn; Becher; Claudel; Kafka and his future literary executor, Max Brod; and Francis

Jammes are just a sample. Little unites this odd collection of artists other than their contempt for the bourgeois and the cultural philistine.

Modernists were at once repulsed and fascinated by modernity. They had an ambivalent relation to the technological explosion that marked the age. The earliest expressionists, such as Paula Modersohn-Becker and the Worpswede group, retreated to the country. But even she took trips to Paris where she acquainted herself with Cézanne's work. The exhibition gave little attention to Worpswede, and perhaps for good reason. Their achievements pale in comparison with those of Die Brücke and Der Blaue Reiter. Unlike Nolde, for example, Worpswede did not seek to energize nature or the individual's relation to it. Instead, they recreated the pastoral values of romanticism while employing colors that were surely less dramatic than those used by the Fauves, let alone by Nolde himself. Worpswede was innovative in developing crafts, and the exhibition shows how this interest was common to France and Germany.

The woodcut, the distortion of figures, the hard line, and the emphasis on instinct and the spiritual as against the reigning materialism of the bourgeoisie all played a role in the art of Ludwig Kirchner, Erich Heckel, and Die Brücke. But they had little use for the sentimentality of their German avant-garde contemporaries. They learned much from the French about the modern city, mass culture, and the crowd. These they considered inescapable elements of contemporary life. Thus Kirchner's street scenes throb with the pulsating energy, crowds, and bustle of urban life. None of the arts could escape the new urban technological world. And so when the poets and novelists exploded traditional forms and syntax, it was not purely a formal matter. The new syntax allowed an imperiled subjectivity to burst free from traditional linguistic constraints while also mirroring the new rhythm of city life. This becomes apparent in the writings of Alfred Döblin and a host of others. It is perhaps even more apparent in the new modernist cinema and the work of directors like Robert Wiene, Fritz Lang, and G. W Pabst. Yet the exhibition placed little emphasis on what was still a relatively new art form. This was all the more strange since cinema radicalized the crisis that had begun with what Walter Benjamin termed the "reproducibility" of art and the development of the poster and, later, photography.

Each of the arts was threatened by the new power of technology, and each sought ways to preserve its identity. The problem was particularly acute for painting, which had to respond to the way in which posters, photography, and film had captured "the real" for themselves. The rise of new visual media threatened to make painting superfluous if not obsolete. *Paris and*

*Berlin* demonstrated the response of painting in an excellent video entitled *The Blue Rider; or, the Return to the Sources* (1911–14) and emphasized Kandinsky's important role in giving new meaning to mimesis and preserving the integrity of his craft by transforming its sense of purpose. Yet it was not merely that he took the inner experience of life, raised it to primacy, and gave it expression. His work also reevaluated and reintegrated the achievements of primitive art, oriental art and artists such as El Greco, so as to create a whole new dimension for painting as a medium. Other artists sought to employ technological advances in conjunction with the aesthetic innovations that the avant-gardes had achieved. Nowhere does this become more apparent than in the works of those one-time German Dadaists who were spotlighted in the exhibition: George Grosz, Otto Dix, Hannah Höch, and especially John Heartfield. In contrast to figures like Marcel Duchamp and Salvador Dalí, who are now far better known, Grosz and Heartfield were explicitly political. They expressed the peculiar nature of the trauma induced by World War I in Germany and the repression of worker uprisings during the early 1920s.

As fauvism and expressionism were absorbed by the cultural establishment, a new generation of radical artists embraced the critical possibilities of the New Sobriety and the permanent revolution of experience offered by surrealism. Many of them joined the Communist Party. They wanted to reach the masses. Hannah Höch continued her experiments with photomontage, while Grosz and Dix offered the public biting satirical sketches. It is John Heartfield, however, who employed photomontage and caricature to the greatest sociopolitical effect. He has since enjoyed a renaissance, and much of the credit for that goes to *Paris and Berlin* for exhibiting many of his finest works. Thus in *The Meaning of the Hitler Salute*, the audience sees the Führer with his arm raised back, palm parallel to the ground, while a larger figure in a business suit slips a wad of banknotes into his outstretched palm. Then there is the poster photograph of a huge hand reaching out to the onlooker, fingers jutting forward, muscles flexed, with a caption that reads: "A hand has five fingers, with these five you can shake the enemy."

Heartfield was a communist propagandist. But he created an entirely new form of visual pedagogy by turning the reproducibility of art to his advantage. Various bohemians and avant-gardists such as Henri de Toulouse-Lautrec had used the poster for commercial advertisements. Others like Käthe Kollwitz in *To All Artists!* and and Max Pechtsein in *Never Again War!* (1924) employed the poster to mobilize political sentiment. Heartfield's works, however, blend montage with narrative in a unique way. They

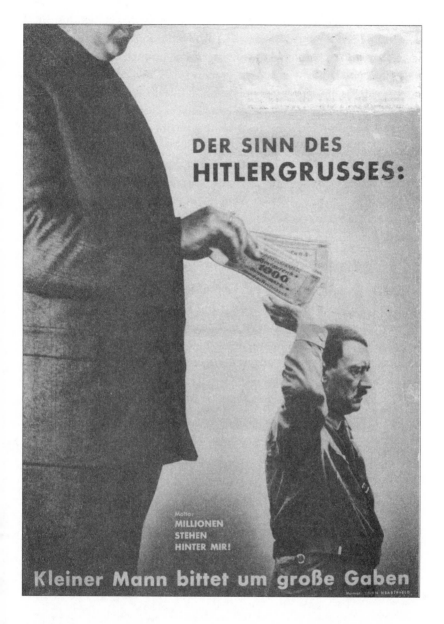

FIGURE 10.3  *The Meaning of the Hitler Salute* (October 16, 1932). Photomontage. Print from the *Arbeiter Illustrierte Zeitung* (AIZ) by John Heartfield. © 2012 Artists Rights Society (ARS), New York / VG Bild-Kunst, Bonn.

*Photo Credit: bpk, Berlin/Art Resource, NY*

illuminate the symbolic character of political events, depict their historical constitution, and—above all—invite critical reflection.

*Paris and Berlin* explored the multiplicity in unity that was modernism. Its philosophical irrationalism and nihilism, its inflated ideals and naive politics, ultimately appear less important in this exhibition than its experimental daring and aesthetic radicalism. Showcasing the interplay between the artistic traditions of two countries that fought on opposite sides in two world wars was a breakthrough. The exhibition provided a cosmopolitan interpretation of modernism that contested the more provincial academic interpretations in both countries. It also showed that, ultimately, the modernists fulfilled their mission—even if not quite in the way they had expected. This exhibition—perhaps for the first time—presented modernism in its social context and with an eye to its explicitly political intentions. Generational conflict, sexual repression, the domination of nature, the disorientation generated by technology and war, feelings of alienation, and the extraordinary artistic responses to all of this emerge from the exhibition. Furthermore, these issues still speak to us. *Paris and Berlin* created a bridge between then and now, offering a lasting glimpse into how modernism educated the sentiments of people, changed their expectations, and contributed to the unfinished struggle for liberation.

# 11

## The Modernist Adventure

POLITICAL REFLECTIONS ON A CULTURAL LEGACY

Classical modernism experienced a slow death at the hands of its enemies and quite a few friends, too. Mussolini began the process on the right, and following the demise of Lenin in 1924, the Communist International furthered it on the left. Authoritarianism on both ends of the spectrum became the full-fledged totalitarianism of Hitler and Stalin, and this shift had an impact on the modernist avant-garde. Whereas previously its artists could more or less write and paint and film what they wished, so long as it was not directly critical of the regime and its revolutionary purposes, all experimental culture now came under attack on the grounds that art should serve the particular policies advocated by the regime. The Degenerate Art Exhibition of 1937 in Munich served as the perfect complement for Stalin's ferocious assault in 1936 on the enormously popular opera *Lady Macbeth of the Mtensk District* (1932) by Dmitri Shostakovich. What the Nazis termed "cultural bolshevism" (*Kulturboshewismus*) was no different than what the Stalinists termed "petty bourgeois formalism." Both expressed the feelings of the philistine appalled by decadence. Babbit and his friends could now rest easy. The classical avant-garde proved yet another casualty of World War II.

The always-fragile international network of the avant-garde with its cafés, galleries, publishing houses, magazines, and cliques—the public sphere of classical modernism—ceased to exist. Those artists, editors, and critics who fled Europe arrived elsewhere as exiles. Some found their way to South America, others to Turkey and Japan, and still others to the Soviet Union and the United States. Erika and Klaus Mann offered the first group portrait of how the exiled intellectuals were cast adrift, tried to recreate the old world,

and, with tinges of bitter nostalgia, often still saw themselves as a family.[1] Even the luminaries of classical modernism were now only individuals trying desperately, some to better and others to worse effect, to make their way in a new world.[2] Their contributions might continue to inspire resistance in authoritarian regimes shackled to provincial aesthetic and cultural norms. But the unqualified preoccupation with form by the modernists, which was meant to insure the autonomy of their art, left them hapless in the face of a more liberal advanced industrial society. They found themselves integrated into a commercial apparatus whose products were packaged and sold through their technical innovations.[3] The only way to preserve autonomy in the old critical sense was by transforming art into a professional enterprise. Thus with the passing of the older totalitarian movements, modernism lost its radical edge in the western capitalist democracies.

New political avant-garde groups surfaced again like the German Gruppe 47 of Alfred Andersch and Günther Grass and, more famously, the Parisian intellectuals who clustered around Jean-Paul Sartre, Simone de Beauvoir, and Albert Camus.[4] But these all existed in the shadow of the resistance, and with the onset of the Cold War, new ideological and personal conflicts ultimately rendered them short-lived. Works like *Nausea* (1938) and *No Exit* (1944) by Sartre and *The Stranger* and "The Myth of Sisyphus" (1942) by Camus indulged in a bohemian subjectivism that was somehow reminiscent of times past. But their arguments soon enough made way for a new literature of engagement. In the increasingly sclerotic Soviet Union, meanwhile, "Zhivago's children" kept trying to reinvent a cultural revolt reminiscent of a prerevolutionary time.[5] Intellectuals in the postwar world, which should actually be termed "the age of Kafka," interpreted the works of this now wildly popular writer as a warning rather than a hope.

New York and Los Angeles became the new art capitals. Modernism crossed the Atlantic, but the crossing proved traumatic. It is a mistake simply to look at the plight of individual exiles. Deportations of entire populations during the 1930s, the rise of the modern culture industry and the bureaucratically centralized state, the cosmic disorientation produced by knowledge of the Holocaust and the gulags during the '40s and the ideological rigidities generated by the Cold War, and the emergence of new social movements and the liberation of the once colonized territories during the '50s and '60s all produced a new existential, cultural, and political context. American artists like James Whistler and other exiles, of course, had influenced French painting following the Civil War.[6] Henry James, T. S. Eliot, Hemingway, and Dos Passos exerted an extraordinary impact on European

literature during the '20s and '30s. But the ethos of classical modernism was still ultimately European. That the United States (or better, white America) should have become the center for the new rebellion against conformity and an obsession with consumerism in the postwar world only makes sense given its individualist ideology and its economic preeminence.[7]

Abstract expressionism emerged in 1946: it was the first American avant-garde movement in painting.[8] Influenced by the German expressionists' explosive use of color, and the automatic techniques of surrealists intent on freeing the subconscious, its major artists created a sensation. Canvases seemed to burst through the drip style of the mercurial Jackson Pollock's action paintings, and Arshile Gorky intensified the employment of color in nonobjective paintings. The color field was introduced by Barnett Newman, Mark Rothko, and the much underrated Hans Hoffmann. Abstract expressionism ousted the kind of engaged realism associated with the artistic public works projects of the New Deal just as communism and the labor movement were coming under attack by McCarthyism. Of course, the abstract expressionists despised the new atmosphere that helped make them popular among the liberal bourgeoisie. If these artists hated the philistine, however, their opposition was based on an inward turn.

Abstract expressionism, for all its aesthetic contributions, had no politics and no utopian vision. This first American avant-garde movement was defined by a slogan belonging to the very philistine its bohemian members despised. The phrase, "Without Me," reflected popular thinking in Germany following World War II and later informed the bitter vision of films like *The Marriage of Maria Braun* (1978) and *Lola* (1981) by Rainer Werner Fassbinder. Abstract expressionism intersected with the Beats of the 1950s and early '60s. There is a sense in which they shared similar concerns and ideological predispositions. Beat writers and poets also offered new stylistic innovations, new demands for individual expression, and a new sense of the uncharted road that remains so much a part of American tradition.[9] As a young man, Jack Kerouac may have admired the great socialist leader Eugene Debs; Allen Ginsberg was a pacifist and champion of gay rights with communist sympathies, whose most important poems, "Howl" (1956) and "Kaddish" (1961) would inspire the counterculture;[10] and even William Burroughs, author of *Junkie* (1953) and the phantasmagoric *Naked Lunch* (1959) had his personal political inclinations. But the response of these artists to the cultural stagnation of the 1950s was ultimately predicated on individualism. Political engagement fell by the wayside: the rebels lacked a cause.

## Judgment

Modernism has conquered much of the globe.[11] But its radical spirit has been tempered: its obsession with the new, its formalism, its individualism, and its utopian politics all require reinterpretation to meet the demands of a new age. Anti-art has entered the museum—as if it could ever have gone anywhere else. Modernism is surely more than a dusty inheritance and a source of mild amusement. But the context for its radicalism has changed. The avant-garde is no longer relevant in the same way as it was around the turn of the twentieth century. The culture industry now performs the tasks once undertaken by the modernist avant-garde: it generates the most sophisticated technical innovations, it transfigures everyday life with "virtual reality," and it indulges the most diverse possibilities for subjective experience. The culture industry institutionalizes the new in advance of its public, and the avant-garde proponents of this or that fad happily comply. Or, at least, that is the case before they connect the dots between their indignation about "everything" and its systemic sources. Whether the technical innovations of the culture industry foster reflection, whether everyday life is more reified, and whether subjectivity is simply being indulged and its content debased are other matters.

Modernists often believed that the new bursts spontaneously on the scene: it is unpredictable. No one foresaw rock and roll, the French new wave cinema, hip-hop, or a host of other developments. Enough modernists believed that their art must mark a complete break with the past. But there is no such thing. Brecht liked to say that the new never emerges ex nihilo—yet still it is new. The new can take different forms: it can illuminate hidden forms of exploitation and repression, generate cultural attitudes that serve as preconditions for political action, and anticipate elements of a utopian (or dystopian) future. How the artist might accomplish such tasks—whether through a fleeting image on a computer screen or through a complex and learned work like Thomas Pynchon's *Gravity's Rainbow* (1973)—is not the province of the critic. There is no reason why an artist should write the book, compose the music, or paint the painting that a particular critic wishes to read, hear, or see.

Modernism championed what Robert Hughes appropriately termed "the shock of the new." But the shock of any work dims with repetition. Just how often can an audience listen to a composition by John Cage being "played" by an artist on a nonexistent instrument? Or look at an overflowing garbage can as a sculpture? Or hear "shit!" the first word of Alfred Jarry's *Ubu the King* (1896), and be scandalized? What shocked in times past now appears

somehow quaint. Shock today is meant to sell. *Art News Blog* reported in 2007 that the *Diamond Skull* by Damien Hirst—a platinum cast from the skull of a person who lived in the eighteenth century encrusted with 8,601 diamonds—was bought for 100 million dollars by an unnamed investment group that planned to resell it at a later date (with Hirst getting a cut). The artwork is no longer a self-contained entity. Novels are often published with an eye to their being made into movies or television shows. And a similar situation exists for other genres. Philosophers may once have treated the work of art as an end in itself. But it has since become either a commodity in its own right or a means for selling another commodity. Anything can serve that purpose. Music from Beethoven and Tchaikovsky is used as the background for television commercials. A song by Woody Guthrie, the influential folk singer and political radical of the 1930s, is used to sell cars, and a holograph of Albert Einstein helps sell computers. Paintings by Klimt and Picasso are popular posters. Frank Wedekind's *Spring Awakening*, a devastating and notorious assault on Victorian sexual morals, now has been transformed into a "coming-of-age" rock musical for tourists wishing to take in a Broadway show. Baudelaire believed that art could never genuinely influence the world. That position has become a pose for artists basking in a new form of power-protected inwardness.

Galleries and museums, like the huge new Tate Modern in London, are presenting what was once considered anti-art: pop art, op art, minimalism, trash art. The very idea of the new has been robbed of its critical character. Modern art no longer unleashes the kind of political fury or sense of insurgency among the right associated with the first Armory Show of 1913 in New York City, where provincial American art students, after having been confronted with the infamous *Nude Descending a Staircase* (1912) by Marcel Duchamp, wound up burning Matisse in effigy and aligning with even more staunch conservatives who insisted on an investigation by the Vice Commission. Back then these reactionaries had something legitimate to fear from modernism and what Peter Gay elegantly termed "the lure of heresy." The new was associated with breaking the shackles of a national academic art, forging a new cosmopolitan style,[12] and a "world standard."[13] Today things are different: Kurt Jacobsen, the prolific social scientist and cultural commentator, once ironically suggested to me that some clever quantitative type should work on a scale that draws the connection between artistic acceptance and "abstract opposition."

Nonconformity, formalism, and inwardness legitimate liberal society. Cultural rebellion is applauded in the urban capitals of the modern world.

Conservatives, provincials, and reactionaries still threaten the experimental artist, but they are on the defensive. Liberal society is the sandbox in which modernists safely build their castles and admire their virtuosity. What was once new has become old. Modernism enabled each to create his own art. Its most important representatives recognized the creative possibilities of the child, the schizophrenic, the "primitive," and the outsider. But the shock of the new is now subject to reification. Hirst is known for exhibitions of his pickled sharks and bovine carcasses as well as the "spin" and "spot" paintings produced by his assistants. Debates also still rage on the Internet over the "art" (or the concocted myth that itself became the artwork) of some sadistic half-wit who took a dog and starved it to death in front of a video recorder—because, after all, all this is new and the new is art.

Too many otherwise intelligent critics have fallen for this nonsense. If anything is art then not only is relativism carried to the absurd but the critic is left to impute a political or social point of reference to the work with which our dog torturer is not in the least meaningfully concerned. All this is an expression of what Herbert Marcuse termed "repressive tolerance"— or rendering relative and thereby defusing what is genuinely critical, radical, and liberating about an artwork. Critical judgment with a social edge is a crucial moment of aesthetic experience. Few modernists believed that the art of one period was better than that of another. Whatever their fuzzy criteria of judgment, however, most thought that within a single historical epoch it was possible to determine differences between progressive and reactionary art—and that "the art of the last few centuries, and even of older art, [was] a process pointing to a goal: the progressive emancipation of the individual from authority and the increasing depth of self-knowledge and creativeness through art."[14]

Stripped of that purpose, the supposedly political implication of the artwork becomes completely self-referential, and determinations of quality appear arbitrary. All of this in turn erodes the ethos of resistance. Radical aesthetics is radical only insofar as it questions a capitalist production process predicated on transforming quality into quantity. Meyer Schapiro put the matter well in aesthetic terms when he wrote, "The problem of abstract art, like that of all new styles, is a problem of practical criticism and not of theory, of general laws of art. It is the problem of discriminating the good in an unfamiliar form which is often confused by the discouraging mass of insensitive imitations. The best in art can hardly be discerned through rules; it must be discovered in a sustained experience of serious looking and judging with all the risks of error."[15]

Modernism was intent on transforming everyday life by multiplying the ways in which we can look and experience it. Marcel Duchamp turned the urinal into a work of art, and Pablo Picasso transformed the seat and handlebars of a bicycle into the head of a bull. A war-torn world was thereby faced with its own absurdity, and art illuminated the fungible character of reality. Such artists opposed the dead hand of tradition. But they did not reject tradition outright: they created their own or made it new. T. S. Eliot noted correctly in his famous essay "Tradition and the Individual Talent" (1919) that modernism recognized the past in its presence and transformed the past in terms of the present.[16] Modernists of the most diverse temperaments combined the aesthetic contributions of what were once considered "primitive" civilizations with the utopian possibilities hidden in technology. These artists thereby enriched reality, increased the resources of creativity, and expanded the realm of experience. Their cosmopolitanism strengthened the ability of art to combat the conventional and habitual. Modernism at its best led T. W. Adorno to identify the paradigmatic moment of art with "fireworks."

Every day now has its fireworks, and—with the proper technology— each moment can be made to stay as long as the individual likes. Such is the character of hyperreality as constructed by the culture industry. Perhaps standards have fallen. But it is difficult to deny the technical advances of mass-market movies like *The Matrix*. Formal experimentation no longer offers much in the way of resistance—not because it is elitist and unpopular, but because it is harmless and resigned to its harmlessness. "Avant-garde" videos of a road whose lines project asymptotically into the future, a bicycle rider falling off and getting back on his bicycle, and the like might be of interest to a certain audience. But the claim that this somehow contests the culture industry is absurd. The same effects can be realized—and probably realized better—by the culture industry. Exceptional achievements have been generated by contemporary avant-garde artists since the time of classical modernism. It would be foolish to argue otherwise. But these usually offer what the culture industry cannot provide. As for intensifying the experience of subjectivity, the culture industry has made it possible for masses of people to enjoy more experiences through the products it offers.

Only blindness to empirical reality makes it possible to suggest that aesthetic experiences generated by popular culture are superficial or not as "deep" as those enjoyed by an elite minority. The profits reaped from television, mass cinema, and rock concerts, no less than the popularity of tabloids, celebrity gossip shows, and the like, attest otherwise. The populace

votes with its pocketbook. Ideology, in terms of custom and prefabricated tastes, enters into the decision of what products to spend the hard-earned cash on. But then, in dialectical terms, ideology always has its moment of truth. Ignoring this moment produces cultural and political paralysis. That is why those who simply rebel against the culture industry never have anything concrete to posit as an alternative. Considered from a critical cultural and progressive political perspective, indeed, the culture industry offers a contested terrain. It should be dealt with as one form of cultural production among others. No more, no less.

## Meaning

Modernity has generated multiple publics with distinct tastes and standards of judgment. The old assumption that popular culture remains stagnant while high culture somehow magically progresses has lost any validity it might once have had. Jazz—perhaps the only genuinely indigenous American art form—fluctuated between high art and popular culture. An array of musical talents ranging from Bessie Smith and Duke Ellington to George Gershwin and Sarah Vaughn to Leonard Bernstein and Miles Davis undermined that distinction. Popular jazz artists like Louis Armstrong, Billie Holiday, and Ella Fitzgerald transformed music as they fashioned and refashioned their own unique interpretations of standard songs into an evolving tradition. As regards the authentic experience of art, which takes the argument in a somewhat different direction, Kant would have known far better than his more "critical" successors that the experience of Emma Bovary reading her dime-store romances was as intense, or "heightened," as that of Adorno and Marcuse listening to Schoenberg or reading Beckett. Obsession with decrying the culture industry in the name of some authentic—yet always indefinable—subjectivity ignores this reality. Even worse, insofar as the culture industry is seen as structuring an administered society, the *aesthetic* confrontation with the culture industry is unthinkingly transformed into a form of *political* resistance.

Walter Benjamin's claim that progress in the arts depends on the ability of artists to offer technical innovations relevant to other artists thus requires qualification.[17] New developments in art cannot ignore the innovations of the culture industry—and many don't. This was already true of the futurists and the surrealists, and it is also the case with pop art, op art, and the arts of our time. Insisting that art *must* evoke the great refusal, or a sense of utopia denied, is really a form of provincial nostalgia for the semi-

nar room masquerading as radicalism. A few will refuse to watch television entirely, and a few more will condemn the Oscars or the Super Bowl. But this personal protest is ultimately symbolic. Not every popular work suc-cumbs to the dynamics of repressive tolerance.

Distinctions between high and popular art have not disappeared. But they have shifted their locus. These were never fixed categories to begin with, and today the new wanders between them. New traditions, genres, and structures of cultural production have been generated in which par-ticular works find their meaning and value. All such systems over time (and through what Niklas Luhmann termed "autopoiesis"[18]) tend to become more complex, jargon-filled, and designed for specialists. Sartre made this point about modern music.[19] But it pertains as well to modernist poetry, literature, and painting. What is true of law as it developed from the Ten Commandments and the Code of Hammurabi to the indecipherable tax forms and specialized courses of contemporary legal study is equally true of art with its phalanx of critics, professors, dealers, and investors—and system-generated "experts"—who determine its value and its purpose.[20]

Aesthetic meaning becomes manifest within this world: art in general and modernism in particular thus become intelligible not through frozen traditions but as dynamic processes constituting a multiplicity of genres and techniques. New forms of high and popular art need to be considered elements or subsystems in what is an ongoing artistic process or system. The autopoietic process generates its own distinctions as the system secures its social space and standing. It is now commonplace to speak about mod-ernist classics, and only the most retrograde philistine would deny space in a museum to traditions deriving from Dada or others that were once asso-ciated with anti-art. What is true for high culture is also true for its putative opposite. There is a rock and roll hall of fame, and the "golden age of televi-sion," with performers like Lucille Ball, Milton Berle, and Jackie Gleason, is often used as a point of reference for judging contemporary shows. Even certain commercials are considered classic. The emergence of new tradi-tions in new genres and the need for classics, critical judgments, and quali-tative distinctions are practical elements of cultural life.

The new speaks to the quest for meaning, or in this case, the modern-ist confrontation with the bourgeois society that rendered existence mean-ingless. Kafka was only the most brilliant exponent of this theme, and it is perhaps best crystallized in Sartre's famous claim that "man is a useless passion." In the 1960s such themes were driven home in critical works like those of Paul Goodman, who wrote about "growing up absurd." The

concern with meaninglessness was usually associated with an attempt to establish some perspective on authenticity or a code of conduct to confront the absurd and the degeneration of norms in modern life. André Gide described the main character of his novel *The Immoralist* as a "palimpsest," whose discovery of an authentic self—outside the variety of social roles imposed on him—led to a kind of revelatory rebirth. The preoccupation with meaning—or the lack of it—became increasingly dominant in the postwar era with the great playwrights associated (for better or worse) with the Theater of the Absurd, including Samuel Beckett, Eugene Ionesco, and Dario Fo.

But this reaction against the presumed meaninglessness of modern life, or what Adorno termed the "ontology of false conditions," also tended to generate a new apocalyptic or redemptive outlook that would find resonance in the counterculture of the 1960s. Many modernists on both sides of the political spectrum envisioned a new man. None of them, of course, had any idea of what he would look like, let alone the invigorated everyday life he would inhabit, and most soon became disillusioned with what the totalitarian movements ultimately provided. When the fascist and communist movements were on the rise, each was engaged in an assault on the quotidian existence of bourgeois society, and each was concerned with unleashing the repressed will, or subjectivity, of the masses. Too few modernists were political defenders of *real* freedom: the supporters of parliamentary democracy constituted the exception rather than the rule. Too many of the politerati camouflaged their ignorance of political reality through aesthetic pronouncements of reliance on the formal virtuosity of their art. Their otherworldliness, however, offered modernists a built-in exit strategy. Once their political claims came under fire, indeed, they—or their admirers[21]—could quickly retreat into the purely aesthetic character of their undertaking. These political artists wanted to have it both ways. They wished to condemn the system without understanding its workings and perhaps even generate solidarity, yet still preserve their autonomy and dissociate themselves from popular "misunderstandings." It is as if for them the very act of creation was an act of resistance.

Art can "speak truth to power," but only in the rarest instances does it offer an actual strategy of political resistance. Diego Rivera fostered both political reflection and solidarity through his art. Billie Holiday did the same while singing about lynchings in "Strange Fruit" (1939), and the unjustly forgotten Ethel Waters did it while singing of jail-time in "Lonesome Walls," poverty in "Bread and Gravy," despair in "Down in my Soul,"

and what it was like to feel so "Black and Blue."[22] Few European modernists were political in this way, and even fewer crystallized the experience of a disenfranchised and exploited community or class. Most exhibited a soft humanism, though many anticipated once-personal issues that have since become political: alienation, anomie, identity, generational conflict, sexual repression, and more. Modernism fostered the cultural and existential preconditions in which radical politics might thrive. How this was done varied according to artist, genre, work, and context. The sheer diversity of forms, plurality of styles, and varied sensibilities attest to the words of Leon Trotsky: "Art, like science, not only does not seek orders but by its very essence cannot tolerate them."

## Liberation

Modernism launched an assault on reification. Its avant-gardes sensed the subterranean cultural crisis that had emerged from the crucible of class conflict, imperialism, industrialization, and mass society. They confronted standardization, bureaucracy, hierarchy, and mass culture in order to liberate the unique subjective experience these trends denied. There is a profound way in which modernists in general, and expressionists in particular, were "left-wing Nietzscheans."[23] Modernists contested universal postulates with Nietzsche's insistence that "the subject is a fiction." Subjectivity was their point of reference, and unleashing its potential was seen as having apocalyptic consequences. Compromise, organization, and institutional realities were merely annoyances. Politics turned into a utopian enterprise of all or nothing, and given the choice, to echo Brecht,[24] the world usually replied: then better nothing. But the assumptions that proved so politically disastrous also opened the way for a critique of the consensual object, and the representational techniques and assumptions associated with it. Exaggeration, collage, montage, and a host of nonrepresentational techniques liberating the unconscious and reconstituting the experiences of everyday life were made possible by the new emphasis on subjectivity with utopian inclinations. Formal experimentation became the source of resistance. Indeed, for better or worse, this aesthetic impulse was then interpreted from the perspective of political action.

Expressionism, futurism, surrealism and the other major modernist movements all evinced similar self-understandings. They all refused to insulate art from society. All of them sought to engage the masses even if the masses did not wish to engage them. None of these movements were

aware, however, of the autopoietic impulses that were taking hold. Especially in the aftermath of World War II, and then again following the 1960s, modernists ever more surely began painting not for society but for each other and their critics. Bertram Wolfe was correct in suggesting that the artistic product gradually became subordinate to the creative process and the experiment trumped the idea of a finished work. Only in this sense did the influence of modernism extend beyond its own artists, drip down to those working in the culture industry, and create a new type of aesthete interested in forms in which to express experience rather than the constitution of experience itself. The modernist assault on the object, fixed forms, and common sense annihilated any possibility of consensually evaluating political forces or articulating the institutional obstacles to social change. Liberation became abstract, indeterminate, and self-referential.

Humanitarian ethics and utopian longings now play less of a role. Resistance has ever more surely involved turning prose inward, poetry into a language game, and music into the preserve of the expert. The preoccupation with form for its own sake—whatever the insistence on experiential authenticity—fits neatly into a commodity culture in which each searches for the proper packaging to fill a new niche. Criticism has been mobilized against "essentialist" claims, as well as ingrained habits and prejudices, in terms of ever more specific and parochial forms of identity and experience.[25] The new outlook projects a cynical and debilitating ambiguity that directs itself against every claim to resistance or rebellion as easily as against every conservative tradition. Postmodern thinkers have produced a stance whereby each interpretive "gaze" or "standpoint" can be treated as equally valid. Beauty returns to the eye of the beholder. Each aesthetic stance becomes equally legitimate—then retracted by its author and arbitrarily transformed into its opposite as circumstances dictate. Supposedly neutral and cool forms of self-observation (not very different from what was once termed navel-gazing) by novelists like Bret Easton Ellis or Michel Houllebecq are justified by the notion that if self-observation is taking place then other forms of observation are taking place as well. The abdication of articulated judgment turns into a principle of judgment.

Ambiguity crystallizes the effort: it becomes the new aesthetic alternative to the old political notion of solidarity. Resistance turns into the crucifix suffused in urine, or a cow cut in half and suspended in formaldehyde. Is this a response to cruelty or resignation in the face of it? Or is it simply a form of sensationalism that is ultimately inarticulate? The aims of a public work thus became privatized. Perhaps it used to be the case that poor writing was

simply a function of fuzzy thinking. With an eye on literature and political discourse, however, Tony Judt made the insightful point that today the situation is different: "Articulacy itself became an object of suspicion in the 1970s. . . . We speak and write badly because we don't feel confident in what we think and are reluctant to assert it unambiguously. Rather than suffering from the onset of 'newspeak,' we risk the rise of 'no-speak.'"[26] Uncertainty and an emphasis on the self-referential is as evident in the most sophisticated poems dedicated to language games as in old pop songs about being "a material girl" and others insisting that "girls just wanna have fun." The issue is not that conflicting elements in a work might enable diverse forms of interpretive signification. Akira Kurosawa in *Rashomon* (1950) explicitly offers multiple perspectives from which members of an audience can choose in seeking—and the point is the search—to make sense of an event. The trend today, however, is to turn ambiguity into an aesthetic end in itself. Not only does such an art paralyze critical judgment (in some perverse reconfiguration of Kant), but no common point of reference remains for the resistance and rebellion that modernist artists so often wished to invoke.

Victor Serge put it well when he demanded of his contemporaries that they "have the courage to see clearly." No one is talking about a return to socialist realism.[27] Always concerned with infringements on their own freedom of expression (which is, after all, the basis for their livelihood), artists are a little less concerned when it comes to the need for commitments that might foster the freedom of others. With the passing of the communist movement, there is no longer any mass-based organization capable of securing political compliance. Socialist realism is a thing of the past. Most artists, in fact, have lost any sense of what that term actually meant. It involved less some general concern with heightening the sensitivity of an audience to social movements and political values, or the preconditions for generating them, than an express concern with the given "line" of the Communist Party regarding any given artistic style or policy. No critic should judge an artwork by whether the artist has produced what he or she wishes to read, see, or hear. Social reality can be illuminated in any number of ways. Thus it is not a question of an artist adhering to any particular style or genre, but of having the willingness and ability to express his or her convictions in a meaningful way.

## Afterglow

Modernism has left behind a rich legacy. It reconfigured reality, contested established logic, and tested the limits of experience. Modernism deepened

our ability to understand society and, thus, the possibilities of criticizing and engaging it. Charlie Chaplin used the nonsense dialogue of Dada in *Modern Times* (1936) and *The Great Dictator* (1940); Ralph Ellison employed surrealism in his *Invisible Man* (1953) to convey the plight of African-Americans. The French new wave filmmakers linked themselves to the political radicals of the 1960s less by depicting the "reflection of reality" than by insisting on the "reality of reflection." Wallace Shawn and Vanessa Redgrave had their own ways of exposing the disorienting impact of political awareness on an individual of conscience, first in Shawn's play *The Fever* (1990), and then in Redgrave's cinematic adaptation. Jorge Luis Borges illuminated the "unreal" within the "real" and Gabriel García Márquez compressed the past and the future in his classic work of magic realism, *One Hundred Years of Solitude* (1967). Even Thomas Mann, the "bourgeois realist" par excellence, employed the interior monologue to great effect in *Lotte in Weimar* (1939) and other novels. All these works exhibit a modernist temperament; all exhibit political engagement; all challenge society; and all have an objective frame of reference for judging the experiences of their characters.

Modernism presented a new form of pedagogy. Its artists began with the assumption that rigidly pitting the real against the abstract is both philosophically senseless and artistically impractical. Their work makes clear that reality is incomplete without the experience of individuals, whose expression usually requires something other than a representational form. Perhaps inadvertently, they also showed how belief in the purity and autonomy of experience is an ideological holdover from the religious mystics. In particularly radical fashion, modernism demonstrated that experiences can be evoked and stories told in a variety of ways. Artists like Picasso and John Heartfield fused seemingly antithetical forms with an eye on a new pedagogy and a reflective form of solidarity. The project of such artists projects beyond what exists. They envision what currently seems implausible, and render possible what currently appears impossible. Brecht once said of Kafka that he "saw what was coming without seeing what was there." But it was the same with Fritz Lang's film *Metropolis*—where half-dead workers have numbers instead of names, and masses of slaves constitute living sacrifices for a fire-eating monster—and countless other works. The artist does not merely project what is but also what can be, and modernism teaches that often the two are connected. Thomas Mann liked to speak of the "signaling function" of the artist, and how he serves as a "seismograph" even though "his sensitivity lacks clear knowledge and thus is capable of making wrongheaded decisions."[28]

Modernism evinced the ways in which the new retains an anticipatory function. The years just before and after World War I seemed to justify those modernists who had expressed their intuitive premonitions of impending catastrophe, such as Franz Marc in his *Fate of the Animals*. Expressionism, like futurism, reflected the mood of impending chaos and apocalypse. Most modernists were critical of World War I. Zurich became the haven of Dada—whose artists were disgusted with everything. The Dadaists reflected the prevalent nihilism even as they turned despair into humor. Always, however, there were explicitly humanistic and political modernists like René Schickele—whose pacifist journal *The White Papers* swam against the nationalist and militarist tide—and Hermann Hesse, Romain Rolland, and Stefan Zweig, whose polemics and exchanges constituted a lasting legacy of the cosmopolitan spirit.

Modernism was a seismograph. Its artists anticipated the famous slogan from 1968, "power to the imagination." Especially for those modernists intent on deconstructing the object and any commonsense understanding of the real, it was difficult to speak about politics. They meant something different by the term. The best of them identified the emancipation of subjectivity and everyday life with a transformative political project. They called for an education of the sentiments and change at the level of the subpolitical. Their pedagogy was also cosmopolitan in a radical way. André Malraux brings this to mind with his notion of an "imaginary museum" in which the great masterpieces of the world confront one another in a kind of cosmopolitan interrogation. No longer is the classic museum that offers the paintings of a single culture (with a smattering of a few others) salient to the diversity of an expanded world. In this new "museum without walls" every civilization evinces its own constantly shifting canon of works, and the relevance of each emerges to contest the arrogance and deficits of the others.[29] Few ideas of our time speak to the new communicative possibilities of the Internet in quite the same way—or with quite the same implications. Here, in the imaginary museum, it is possible to see what brings people together—and what keeps them apart.

Whatever the expressly political misconceptions of the modernists, whatever their dislike of liberal institutions, and whatever their personal prejudices, they popularized a new form of aesthetic pluralism. This not only expanded the range of experiential possibilities but also—strangely or, perhaps, dialectically—enabled modernism to provide a cultural content for political liberalism. This aspect of modernism has been neglected perhaps because of a preoccupation with what Lionel Trilling called the "lib-

eral imagination." Unconcerned with privileging any particular vision of the public good, its most basic principles like the rule of law are empty of all empirical and experiential content.[30] Thus even while completely oblivious to institutional matters, the new legacy of modernism projects *the exercise of pluralism* that liberal institutions formally guarantee.

Mystical and often racist outlooks (like that of D. H. Lawrence) mixed with genuine respect for the then still unrecognized cultural genius of Africa, Asia, and Latin America. Western modernists were mostly unconcerned with their own community, and in this respect, their cosmopolitanism can be seen as "detached."[31] Often, to be sure, this detachment took perverse forms: The Tahitian paintings of Gauguin, in which the word "*jouir*" (connoting sexual pleasure) occasionally appears as a frame around the entry to his house, and Gide's *The Immoralist* actually justify the sexual exploitation of women and young boys of "primitive" lands. These artists celebrated the freedom of those whom they treated as western colonizers always treated the colonized. Like so many other modernists, they reflected the imperialist mentality of the modern society they putatively sought to oppose. Nevertheless, the best of them refashioned existing cultural traditions with works that challenged parochial understandings of identity and community.

What became apparent in the 1920s was that the real enemy of modernism was not bourgeois society. A very different set of philistines now seemed insistent less on the traditions associated with the academy than on the predetermined political function to be served by the artwork. Distinctions were irrelevant to them. Political or apolitical, expressionist or cubist, representational or nonrepresentational, line or color—none of this mattered to the Nazis or the communists. They had engaged in a fierce political competition prior to the Hitler-Stalin Pact of 1939. Yet their marches sounded alike, their paintings looked alike, and their novels read alike. Certain modernists succumbed to totalitarianism or later, in conquered countries, compromised with the fascist victors.[32] But their sensibility always rubbed the authoritarian personality the wrong way. Few modernists could ultimately stomach the conformity that totalitarianism demanded. Their aesthetic daring undermines any attempt to identify their enterprise with the kind of barbarism that few artists could have possibly imagined.

Modernism changed the way life was experienced. Its cosmopolitanism was less a form of political theory than cultural practice. There was little reference to some rationally ordered universe. Modernists understood pluralism as something other than a set of aesthetic or cultural ghettoes, each provincially indifferent to its neighbor. Their cosmopolitan sensibility

was integrative. Their ability to blend not merely traits of the old with the new but also the most diverse traditions serves as perhaps the most radical element of their legacy. This cosmopolitan impetus enabled modernists to challenge established artistic norms, multiply the possibilities of experience, and develop a new cultural enterprise. Disgust with the philistine expressed itself as disgust for provincial attitudes and the ingrained habits of everyday life. Modernists sought to make the world more exciting, more fulfilling, and more joyous. That is what led them to contest the traditions associated with the pillars of reaction, or what Stendhal termed "the red and the black": the army and the church. Indeed, just as the "republic of letters" inaugurated an international intellectual community during the Enlightenment, modernism created a new one roughly a century later.

Modernism has much to offer in generating a new cosmopolitan sensibility and a radical political enterprise. An art that builds on its legacy *can* illuminate the feelings and conditions that generate, or constrict, the emergence of a transformative project. Its art can indeed heighten the sensitivity of an audience toward human agency. Modernism transformed the way we hear, see, and think, and it radically expanded the sources from which art can draw. Goethe may have popularized the idea of world literature, but the *world* of art (with a far less Eurocentric bias) begins with modernism. Its construction remains incomplete, and furthering that enterprise is the province of the young. The old enemies of modernism have not yet been vanquished either. They may wear new costumes and use different language. But they remain with us and it is still the young rather than the established connoisseurs, dealers, and scholars of modernism who will need to face them. Auden was right when he wrote, "But today the struggle!" Art can only illuminate the longing for freedom. But that is no small thing. With respect to modernism, indeed, it offers the foundation on which a new cultural radicalism—appropriate to a new age—can build today.

# Notes

Unless otherwise noted, all translations in the book are mine.

## 1. The Modernist Impulse: Subjectivity, Resistance, Freedom

1. Edmund Burke, *A Philosophical Inquiry into the Sublime and the Beautiful* (New York: Oxford University Press, 2009); Immanuel Kant, *The Critique of Judgment* (New York: Oxford University Press, 2007), 75ff.; Friedrich von Schiller, *On Naïve and Sentimental Poetry* and *On the Sublime*, trans. Julius A. Elias (New York: Frederick Ungar, 1966).

2. Note the 1962 introduction by Georg Lukács in his *Theory of the Novel*, trans. Anna Bostock (Cambridge, Mass.: MIT Press, 1974).

3. "Pictorial perception must be like the repetition, the redoubling, the reproduction of the perception of everyday life. What had to be represented was a quasi-real space where distance could be read, appreciated, deciphered in the way that we ourselves see a landscape. There, we enter a pictorial space where distance does not offer itself to be seen, where depth is no longer an object of perception and where spatial positioning and the distancing of figures are simply given by signs which have no sense or function except inside the picture." Michel Foucault, *Manet and the Object of Painting*, trans. Matthew Barr (London: Tate, 2009), 41–42.

4. Peter Gay, *Modernism: The Lure of Heresy from Baudelaire to Beckett and Beyond* (London: Vintage, 2007), 18.

5. Note the fine collection of articles for *Die Aktion* by its editor Franz Pfemfert, *Ich setze diese Zeitschrift wider diese Zeit*, ed. Wolfgang Haug (Darmstadt: Luchterhand, 1985).

6. Stephen Bury, introduction to *Breaking the Rules: The Printed Face of the European Avant-Garde, 1900–1937* (Chicago: University of Chicago Press, 2007), 6ff.

7. Janet Lyon, *Manifestoes: Provocations of the Modern* (Ithaca: Cornell University Press, 1999).

8. Note the standard biography by Richard Ellmann, *Oscar Wilde* (New York: Vintage, 1988). A fresh perspective that offers an important look at the gay culture in which Wilde participated is provided by Neil McKenna, *The Secret Life of Oscar Wilde* (New York: Basic Books, 2006).

9. Georg Lukács, *History and Class Consciousness: Studies in Marxist Dialectics*, trans. Rodney Livingstone (Cambridge, Mass.: MIT Press, 1971), 83ff.

10. "There is a similarity between logical empiricism and surrealism that does honor to the latter. It is in total agreement with the modern empirical tendency to eliminate all 'non-constitutive' concepts as suspicious atavisms. . . . Surrealism not only has made the realities of the dreaming individual equal to the perceptions of the waking individual but has ranked them higher. Surrealist paintings are basic protocols about dream experiences. Protocols also constitute the only substance for logical empiricism, on which the entire field rests. If scientific philosophers finally proceed to formally affirm these protocols not only as substance but as something to actually execute, libraries would appear whose every page would convey a surrealistic character." Max Horkheimer, *A Life in Letters: Selected Correspondence*, ed. and trans. Manfred R. Jacobson and Evelyn M. Jacobson (Lincoln: University of Nebraska Press, 2007), 96–7.

11. Of particular interest are Michael Curtis, *Three Against the Republic: Sorel, Barres, Maurras* (New Brunswick, N.J.: Transaction, 2010); and Vincent Sherry, *Ezra Pound, Wyndham Lewis, and Radical Modernism* (New York: Oxford University Press, 1993). Note also the unsparing essay by Wyatt Mason, "Uncovering Celine," *New York Review of Books,* January 14, 2010, 16ff.

12. Douglas Kellner, "Expressionist Literature and the Dream of the 'New Man,'" in *Passion and Rebellion: The Expressionist Heritage*, ed. Stephen Eric Bronner and Douglas Kellner (New York: Columbia University Press, 1988), 166ff.

13. For a different perspective, which highlights the postmodern assault on the binary distinction between high and popular culture, see Andreas Huyssen, *After the Great Divide: Modernism, Mass Culture, Postmodernism* (Bloomington: Indiana University Press, 1987).

14. Gay, *Modernism*, 24.

15. Andrew Hewett, *Fascist Modernism: Aesthetics, Politics, and the Avant-garde* (Stanford: Stanford University Press, 1993).

16. Max Horkheimer, *Dawn and Decline: Notes 1926–1931 and 1950–1969*, trans. Michael Shaw (New York: Continuum, 1978), 204.

17. Note the revealing appendix, "Karl Marx, der Tod und die Apokalypse," in Ernst Bloch, *Geist der Utopie* (Frankfurt: Suhrkamp, 1971).

18. Herbert Marcuse, "Correspondence with Martin Heidegger, 1947–48," Herbert Marcuse Official Homepage, http://www.marcuse.org/herbert/pubs/40spubs/47MarcuseHeidegger.htm. For critical theory more generally, see Ralph Dumain's "The Autodidact Project," http://www.autodidactproject.org/.

19. Modernist works were to be presented as "as documents illustrating the depths of that decline into which the people had fallen." In the exhibition, which would serve as "a useful lesson," "racially impure," "decadent," "Jewish," "pacifistic," and "bolshevist" artists would be enshrined as a warning. Induced prejudice and genuine curiosity led thousands to attend and hear the poorly played music of Bertolt Brecht and Kurt Weill as they looked at the paintings of Wassily Kandinsky, Oskar Kokoschka, Paul Klee, and their modernist comrades. Indispensable is the translation of the brief 1937 catalogue *Hitler's Degenerate Art*, ed. Joachim von Halasz (London: Foxly Books, 2008). Also see the excellent study by Reinhard Merker, *Die bildenden Kuenste im National-sozialismus: Kulturideologie, Kulturpolitik, Kulturproduktion* (Koln: DuMont, 1983), 163ff.

20. Bury, *Breaking the Rules*, 13.

21. "I will try to distinguish the essay as sharply as possible in order, that I might thereby depict it as a form of art." Georg von Lukács, "Ueber Wesen und Form des Essays," in *Die Seelen und die Formen* (Berlin: Luchterhand, 1971), 8.

22. Of particular interest is Ambroise Vollard, *Recollections of a Picture Dealer*, trans. Violet M. MacDonald (New York: Dover, 1936).

23. It was as if "a space had to be kept between painting and representing: the two procedures must never quite mesh, they were not to be seen as part and parcel of each other. That was because (the logic here was central to the modernist case) the normal habits of representation must not be given a chance to function; they must somehow or other be outlawed. The established equivalents in paint—between that color and that shadow or that kind of line and that kind of undergrowth—are always *false*. . . . So painting put equivalence at a distance." T. J. Clark, *The Painting of Modern Life: Paris in the Art of Manet and His Followers* (Princeton: Princeton University Press, 1984), 20–21.

24. T. W. Adorno, "Versuch das Endspiel zu verstehen" in *Noten zur Literatur* (Frankfurt am Main: Suhrkamp, 1961) 2:188ff.

25. André Breton, *Manifestoes of Surrealism* trans. Richard Seaver and Helen R. Lane (Ann Arbor: University of Michigan Press, 1972), p. 47.

26. Yvan Goll, "Two Superdramas," in *An Anthology of Expressionist Drama*, ed. Walter H. Sokel (New York: Bantam, 1963), 9.

27. H. Stuart Hughes, *Consciousness and Society: The Reorientation of European Social Thought, 1890–1930* (New York: Vintage, 1958), 118.

28. Gilles Deleuze, *Bergsonism*, trans. Hugh Tomlinson and Barbara Habberiam (Cambridge, Mass.: Zone Books, 1990).

## 3. Experiencing Modernism: A Short History of Expressionist Painting

1.   Note the fine survey by Dietmar Elgar, *Expressionism: A Revolution in German Art* (New York: Taschen, 2007); and the indispensable *German Expressionism: Documents from the End of the Wilhelmine Empire to the Rise of National Socialism*, ed. Rose Carol Washton Long (Berkeley: University of California Press, 1993).

2.   Jean-Michel Palmier, *L'Expressionnisme comme révolte* (Paris: Payot, 1978), 184ff.

3.   This theme is developed in the exhibition catalog *Expressionism: A German Intuition, 1905–1920* (New York: Solomon R. Guggenheim Foundation, 1980).

4.   Note the classic study by Bernard S. Myers, *The German Expressionists: A Generation in Revolt* (New York, 1966), 40.

5.   Barbara Drygulski Wright, "Sublime Ambition: Art, Politics, and Ethical Idealism in the Cultural Journals of German Expressionism," in *Passion and Rebellion: The Expressionist Heritage* (New York: Columbia University Press, 1988), 82ff.

6.   Note the important work by David Pan, *Primitive Renaissance: Rethinking German Expressionism* (Lincoln: University of Nebraska Press, 2001).

7.   With his integration of multiple styles, his use of animals to transfigure nature, his anticipations of conflagration, his daring use of color and plane, and the immediacy of his depictions and the simple joy they produce, Marc is among the most important—and undervalued—figures of modern art. See Frederick S. Levine, *The Apocalyptic Vision: The Art of Franz Marc as German Expressionism* (London: Icon, 1979).

8.   Richard Hamann and Johst Hermand, *Expressionismus* (Berlin: Akademie Verlag, 1977), 69.

9.   Ibid., 171.

10.  Palmier, *Expressionnisme en révolte*, 172ff.

11.  Peter Paret, *The Berlin Secession: Modernism and Its Enemies in Imperial Germany* (Cambridge, Mass.: Harvard, 1980), 200ff.

12.  Peter Selz, *German Expressionist Painting* (Berkeley: University of California Press, 1957), 53ff.

13.  Peter Vergo, *Art in Vienna, 1898–1918: Klimt, Kokoschka, Schiele and Their Contemporaries* (Ithaca: Cornell University Press, 1975), 199.

14.  Quoted in Hans Fehr, *Emil Nolde: Ein Buch der Freundschaft* (Munich: Paul List Verlag, 1960), 62.

15.  Frances Carey and Antony Griffiths, *The Print in Germany, 1880–1933* (London: British Museum, 1984), 18.

16.  Herman Bahr, *Expressionismus* (Muenchen: Piper Verlag, 1918).

17.  John Willett, *Art and Politics in the Weimar Period: The New Sobriety, 1917–1923* (New York: Pantheon, 1978), 72ff and 95ff.

18.  Peter Gay, *Weimar Culture: The Outsider as Insider* (New York: Harper and Row, 1968).

19. Siegfried Kracauer, *From Caligari to Hitler: A Psychological History of the German Film* (Princeton: Princeton University Press, 1947), 59.

20. Willett, *Art and Politics in the Weimar Period*, 95ff.

21. Steve Plumb, *Neue Sachlichkeit, 1918–1933: Unity and Diversity of An Art Movement* (New York: Rodipi, 2006). See also Margot Morgan, "The Decline of Political Theater in Twentieth-Century Europe: Shaw, Brecht, Sartre, and Ionesco Compared" (PhD dissertation, Rutgers University, New Brunswick, N.J., 2010), 69–83.

22. George Grosz, *Ecce Homo* (New York: Dover, 1976).

23. Eckhard Siepmann, *Montage: John Heartfield: Vom Club Dada zur Arbeiter Illustrierte Zeitung* (Berlin: Elefanten Verlag, 1977).

## 4. The Modernist Spirit: On the Correspondence Between Arnold Schoenberg and Wassily Kandinsky

1. Arnold Schoenberg and Wassily Kandinsky, *Letters, Pictures and Documents*, ed. Jelena Hahl-Koch and trans. John C. Crawford (London: Faber and Faber, 1984). Note also the work deriving from an exhibit by the two men at the Jewish Museum in New York: Fred Wasserman, *Schoenberg, Kandinsky, and the Blue Rider* (New York: Scala, 2007).

2. Alma Mahler-Werfel, *Mein Leben* (Frankfurt: Fischer, 1963), 145 and passim.

3. Note the letter by Schoenberg written on April 9, 1923, and the poignant response by Kandinsky five days later, along with the draft of yet another letter by Schoenberg on May 4, 1923 in Schoenberg and Kandinsky, *Letters, Pictures and Documents*.

4. Henry A. Lea, "Musical Expressionism in Vienna," in *Passion and Rebellion: The Expressionist Heritage*, ed. Stephen Eric Bronner and Douglas Kellner (New York: Columbia University Press, 1988), 315ff.

5. Note the sketch and description by B. F. Dolbin and Willy Haas, *Gesicht einer Epoche* (Munich: Bertelsmann, n/d), 125ff. See also Marc A. Weiner, "Hans Pfitzner and the Anxiety of Nostalgic Modernism," in *Legacies of Modernism: Art and Politics in Northern Europe, 1890–1950*, ed. Patrizia C. McBride (New York: Palgrave, 2007), 17ff.

6. Paul Hofmann, *The Viennese: Splendor, Twilight, and Exile* (Anchor: New York, 1988), 8, 138ff.

7. Peter Selz, *German Expressionist Painting* (Berkeley: University of California Press, 1957), 185ff.

8. Ibid., 177ff.

9. Jelena Hahl-Koch, "Kandinsky and Schoenberg," in Schoenberg and Kandinsky, *Letters, Pictures, Documents*, 148.

10. Schoenberg and Kandinsky, *Letters, Pictures and Documents*, 23.

11. Ibid.

12. Ernst Bloch, *The Principle of Hope*, trans. Neville Plaice, Stephen Plaice, and Paul Knight (Cambridge, Mass.: MIT Press, 1986), 3:1090.

13. Schoenberg and Kandinsky, *Letters, Pictures and Documents*, 35.

14. Theodor W. Adorno, "Arnold Schoenberg (1874–1951)," in *Prismen* (Frankfurt: Suhrkamp, 1955), 181.

15. Quoted in "Die 'Philosophie' von Klimt und der Protest der Professoren," in *Die Wiener Moderne: Literatur, Kunst, und Musik zwischen 1890 und 1910*, ed. Gotthart Wunberg (Stuttgart: Reclam, 1981), 522. The article concerned the 1894 protest by a number of reactionary professors on allowing three nudes by Klimt to adorn the ceiling of a university building. Note the discussion by Carl E. Schorske, *Fin-de-Siècle Vienna* (Vintage: New York, 1981), 225ff.

16. Schorske, *Fin-de-Siècle Vienna*, 330.

17. Schoenberg and Kandinsky, *Letters, Pictures and Documents*, 27.

18. Ibid., 54.

19. Ibid., 57.

20. Thomas Mann, *The Genesis of a Novel*, trans. Richard and Clara Winston (London: Secker and Warburg, 1961), 40.

21. Note the fine discussion by John Bokina, *Opera and Politics: From Monteverdi to Henze* (New Haven: Yale University Press, 1997), 155ff.

22. Robert Hughes, *The Shock of the New: The Hundred-Year History of Modern Art; Its Rise, Its Dazzling Achievement, Its Fall* (New York: McGraw-Hill, 1980), 202.

23. Meyer Schapiro, "Nature of Abstract Art," in *Modern Art: 19th and 20th Centuries; Selected Papers* (New York: Braziller, 1978), 201.

24. Hahl-Koch, "Kandinsky and Schoenberg," 142.

25. Schoenberg and Kandinsky, *Letters, Pictures and Documents*, 21.

26. Apollinaire once said of Kandinsky that "the only thing he obeys is chance." Guillaume Apollinaire, "The Opening," in *Apollinaire on Art: Essays and Reviews, 1902–1918*, ed. Leroy C. Breunig and trans. Susan Suleiman (New York: MFA Publications, 1972), 214.

27. Schorske, *Fin-de-Siècle Vienna*, 327.

28. Adorno, "Arnold Schoenberg," 187; Schorske, *Fin-de-Siècle Vienna*, 361.

29. Schorske, *Fin-de-Siècle Vienna*, 351.

30. Schapiro, "Nature of Abstract Art," 210.

31. Allan Janik and Stephen Toulmin, *Wittgenstein's Vienna* (New York: Dee, 1973), 250ff.

32. Kandinsky, "Commentaries on Schoenberg's Theory of Harmony," in *Letters, Pictures, Documents*, 131.

33. Janik and Toulmin, *Wittgenstein's Vienna*, 106–7.

34. Kandinsky, "Commentaries on Schoenberg's Theory of Harmony," 131.

## 5. Modernism in Motion: F. T. Marinetti and Futurism

1. All quotations are from the anthology *Marinetti: Selected Writings*, ed. R. W. Flint, trans. T. W. Flint and Arthur A. Coppotelli (New York: Farrar, Straus and Giroux, 1971). See also the excellent new collection by Lawrence Rainey, Christine Poggi, and Laura Wittman, eds., *Futurism: An Anthology* (New Haven: Yale University Press, 2009).

## 6. Ecstatic Modernism: The Paintings of Emil Nolde

1. Martin Gosebruch, ed., *Nolde: Watercolors and Drawings*, trans. E. M. Kustner and J. A. Underwood (New York: Praeger, 1973), 7.

2. "There is no doubt, however, that Nolde's contempt for rationality contributed subliminally to the popularity of his pictures. His appeal to the instincts has become a threat to his art. For one would misunderstand the work itself if one were to take it only as the testimony of a blind, eruptive painter." Emil Nolde, *Gemälde aus dem Bestlz von Frau Jolanthe Nolde*, text by Jens C. Jensen (Heidelberg: Kurpfälzisches Museum, 1969), 12.

3. Paul Klee described Nolde as an "elemental spirit" and a creature of the "lower regions" in his contribution to Rudolph Prosbt and others, *Festschrift für Emil Nolde: Anlässlich seines 60 Geburtstages* (Dresden: Neue Kunst Fides Verlag, 1927).

4. Peter Selz, *German Expressionist Painting* (Berkeley: University of California Press, 1974), 124.

5. Thus Alfred Hentzen asserts that, "certainly, the significance of a work of art is absolute and independent of the circumstances under which it was created." Alfred Hentzen and Martin Urban, *Unpainted Pictures: Emil Nolde, 1867–1950* (New York, Knoedler, 1966).

6. Peter Gay, *Modernism: The Lure of Heresy from Baudelaire to Beckett and Beyond* (London: Vintage, 2007), 424.

7. Quoted in Hans Fehr, *Emil Nolde: Ein Buch der Freundschaft* (München: Paul List Verlag, 1960), 54.

8. On the conflict over French influence and the call for a new German art, see Peter Paret, *The Berlin Succession: Modernism and Its Enemies in Imperial Germany* (Cambridge: Harvard University Press, 1980), 156ff.

9. Emil Nolde, *Das eigene Leben: Die Zeit der Jugend, 1867–1902* (Flensburg:Verlagshaus Christian Wolff, 1949), pg. 44.

10. "Idealism and materialism face each other like opposite poles of a magnet, attracting and repelling each other." Nolde, *Jahre der Kämpfe* (Berlin: Rembrandt Verlag, 1934), 124.

11. Emil Nolde, *Briefe aus den Jahren, 1894–1926*, ed. Max Sauerlandt (Berlin: Rembrandt Verlag, 1927), 35.

12. "Instinct is ten times more important than knowledge." Nolde, *Das eigene Leben*, 200.

13. Rudolf Probst, introduction to *Festschrift für Emil Nolde*, 16.

14. "This early watercolor is also important in determining Nolde's place in the history of European art. Werner Haftmann's repeated assertion in his *Painting in the Twentieth Century* that Nolde's style did not crystallize until around 1905, when he came into contact with French Post-Impressionism, is true enough as regards execution or realization—that 'working himself up' to his true level of which we have been speaking—but it is certainly not of the essentials of his painting, which were anticipated in the Sunrise watercolor long before Nolde had any knowledge of the achievements of the Post-Impressionists." Gosebruch, *Nolde*, 18.

15. "I walked around in the city, a stranger, with blue-black glasses, and often could hardly find the streets. Life seemed as if lost to me." Nolde, *Das eigene Leben*, 270.

16. On Kaiser Wilhelm II's birthday celebration Nolde wrote, "Once again I'm walking around here: everything is repugnant to me. This metropolis—no one is close to my heart, I'm more lonely than ever before. These straight, long, fog-choked streets—I don't like being here." Nolde, *Briefe aus den Jahren*, 38.

17. Probst, *Festschrift für Emil Nolde*, 12.

18. Quoted in Fehr, *Emil Nolde*, 62.

19. Nolde, *Briefe aus den Jahren*, 99.

20. Ibid., 164.

21. Emil Nolde, *Welt und Heimat: Die Südseereise, 1913–1918* (Köln: Dumont, 2002).

22. Nolde, *Das eigene Leben*, 197.

23. Nolde, *Briefe aus den Jahren*, 98.

24. Nolde, *Das eigene Leben*, 199.

25. Nolde, *Jahre der Kämpfe*, 90ff.

26. Werner Haftmann, *Emil Nolde* (New York, 1959). 4.

27. Max Sauerlandt, *Emil Nolde* (Munich, 1921), 58.

28. Oskar Schlemmer, entry for September 19, 1935, in *The Letters and Diaries of Oskar Schlemmer*, ed. Tut Schlemmer and trans. Krishna Winston (Middletown, Conn.: Wesleyan University Press, 1972), 341.

29. "Psychic and natural forces that the Germanic middle ages drove from [their] sanctuary and banished outside, as chimeras and grotesques on roof ridges and towers, fill this world as if there had never been a Cross. Not until Emil Nolde does German art take possession of its Germanic/nordic heritage, a great hope of the earth, nipped in the bud more than a thousand years ago and buried under Christian-oriental and antique material. Christian piety here—humanism, classicism, Weimar and the Greek spirit there—between both poles glides the German, passionately grasping, turning abruptly back and forth in fulfillments that ebb away, because his own history prevents him from taking possession of a sunken heritage." Heinrich Zimmer, *Festschrift für Emil Nolde*, 35.

30. In that letter to Joseph Goebbels, Nolde wrote the following: "When National Socialism also labeled me and my art 'degenerate' and 'decadent,' I felt this to be a profound misunderstanding because it is just not so. My art is German, strong, austere, and sincere." Nolde to Goebbels, *Voices of German Expressionism*, ed. Victor Meisel (Englewood Cliffs, N.J.: Prentice-Hall, 1970), 209.

31. Ibid., 55.

## 7. Modernism, Surrealism, and the Political Imaginary

1. Note the excellent survey by Mary Ann Caws, *Surrealism* (London: Phaidon, 2010); and the standard work by Maurice Nadeau, *A History of Surrealism*, trans. Richard Howard (Cambridge, Mass.: Harvard University Press, 1989).

2. André Breton, *Manifestoes of Surrealism*, trans. Richard Lane and Helen Seaver (Ann Arbor: University of Michigan Press, 1969), and *What Is Surrealism? Selected Writings*, ed. Franklin Rosemont (New York: Pathfinder, 1978).

3. Note the listing of authors according to the criterion of "Read . . . Don't Read" in André Breton, "The First Dalí Exhibition," in *What Is Surrealism?* 46.

4. Lenin highlighted the primacy of consciousness in revolutionary theory and thereby legitimated carrying through the proletarian revolution in Russia under conditions of economic underdevelopment with his famous claim that "intelligent idealism is closer to intelligent materialism than stupid materialism." Lenin, "Philosophical Notebooks," in *Collected Works* (Moscow: International Publishers, 1961), 38:276.

5. William S. Rubin, *Dada and Surrealist Art* (New York: Abrams, 1968), 64.

6. "My 'politics' is only concerned with the 'spiritual' [*Geistigen*] and, in Germany, it's useless to upset oneself." Hugo Ball, *Briefe, 1911–1927* (Zurich: Bensinger Verlag, 1957), 41.

7. Julius Braunthal, *History of the International* (New York: Praeger, 1967) 2:36ff.

8. Walter Benjamin, "Surrealism," in *Reflections: Aphorisms, Essays, and Autobiographical Writings*, ed. Peter Demetz and trans. E. Jephcott (New York: Harcourt, 1978). Also note the fine discussion by Richard Wolin, *Walter Benjamin: An Aesthetic of Redemption* (New York: Columbia University Press, 1982), 126ff.

9. "The immoderation of the Surrealists attracted [Benjamin] more profoundly than the studied pretentiousness of literary Expressionism, in which he discerned elements of insincerity and bluff. . . . Benjamin was not an ecstatic, but the ecstasies of revolutionary utopias and the surrealistic immersion in the unconscious were to him, so to speak, keys for the opening of his own world for which he was seeking altogether different, strict, and disciplined forms of expression." Gershom Scholem, *Walter Benjamin: The Story of a Friendship*, trans. Harry Zohn (New York: Schocken, 1981), 135.

10. Breton, "The Automatic Message," in *What Is Surrealism?* 101.

11.  "An appeal to automatism in all its forms is our only chance of resolving, outside the economic plane, all the antinomies which, since they existed before our present social regime was formed, are not likely to disappear with it. . . . [These] are the contradictions of being awake and sleeping (of reality and dream), of reason and madness, of objectivity and subjectivity, of perception and representation, of past and future, of the collective sense and individual love; even of life and death." Breton, "Limits Not Frontiers of Surrealism," in *What Is Surrealism?* 155.

12.  Breton, *Manifestoes of Surrealism*, 47.

13.  For some interesting reflections, see Herbert Marcuse, "Letters to the Chicago Surrealists," in *Arsenal* 4 (1989): 31–47.

14.  Breton, "Interview with 'View' Magazine," in *What Is Surrealism?* 203–4.

15.  Alexandre Kojève, *Introduction to the Reading of Hegel: Lectures on the "Phenomenology of Spirit,"* ed. Allan Bloom and trans. James H. Nichols Jr. (New York: Basic Books, 1969).

16.  Breton, "What Is Surrealism?" in *What Is Surrealism?* 129.

17.  Stephen Eric Bronner, "Sketching the Lineage: The Critical Method and the Idealist Tradition," in *Of Critical Theory and Its Theorists*, 2nd ed. (New York: Routledge, 2002), 16ff, 21ff.

18.  Breton, "What Is Surrealism?" 130; italics added.

19.  Surrealism in "its very definition holds that it must escape, in its written manifestation, or any others, from all control exercised by reason." Ibid., 128.

20.  Herbert Read, "Surrealism and the Romantic Principle," in *The Philosophy of Modern Art* (New York: Meridian Books, 1955), 110ff.

21.  Theodor W. Adorno, "Looking Back on Surrealism" in *Notes to Literature*, 2 vols., trans. Shierry Weber Nicholson (New York: Columbia University Press, 1991), 88.

22.  Breton, "What Is Surrealism?" in *What Is Surrealism?* 125.

23.  Breton, "On Proletarian Literature," in *What Is Surrealism?* 89ff.

24.  See Breton's beautiful "Visit with Leon Trotsky" in *What Is Surrealism?* 173ff.

25.  Ibid., 175ff.

26.  Breton, "Declaration on the Second Moscow Trial," in *What Is Surrealism?* 168ff.

27.  Note Breton's "Speech to Young Haitian Poets," which inflamed the intellectuals of that impoverished country in 1945 and sparked a successful uprising against a dictatorial regime. *What Is Surrealism?* 258ff.

28.  "But the painting quickly became legendary and has remained legendary. It is the most famous painting of the twentieth century. It is thought of as a continuous protest against the brutality of fascism in particular and modern war in general. How true is this? How much applies to the actual painting and how much is the result of what happened after it was painted?" John Berger, *Success and Failure of Picasso* (Penguin: Baltimore, 1965), 165ff.

29.  Sara Cochran, "Spellbound," in *Dalí and Film*, ed. Matthew Gale (New York: Museum of Modern Art, 2008), 174ff.

30. Fixing a call for radical forms of worker democracy with a critique of "total consumption" and the prefabrication of experience through the "spectacle" of commodity culture, the situationists were a blend of vanguard and avant-garde who sought to bring the revolution into everyday life by staging what might be termed counterspectacles and deconstructing the givenness of our perceptions. Their most famous representative, who became something of a cult figure in the 1960s, was Guy DeBord. See his book *The Society of the Spectacle*, trans. Fredy Perlman and John Supak (Chicago: Black and Red, 1983).

31. "None of the painters ever took the trouble to study the writings of Marx and Lenin whose names on occasion they evoked. Even Modigliani, whose brother was an outstanding leader of the Italian Socialists, knew nothing of the literature of Marxism. Mastering political and economic treatises was not their métier. All that Diego [Rivera] ever knew of Marx's writings or of Lenin's, as I had ample occasion to verify, was a little handful of commonplace slogans which had attained wide currency." Bertram D. Wolfe, *The Fabulous Life of Diego Rivera* (New York: Stein and Day, 1969), 419.

32. Ibid., 142.

33. Luis Martin Luzano and Juan Coronel Rivera, *Diego Rivera: The Complete Murals* (New York: Taschen, 2008).

34. Ibid., 203.

35. Ibid., 263.

## 8. Modernism Changes the World: The Russian Avant-Garde and the Revolution

1. Stephen Eric Bronner, "In the Cradle of Modernity: The Labor Movement and the First World War," in *Moments of Decision: Political History and the Crises of Radicalism* (New York: Routledge, 1992), 13ff.

2. Quoted in Augustin Souchy, *Erich Mühsam: Sein Leben, Sein Werk, Sein Martyrium* (Karlsruhe, 1984), 43–44. Also see the relevant sections in Victor Serge, *Memoirs of a Revolutionary, 1901–1941*, trans. Peter Sedgwick (Oxford: Oxford University Press, 1963).

3. Antonio Gramsci, "The Revolution against 'Capital,'" in *Selections from Political Writings, 1910–1920*, ed. Quintin Hoare and trans. John Matthews (New York: International Publishers, 1977), 34ff.

4. Franz Pfemfert, "That is Bolshevism," quoted in Helmut Hirsch, *Experiment in Demokratie: Die Geschichte der Weimarer Republik* (Wuppertal: Peter Hammer Verlag, 1972), 38.

5. John Willett, *Art and Politics in the Weimar Period: The New Sobriety, 1917–1933* (New York: Pantheon, 1978), 40.

6. Note the outstanding study by Camilla Gray, *The Russian Experiment in Art, 1863–1922* (London: Thames and Hudson, 1962), 93ff and 143ff; and the classic

work by Vladimir Markhov, *Russian Futurism: A History* (Washington, D.C.: New Academia, 2006). Also see Anna Lawton, ed., *Words in Revolution: Russian Futurist Manifestoes, 1912–1928* (Ithaca: Cornell University Press, 1988).

7. Leon Trotsky, *Literature and Revolution*, trans. Rose Strunsky (Ann Arbor: University of Michigan Press, 1971), 256.

8. Ibid., 219ff.

9. Note again the excellent discussion in Gray, *The Russian Experiment in Art*, 226ff.

10. Boris Nikolaevsky, "Letter of an Old Bolshevik," in *Power and the Soviet Elite: "The Letter of an Old Bolshevik" and Other Essays*, ed. Janet D. Zagoria (Ann Arbor: University of Michigan Press, 1975).

11. The difference is illustrated starkly through the characters of the Bolshevik Ivanov and the apparatchik Gletkin in what remains a seminal novel by Arthur Koestler, *Darkness at Noon* (New York: Bantam, 1969).

12. Tony Judt, *The Burden of Responsibility* (Chicago: University of Chicago Press, 1998), 80.

13. The tragic dimensions of this drama of communist lies and internecine murder is wonderfully portrayed in one of the greatest and least recognized novels of the twentieth century, Manès Sperber's *Wie eine Träne im Ozean* (Munich: DTV Verlag, 1980).

## 9. Modernists in Power: The Literati and the Bavarian Revolution

1. Note the seminal work by Pierre Broué, *The German Revolution, 1917–1923*, ed. Ian Birchall and Brian Pearce, and trans. John Archer (Chicago: Haymarket Books, 2005).

2. F. L. Carsten, *Revolution in Central Europe, 1918–1919* (Berkeley: University of California Press, 1972), 263.

3. Note the excellent study by Bernard Grau, *Kurt Eisner: Eine Biographie* (München: Beck, 2001).

4. Kurt Eisner, *Sozialismus als Aktion: Ausgewählte Aufsätze und Reden*, ed. Freya Eisner (Frankfrut: Suhrkamp, 1979).

5. Stephen Eric Bronner, "Working Class Politics and the Nazi Triumph," in *Moments of Decision: Political Crises in the Twentieth Century* (New York: Routledge, 1992), 35ff.

6. The standard biography is by Eugene Lunn, *Prophet of Community: The Romantic Socialism of Gustav Landauer* (Chicago: Charles Kerr, 1973). Landauer's most important writings are connected in *Revolution and Other Writings: A Political Reader*, ed. Gabriel Kuhn (Oakland, Calif.: PM Press, 2010).

7. Marta Feuchtwanger, *Nur eine Frau* (München: Knaur, 1984), 133.

8. Augustin Souchy, *Erich Mühsam: Sein Leben, Sein Werk, Sein Martyrium* (Reutlingen: Trotzdem Verlag, 1984), 10.

9. Erich Mühsam, *Unpolitische Erinnerungen* (Berlin: Aufbau, 2003).

10. Max Nomad, *Dreamers, Dynamiters, and Demagogues: Reminiscences* (New York: Waldon, 1964), 16ff.

11. Henry Pachter, "Erich Mühsam (1878–1934): A Centenary Note," in *Weimar Études* (New York: Columbia University Press, 1984), 252.

12. A beautiful portrait of Erich Mühsam is provided by Erika and Klaus Mann, *Escape to Life: Deutsche Kultur im Exil* (Reinbeck: Rowohlt, 1996), 33ff.

13. Quoted in Charles Bracelen Flood, *Hitler: The Path to Power* (Boston: Houghton Mifflin, 1989), 4.

14. Rosa Leviné-Meyer, *Levine the Spartacist* (London: Gordon and Cremonesi, 1973), 6ff.

15. "It has often been asked in communist literature why the party let itself be forced into a policy that from the onset it judged disastrous. Very simply, the communists could not resist the drive of the Munich workers who, irritated after the garrison coup, wanted to defend Munich." Ruth Fischer, *Stalin and German Communism: A Study in the Origins of the State Party* (New Brunswick: Transaction, 2006), 105.

## 10. Exhibiting Modernism: *Paris and Berlin, 1900–1933*

1. *Paris and Berlin, 1900–1933* exhibition catalog (Paris: Centre Georges Pompidou, 1978).

2. Michel Foucault, interview, *Der Spiegel*, October 20, 1978.

## 11. The Modernist Adventure: Political Reflections on a Cultural Legacy

1. Erika and Klaus Mann, *Escape to Life: Deutsche Kultur im Exil* (Hamburg: Rowohlt, 1996).

2. "No. There was no exile-literature in the sense of a genuinely vocal movement. Each author stood alone, found his own contacts, while looking with a particular penchant to the past." Georg Stefan Troller, "Sprache und Emigration: Vom Überleben der deutschen Künstler in erzwungenen Fremde," in *Lettre International* 87 (Winter 2009): 95.

3. Eduardo Subirats, "Kritik der Avantgarde: Die Beseitigung und die Wiedereroberung der Autonomie der Kunst," in *Lettre International* 85 (Summer 2009): 65.

4. See Stephen Eric Bronner, "In the Shadow of the Resistance: Albert Camus and the Paris Intellectuals," and, for an analysis of the context, "The Sickness Unto Death: International Communism Before the Deluge," in *Imagining the Possible: Radical Politics for Conservative Times* (New York: Routledge, 2002).

5. Vladislav Zubok, *Zhivago's Children: The Last Russian Intelligentsia* (Cambridge, Mass.: Harvard University Press, 2010).

6. Note the fine discussion by Annie Cohen-Solal, *Painting American: The Rise of American Artists, Paris 1867–New York 1948* (New York: Alfred Knopf, 2000).

7. It is worth noting that American techniques of mass production and mass consumption were exported to Europe with remarkable effect in the aftermath of World War I. See Victoria de Grazia, *Irresistible Empire: America's Advance Through Twentieth-Century Europe* (Cambridge, Mass.: Belknap Press of Harvard University Press, 2006).

8. Irving Sandler has provided a thorough study in *Abstract Expressionism and the American Experience* (Manchester, Vt.: Hudson Hills, 2009). See also Dore Ashton, *The New York School: A Cultural Reckoning* (Berkeley: University of California Press, 1992). A fine compilation of writings and statements by the major artists is provided in Ellen G. Landau, ed., *Reading Abstract Expressionism: Context and Critique* (New Haven: Yale University Press, 2005).

9. Note the interesting documentary *American Road*, directed by Kurt Jacobsen and Warren Leming (Chicago: Cold Chicago Productions, 2010).

10. Eliot Katz, "Radical Eyes: Political Poetics and 'Howl,'" in *The Poem That Changed America: "Howl" Fifty Years Later*, ed. Jason Shinder (New York: Farrar, Straus and Giroux, 2006), 183–211.

11. Peter Brooker, *Geographies of Modernism: Literatures, Cultures, Spaces* (New York: Routledge, 2005); Laura Doyle and Laura Winkiel, eds., *Geomodernisms* (Bloomington: Indiana University Press, 2005); and Vinay Dharwadker, ed., *Cosmopolitan Geographies: New Locations in Literature and Culture* (New York: Routledge, 2000).

12. Rebecca L. Walkowitz, *Cosmopolitan Style: Modernism Beyond the Nation* (New York: Columbia University Press, 2007).

13. Meyer Schapiro, "The Introduction of Modern Art in America: The Armory Show," in *Modern Art, 19th and 20th Centuries: Selected Papers* (New York: Braziller, 1978), 136–7.

14. Ibid., 151.

15. Schapiro, "Recent Abstract Painting," in *Modern Art, 19th and 20th Centuries*, 232.

16. T. S. Eliot, *The Sacred Wood: Essays on Poetry and Criticism* (London: Methune, 1920).

17. Walter Benjamin, "The Author as Producer," in *Understanding Brecht*, trans. Anna Bostock (London: New Left, 1973), 85ff.

18. Niklas Luhmann, *Social Systems*, trans. John Bednarz Jr. with Dirk Baecker (Stanford: Stanford University Press, 1996).

19. "It is certain that modern music is shattering forms, breaking away from conventions, carving its own road. But exactly to whom does it speak of liberation, freedom, will, of the creation of man by man—to a stale and genteel listener whose ears are blocked by an idealist aesthetic. Music says 'permanent revolution' and the bourgeoisie hear 'Evolution, progress.' And even if, among the young intellectuals, a few understand it, won't their present impotence make them see this liberation as a beautiful myth, instead of their own reality. . . . The artist has no language which permits them to hear him. He is speaking of their freedom—

since there is only one freedom—but speaking of it in a foreign tongue." Jean-Paul Sartre, "The Artist and His Conscience," in *Situations*, trans. Benita Eisler (Greenwich, Conn.: Fawcett, 1965), 145.

20. Peter Bürger, *Theory of the Avant-Garde*, trans. Michael Shaw (Minneapolis: University of Minnesota Press, 1984). See also the economistic yet provocative work by Ralph Sassower, *The Golden Avant-Garde: Idolatry, Commercialism, and Art* (Charlottesville: University of Virginia Press, 2006).

21. "We need to go back and try to understand what [modernists] were up to *as writers*, not dismiss them as reactionaries or misogynists, or adulate them as gay or feminist icons." Gabriel Josipovich, *What Ever Happened to Modernism?* (New Haven: Yale University Press, 2010), 177.

22. The impact of music on the political struggle of African-Americans—or at least on the sensibilities generating and underlying that struggle—is an important theme. Consider the discussions of a "blues people" by Cornel West in *Democracy Matters: Winning the Fight Against Imperialism* (New York: Penguin, 2005); and see also Angela Y. Davis, *Blues Legacies and Black Feminism: Gertrude "Ma" Rainey, Bessie Smith, and Billie Holiday* (New York: Vintage, 1999).

23. Seth Taylor, *Left-Wing Nietzscheans: The Politics of German Expressionism, 1910–1920* (New York: de Gruyter, 1990).

24. See the touching yet cynical poem by Bertolt Brecht about Karl Korsch, his ultra-left teacher in Marxism, "Über meinen Lehrer," in *Gesammelte Werke* (Frankfurt: Suhrkamp, 1967) 10:65ff.

25. Stephen Eric Bronner, "Postmodernism and Poststructuralism: Deconstruction, Desire, Difference," in *Ideas in Action: Political Tradition in the Twentieth Century* (Lanham, Md.: Rowman and Littlefield, 1999), 187ff.

26. Tony Judt, "Words," in *New York Review of Books*, July 15, 2010, 4.

27. Socialist realism was introduced in 1934 by Andrei Zhdanov in his "Rede auf dem 1. Unionskongress der Sowjetschriftsteller" in *Marxismus und Literatur: Eine Documentation in Drei Bänden* (Reinbek: Rowohlt, 1969) 1:347ff. See also the famous critique by the former Soviet dissident Abram Tertz [Andrei Sinyavsky], *The Trial Begins/On Socialist Realism* (New York: Doubleday, 1960).

28. Thomas Mann, *The Genesis of a Novel*, trans. Ralph and Clara Winston (London: Secker and Warburg, 1961), 115.

29. André Malraux, *The Voices of Silence*, trans. Stuart Gilbert (London: Secker and Warburg, 1953).

30. Bronner, *Ideas in Action*, 26ff.

31. Amanda Anderson, *The Powers of Distance: Cosmopolitanism and the Cultivation of Detachment* (Princeton: Princeton University Press, 2001).

32. Frederic Spotts, *The Shameful Peace: How French Artists and Intellectuals Survived the Nazi Occupation* (New Haven: Yale University Press, 2008).

# Index

*Page numbers in italics signify graphics.*